LIFE THROUGH AN
APERTURE

LIFE THROUGH AN
APERTURE

THE FILMS AND PHOTOGRAPHY OF
KEITH HAMSHERE

KEITH HAMSHERE
WITH GARETH OWEN

Author's Note

I discuss films in the order in which I worked on them, which wasn't necessarily the same order as their release, as some movies had long post-production periods whereas others were released within just a few months of shooting wrapping.

A filmography, by year of release, can be found at the end of this book.

First published 2024

The History Press
97 St George's Place, Cheltenham,
Gloucestershire, GL50 3QB
www.thehistorypress.co.uk

© Keith Hamshere, 2024

The right of Keith Hamshere to be identified as the Author of this work has been asserted in accordance with the Copyright, Designs and Patents Act 1988.

All rights reserved. No part of this book may be reprinted or reproduced or utilised in any form or by any electronic, mechanical or other means, now known or hereafter invented, including photocopying and recording, or in any information storage or retrieval system, without the permission in writing from the Publishers.

British Library Cataloguing in Publication Data.
A catalogue record for this book is available from the British Library.

ISBN 978 1 80399 407 9

Typesetting and origination by The History Press
Printed and bound in India by Thomson Press

CONTENTS

Forewords		7
Prelude	When I'm Cleaning Windows ...	9
Scene 1	Opportunity Knocks	11
Scene 2	Oliver Twist	17
Scene 3	Disney and Winner	23
Scene 4	Into the Aperture	33
Scene 5	*2001: A Space Odyssey*	37
Scene 6	*Battle of Britain* to *The Little Prince*	55
Scene 7	More Kubrick, and *Barry Lyndon*	81
Scene 8	A Man Called Otto	87
Scene 9	Enter James Bond	97
Scene 10	*The Deep* and *Death on the Nile*	101
Scene 11	And the Winner Isn't	107
Scene 12	Sci-Fi and *Superman*	117
Scene 13	M(o)ore Bond	129
Scene 14	Enter Lucasfilm	161
Scene 15	Not Everyone's a Winner	185
Scene 16	UK Boom	205
Scene 17	*Star Wars* – the Prequels	221
Scene 18	Mummy, Mummy	231
Scene 19	Mission: Retirement	243
Scene 20	Reflections	271
Credits		273
Acknowledgements		275

FOREWORDS

I commend you, dear Sir, for putting pen to paper, hand to iPad, and mind and heart to writing your memoirs. You were a great friend to me throughout the years of making and playing James Bond. You were a constant companion of good friendship and great laughter within the hurly-burly of each day on set.

You gave me the world and your friendship throughout those days, even if you did try to burn me to death while getting one of the most iconic photographs of Bond! – Much love, aloha.

Pierce Brosnan

I have been fortunate enough to work with Keith Hamshere on several feature films and *The Young Indiana Jones Chronicles*. I am a perfectionist when it comes to my projects and am particularly strict about photography. There is not a print or transparency released without my approval. Keith is an artist of extraordinary talent. Photographers of his calibre are extremely rare. I have the highest regard for Keith as an individual as well as an artist.

George Lucas

I worked with Mr Hamshere on *Patriot Games* and *Indiana Jones and the Temple of Doom*. His diligence and commitment, together with his great skill, made him a valued member of these productions.

Harrison Ford

I've worked in publicity for years with producers and directors such as George Lucas, Francis Coppola, Saul Zaentz and Steven Spielberg. I can state, without hesitation, that Keith Hamshere is the most remarkable photographer I've ever worked with. Keith has a rare talent!

Lynn Hale, former publicity chief of Lucasfilm Ltd

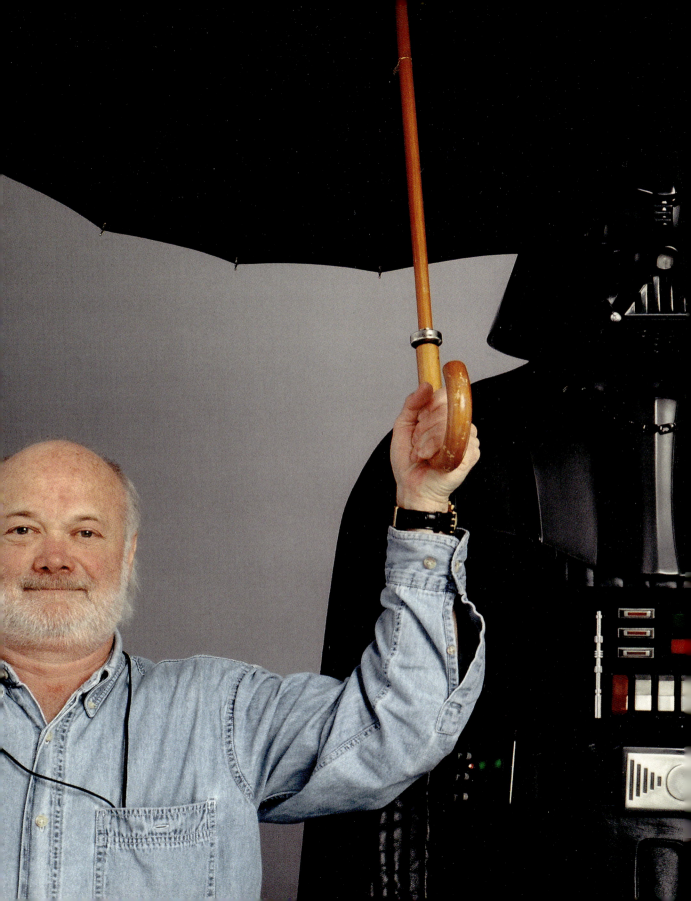

Prelude

WHEN I'M CLEANING WINDOWS …

I suppose you might say the beginnings of my career can be traced back to Ilford Isolation Hospital and Sanatorium in Essex (later Chadwell Heath Hospital) in 1955. No, I wasn't born then – that auspicious occasion came on 22 February nine years earlier – but rather I remember waking up with a very sore throat having had my tonsils removed.

Why is this so significant, you might ask.

My father, Charles Hamshere, worked for the local rates department in Ilford Town Hall and was involved in various civic activities and society events, including charity fundraisers for the hospital. Every year he would help organise their summer fete – you know, the usual mix of tombola, raffle, cake stalls and so forth but also, and most importantly, a talent contest.

Sister Peppiet was the stern but kindly nurse who looked after me during my stay and – funny the details you remember – one day strolled over with a bottle half full of someone's urine and asked that I give a sample in the same said bottle. She and my father had a conversation about the forthcoming fete and talent contest, and he mentioned I played the ukulele. I became a fan of George Formby through his records, and once having seen him perform live at the theatre on Bournemouth Pier I forever after badgered my mother and father for a ukulele. If you're not familiar with Formby, he was actually a huge star – actor, singer, songwriter and comedian – most famous for playing the instrument and bursting into song at any opportunity. He had headlined in about twenty British films by this time, though ironically we rarely ever visited the pictures, so I only knew him through radio, records and that one show in Bournemouth.

Anyway, for my ninth birthday, and to my immense joy, I received a ukulele as a gift – which I still own to this day – and duly trotted down to the Ilford music shop to buy sheet music to teach myself all the George Formby numbers, much to the annoyance of my elder brother Ian. Within a month or two I was considered so good that, unbeknown to me, my father put my name down for the upcoming hospital talent show. 'When I'm Cleaning Windows' was Formby's biggest hit and one I was usually called upon to sing.

There I was in the grounds of the hospital helping Sister Peppiet and my uncle Tom and

Me with Darth Vader holding a black umbrella used to create black fill to stop reflections.

aunt Amy put together the stalls for the fete and the next thing I knew my father appeared, thrust the uke into my hands and put me on the stage, telling me to sing:

> Now I go cleanin' windows to earn an honest bob
> For a nosy parker it's an interestin' job
> Now it's a job that just suits me.
> A window cleaner you would be.
> If you can see what I can see
> When I'm cleanin' windows ...

I suppose I was a bit of a novelty among the amateur comedians, magic acts and other turns and was certainly the youngest of all the entrants. Though just as I had never really been interested in the cinema, no one in my family was remotely musical nor did we have a piano in our front parlour. Quite where I developed my interest I'll never really know, nor was I thinking it would be anything more than a bit of fun and a novelty act in the next couple of hospital fetes, but not only did it lead to me developing a career as a child actor – becoming the first Oliver in London's West End and working for Walt Disney – it later led to a five-decade career behind the scenes in the movies as a stills photographer, again despite having no real knowledge of or background in the medium.

I'm probably best known for my photographic work nowadays and I've been very lucky. I still pinch myself actually when I think of all the lovely and talented people I've worked with on films such as *2001: A Space Odyssey*, *Barry Lyndon*, *The Deep*, *Superman II* and *III*, *Krull*, *Willow*, *Indiana Jones and the Temple of Doom*, *The Madness of King George*, *The Mummy*, *Star Wars* (*Episodes I*, *II* and *III*), *Band of Brothers*, nine James Bond adventures and even a few films with Michael Winner, among many others.

I often regale family and friends with stories from my career, so much so that many of them have encouraged me to put it all down on paper – perhaps as a way of shutting me up?

But, hand on heart, I bet not many people 'in the business' can say they owe it all to being able to play a ukulele in the style of George Formby ... well read on, because I can and do!

Scene 1

OPPORTUNITY KNOCKS

Carroll Levis was a Canadian-born broadcaster who, in an attempt to fill time in one of his early radio shows in Toronto, persuaded a boy in the audience to sing a song. Following terrific listener reaction, he started a local radio talent show called 'Saturday Night Club of the Air'.

In 1935, he moved to England and met radio producer Eric Maschwitz, and together they toured British cities to find new talent. His touring stage shows attracted thousands of applicants and his first radio shows, *Carroll Levis and his Discoveries*, were broadcast in September 1936. The *Radio Times* reported the following year that 'in the last two years he has heard thirty thousand people. Of the amateur acts he has introduced, forty-five have turned professional. Not one of them is earning less than £5 a week, and one is getting as much as £25.'

Among the performers 'discovered' by Levis were comedian and actor Jim Dale, comedian Barry Took, and actress Anne Heywood. Oh yes, and me!

Not long before Christmas 1957, with my ukulele in hand, Dad and I boarded the Routemaster bus to Finsbury Park, where Carroll Levis was auditioning youngsters for a junior discovery show that was going to appear on television the following year. I'd taken part in a few local talent shows up until then, but Dad thought this was it – a chance for the big time.

The Finsbury Park Empire was full of mums and dads with their little hopefuls jostling for a position on stage where all the auditions were taking place. I was really nervous as it was one thing getting up in front of twenty people and having a bit of a sing-song, but this was on a completely different scale on a huge stage, with lighting and microphones and all sorts of suits in the audience – and some of the kids were *really* talented, too.

It was getting late in the afternoon and Dad was of the attitude, 'Well we have come, so you'd better do something.' Without ever registering or putting my name down, just as one of the last kids exited the stage, Dad saw his chance and lifted me up, urging me to sing, so I did my favourite Formby number and received a big round of applause, before being edged off the stage by the next enthusiastic little star. The officials took our phone number and thanked us for attending. That was that.

A week or two later the phone rang. It was Carroll Levis's office and they said they wanted me to be in their first TV show, which was due to transmit early in the New Year. Wow. They were going to send a letter over to confirm, though there was a slight snag – because I hadn't filled in the registration paperwork at the Finsbury Park Empire we weren't aware that all children had to be 12 years old to appear in the show. I was 11.

Thinking on his feet, Dad said I was about to turn 12 in a few weeks, so would be of legal age by the time the show came around. That seemed to satisfy them.

As the New Year dawned, so did my burgeoning career as a child performer and Levis arranged for me to appear both on his TV and his radio shows – I won both, and was invited back the following week, and then the week after, and the week after that. In total I did five TV and six radio episodes and won by audience members sending in votes on a postcard each week. I never realised we had such a big family, but it also meant I had to extend my repertoire and quickly learn more George Formby songs.

It was my first time in a TV studio, so I had no idea about cameras, lights and all the technicalities and must admit I found it all rather exciting. Just as 'showbiz' made an impression on me, it seems I had made an impression too – the phone rang at home one evening and Carroll Levis's production office said Mr Max Bygraves had spotted me on the show and wondered if I'd be willing to go up to the London Palladium to audition.

'Audition for what?' I wondered.

He was actually putting together his own variety show *Swinging Down the Lane*, which was to run nine months at the doyen of London theatres and feature a supporting cast including African American singing trio the Peters Sisters, dancer-singer Aleta Morrison (who went on to become one of Pussy Galore's pilots in *Goldfinger*), trampoline act the Schaller Brothers, Bob Williams and his disobedient dog, and male comedy double act and instrumentalists Hope and Keen.

The next thing I knew I was standing in the lobby of the Palladium and was awestruck by its elegance and scale – certainly the biggest theatre I'd ever been in – and once we had explained we were there to see Mr Bygraves, Max came down the elegant staircase to greet Mum, Dad and me and explained he was looking for a boy to perform in a little comedy act involving fishing.

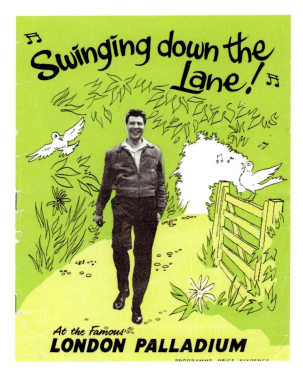

London Palladium with Max Bygraves.

'Would you like to do a little song or something?' Max asked, obviously keen to see a bit more of my range.

I marched onto the stage with my uke and started singing 'I Love to Play My Ukulele', which was actually one of his songs. In hindsight I realise just how cheeky that must have seemed, but Max smiled widely and laughed his head off. I couldn't do anything wrong from that point on and he instantly offered me the job. I took part in rehearsals for a few weeks, mainly at weekends, and we opened in early 1959.

Obviously it impacted on my schoolwork quite a lot as there were seven shows a week, including two matinees, but bumping into stars such as Buddy Holly – who was there to star in Bruce Forsyth's *Sunday Night at the London Palladium* – spurred me on no end, and with Dad's connections at the Town Hall he was easily able to speak with the local education officials about allowing

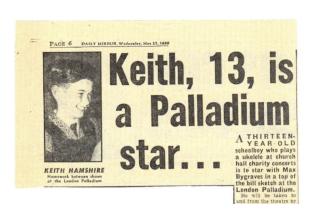

A newspaper clipping from the *Daily Mirror* about my upcoming performance at the London Palladium.

me time off school. Actually, all my teachers were really supportive and encouraging. You have to remember it was just a decade after the end of the Second World War and London, and its environs, were still being rebuilt: times were still pretty bleak so to learn one pupil had been offered a job in the glittering West End was quite a feather in the school's cap and extremely exciting. I had to go to school for 9 a.m., was home by 4 p.m. to brush my teeth, then hopped on a train with my mum to be at the theatre ready to go on in the first act. Fortunately, I could then leave at the interval, as I was only there for that one sketch, so we'd usually be home by about 9.30 p.m., then straight to bed and be ready to do the same again next day. Only on Wednesday matinee days I'd need to leave school at lunchtime.

I can't recall exactly how much I was paid – because I was a minor, my father handled that side of things; he was very good to me, so I won't grumble, though when I wanted to buy my first car I asked how much I had in the kitty, and he shook his head to signify 'nothing'. Hmmm.

The sketch, by the way, was quite simple but rather funny. Max was sitting on a stool singing a song with all the latest (and most expensive) fishing gear, and along I came with a little stick, bent pin, and cast off ... catching the biggest fish you'd ever seen, before walking off stage arm-in-arm with Max singing a song.

Max asked if I would like to record a song with him for release on his next LP (vinyl record) called 'Oh My Papa'. I still have a copy Max signed to me and listened to it a while ago – it seems like a different life to me now. To think, there I was a year before, just an ordinary kid playing a ukulele at the odd talent show and now I was appearing in the West End, making a record with the huge star Max Bygraves and then doing the rounds promoting it on various TV shows. I was taking more and more time off school to dash off somewhere or other, and then, to top it all, one day a TV news crew appeared at the house and wanted to film me cycling to school (which excited the neighbours) and then pick up with me later on arriving at the Palladium, all for a report on this 'young rising star' named Keith Hamshere. It was all a bit bonkers but fortunately my schoolmates never teased me and, like the teachers, were actually incredibly supportive. As there were no other actors at school or even a drama class, I must have seemed quite 'unusual' at the time.

Thankfully, my parents kept me very grounded, as did the lovely stage-door keeper at the Palladium, George Cooper – he'd met them all. George was a kindly, diminutive man who wore glasses (I can talk!), who not only gave me a tip as to my next West End job, but kindly reassured me and calmed me on the one day I was late and thought that was it, my career was over.

You see, by this time Dad had bought a little car and used to sometimes drive me and Mum – who was my constant chaperone, a requirement by law up until the age of 15 – up to the theatre via

Aleta Morrison, London Palladium, 1959.

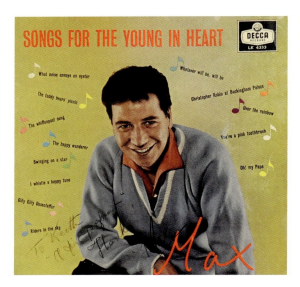

Signed LP from Max Bygraves.

Hackney Marshes, Mile End Road and into Oxford Street in central London. One day the traffic was really, really awful – we panicked and hopped out at Mile End and onto the Tube, but it was hopeless, and I arrived *after* my sketch. Thankfully, Max's son Anthony – who was pretty much the same age as me and who had seen the show several times and actually understudied me during rehearsals – was visiting his father and kindly stepped in.

George reassured me all would be OK and to just pop up to Max's dressing room.

'That's fine, don't worry about it ... Anthony was here ... he loved doing it ... don't worry,' Max said kindly.

I learned a valuable lesson that day and have *never* been late again and if anything am annoyingly early for every appointment.

I should mention Anthony Bygraves and I actually became great friends. On one occasion I went to stay at Max's house in Edgware, north London, for a weekend, and it had a large garden with a private lake adjoining, which was also shared by a few other properties.

Anthony said, 'C'mon let's swim to that little island in the middle of the lake.'

The fact that I couldn't swim didn't put me off: 'Yes of course, yes mate, let's go!' I exclaimed, and full of bravado I jumped into the lake following Anthony, who was a good swimmer, and somehow splashing around on my back I made it to the island and survived. I can't quite recall how I got back though.

The following day we went off with Max in his Rolls-Royce for a picnic to Woburn, with Max's wife Blossom and one of Anthony's sisters. I felt like a film star!

You couldn't say I had a 'star' dressing room at the Palladium, however: I was in a broom cupboard right at the top of thirteen flights of stairs, with a window overlooking sewage pipes and a brick wall. I had the customary mirror with light bulbs but that was about it. But, then again, how many children can say they had their own dressing room at the Palladium?

George Cooper, stage-door keeper at the Palladium, with Bruce Forsyth (L) and Norman Wisdom (R).

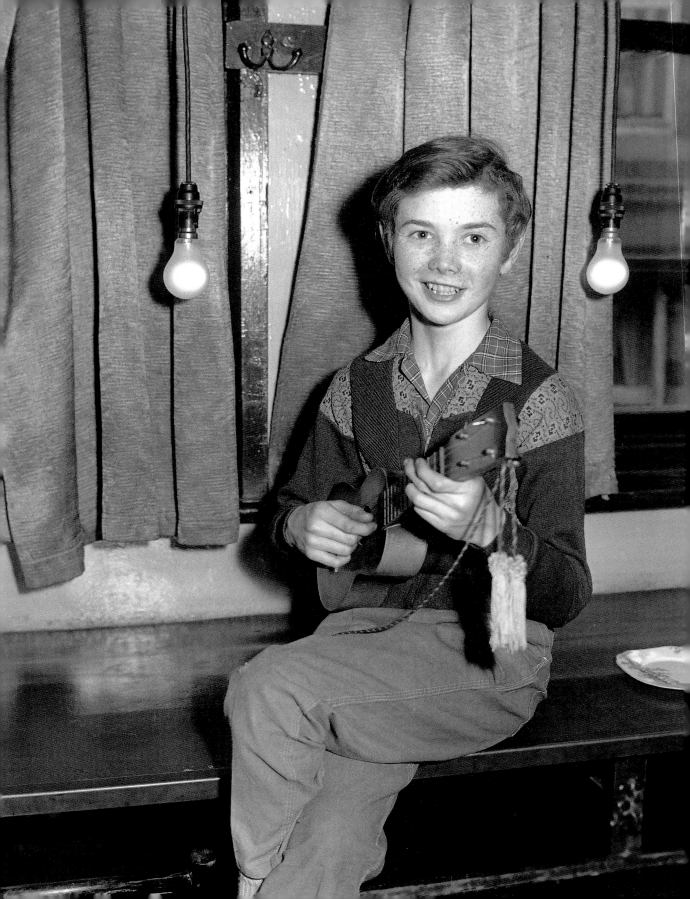

Scene 2

OLIVER TWIST

Swinging Down the Lane was into its final month or two, and it was stage-door keeper George who told me that Lionel Bart's *Oliver!* was being pulled together and they were auditioning for the younger parts and suggested I should go up for it. Now, around about this time I acquired my first agent, Joe Collins – Joan Collins's father. It was one of those curious things where to act on stage you had to be a member of the Variety Artistes' Federation (now Equity) and to be a member you needed an agent. With George's tip-off, Joe and his colleague Cyril Gibbons got me an audition for the role of Oliver Twist. The show was planned to open at the New Theatre in St Martin's Lane, now the Noël Coward Theatre, so I went along there and joined a lengthy line of other boys to meet Lionel Bart and Peter Coe, the director, sang a few numbers and that was that. I was called back to audition again, and again, and again, and in the end I must have completed thirty interviews; it got really boring by the end to be honest, singing the same numbers to different faces.

My agent called and said, 'I think it's between two of you for Oliver but you're certainly going to be one of the boys.' I must admit I'd never read the Dickens book, never seen the David Lean film, so knew very little – other than the script – about Oliver Twist and his mates. Even today I've still not read the book, so I guess you couldn't say I was a method actor throwing myself into it all.

Word then came through: I'd got it, the title role!

Before I knew it the real rehearsals started. It was really demanding work: from early morning until late at night I was having singing sessions at a piano with Lionel Bart and Peter Coe, tackling some dramatic scenes and being put through my paces at the theatre – all in at the deep end. I had to be chaperoned, of course, which meant Dad having time off work, while Mum had to try to be a homemaker and look after my older brother. She tried to chaperone me as much as she could, too.

Sean Kenny was the designer of *Oliver!* and as the episodic story requires quick and varied changes of locale he had to be highly creative and revolutionary in accommodating it. He actually constructed a circular set that changed from a kitchen to the 'Who Will Buy?' set and then some stairs came in where we boys were escaping and running away after robbing people. At one point they wanted me to faint at the top of the stairs, fall and be caught by one of the

Just got *Oliver!* rehearsal – with my ukelele.

Me reading the script of *Oliver!*

Me as Oliver – 'Please, sir, can I have some more?'

dancers. Peter Coe thought it would be dramatic, but after much debate the producers thought it too risky and wouldn't allow it. Upon his premature death aged 42 in 1973 he was said to have had 'an unusual combination of abilities: he had the creativity to dream up a design, but he also had a brilliant engineer's brain, so he didn't only dream it, he knew how to make it'.

The cast included Ron Moody, Georgia Brown and Danny Sewell (as Fagin, Nancy and Bill). Sir Tony Robinson was one of the boys, and Barry Humphries played Mr Sowerberry the undertaker. We opened in Wimbledon Theatre in 1960 as a 'tryout' as they described it (being cheaper!) ahead of transferring to the West End. This allows the production to iron out any glitches, maybe change some songs or routines that don't work and generally polish things up in front of an audience.

It was *not* received well in Wimbledon. There was some frantic rejigging with one number dropped, one or two routines moved from part one to part two, and lots of little tweaks. One or two of the kids didn't quite make it and the rest of us were tremendously nervous as we made the move to the New Theatre for a sold-out first night. Expectations were high, and thankfully we didn't disappoint – pow! It was magical, all clicked brilliantly, and we took thirty-three curtain calls.

All the cast were lovely and Ron Moody in particular was a delight. He used to do little things like, when Fagin was cooking with his back to the audience, he would eat a banana in front of us and wink, and then turn to the audience to deliver his lines. It kept it all fun for us.

My contract was an open-ended one that probably sounded great at the time, but actually caused me to miss out on a lot of other jobs including a possible film version, as 20th Century Fox had bought the rights. However, the show wouldn't release me and in the end they had to wait for Carol Reed to make

The programme for *Oliver!*

a film version in 1968. I was also asked to go to Broadway with the show. *C'est la vie*.

I got to meet a lot of interesting people at stage door every night – quite famous people who just wanted to say hello (as no one was allowed back stage). Then one evening after the show I received a note saying I was wanted across the road at the Talk of the Town. Who was starring that night? Max Bygraves! I was ushered through to the front, and the best table, feeling like a star with my glass of lemonade as Max then introduced me as being in the audience, to much applause. Surprisingly, he then asked me to go up on stage and sing a song from *Oliver!*, which I had known nothing about.

After we finished and walked into the wings, Max said, 'You didn't expect that did you?' He then explained he'd bought the rights. In fact, Lionel Bart had faced severe financial difficulties, and sold his past and future rights to *Oliver!* to Max for £5,000 (some reports say £350, but I'm not so sure Bart would have seen that as a decent price!). Max later sold them on for £250,000.

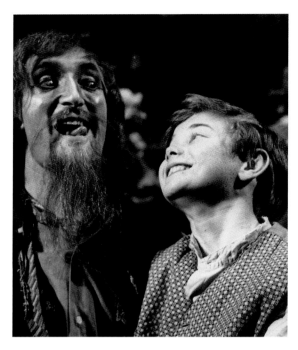

Me with Ron Moody, who played Fagin, in 1960.

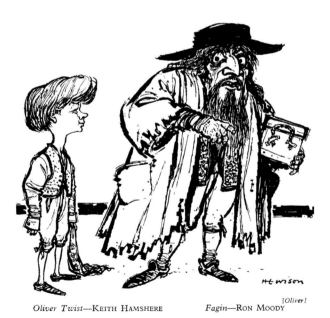

A *Punch* magazine cartoon of *Oliver!*

I was in *Oliver!* for fourteen long months, six days a week non-stop. I did have a bit of a breakdown, caused by stress really, and suffered inflammation of my throat and was signed off for a week, but otherwise I was on every night and every matinee. I never really knew how it came to end, but I think it was partly manipulated by Walt Disney, who had come to see the show.

My agent Joe Collins was involved in casting a film for Disney called *In Search of the Castaways* and thought it might be opportune for me to break away from the West End and take my first role in a film. He asked if I would be interested. I said, 'yes of course', and then little things started happening like my name not appearing on the new posters or advertising for *Oliver!* It was as though I was being eased out of the show – though for all the right reasons.

I was sorry to leave my stage family and leave behind the £30 a week I was earning, but it was rather nice to think I had created the part

Tony Robinson, Steve Marriott, me, Martin Horsey (the artful Dodger) and the rest of the boys from *Oliver!*

that other boys including Phil Collins, Leonard Whiting and Davy Jones took on.

In 1963, Lionel Bart received the Tony Award for Best Original Score. The original London run went on to clock up 2,618 performances, while the Broadway run lasted from early 1963 to late 1964 for 774 performances. There have been many revivals in London, including 1977, 1983, 1994 and 2009 – I wasn't asked back, by the way, but I can still pick a pocket or two y'know.

As soon as I ended my run at the Palladium my agent Joe Collins told me about a show called *Clown Jewels* at the Victoria Palace theatre that starred the Crazy Gang – a group of British entertainers formed in the early 1930s. Their most famous members were probably Bud Flanagan and Chesney Allen – who were pretty much resident at the theatre and a great favourite of the former King and Queen Mother. I was asked if I could play a young Bud Flanagan, for a three-week stint, and sing a couple of songs while wearing a straw hat and fur coat. It was genuine fun and kept me in gainful employment until Walt Disney was ready for me.

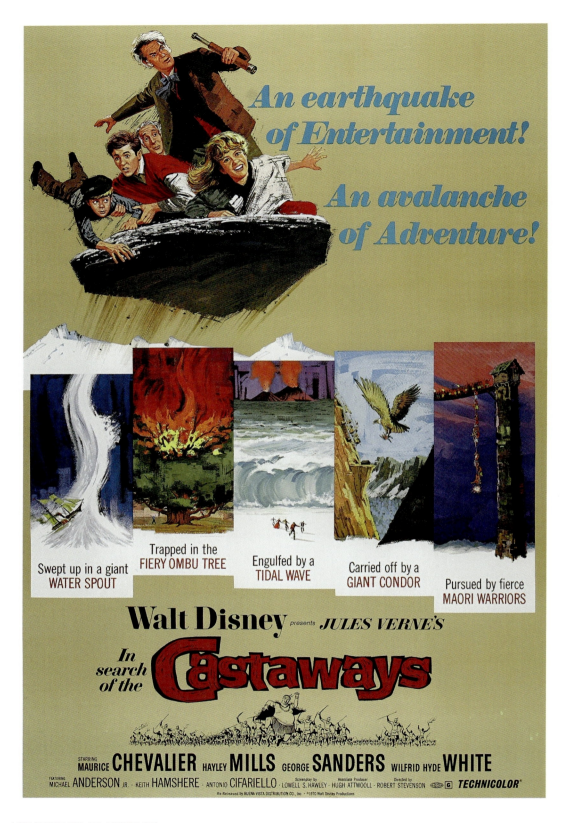

Scene 3

DISNEY AND WINNER

In 1950 the 'The Eady Levy' had been introduced as a tax of ¼ penny (a farthing) on box office receipts in the United Kingdom, with the intention of it being re-invested to support the British film industry. To benefit from the fund, and as a British film, a minimum of 85 per cent had to be shot in the UK or the Commonwealth, and only three non-British individual salaries could be excluded from the costs of the film to try to maximise the employment of British actors, technicians and film crew.

The fact a substantial chunk of their budget could be financed through the scheme obviously appealed to many American producers and saw several set up in the country, including Albert R. 'Cubby' Broccoli and Walt Disney.

I was asked to meet Walt at a News Theatre in Oxford Street that he'd taken over, and I know we had our photograph taken together but I've sadly never been able to find a copy since. We had a chat and he offered me the film *In Search of the Castaways*. Wow.

Under the guidance of his associate producer Hugh Attwooll, Disney had decided to build on the success of a couple of films he'd produced in the UK by setting up a programme at Pinewood Studios. *The Sword and the Rose* was the first in 1952 and ten years later came my new film, based on a novel by Jules Verne.

Walt seldom visited the UK and Hugh was very much in charge, with his production manager Peter Manley and head of publicity John Willis. Though quite possibly more important to me was Johnny Jay, one of two stills photographers. Johnny took a lot of publicity photographs with me in the studio and at my home, and really got me interested in what he was doing. In fact, I was really interested in what all the technicians were doing on set as it was all new and exciting to me, but Johnny in particular – and quite unknowingly – sowed the seeds for the next chapter in my career.

The Disney organisation was one of the first 'renters' at Pinewood, which up until then had pretty much produced its own films under the Rank banner, and the American way of working caused a few waves at the studio. Pinewood traditionally had a tea trolley visit sets morning and afternoon for the obligatory tea break, but when Hugh said he wanted hot and cold running drinks and snacks available all day, as in US studios, there was a fear among management that

In Search of the Castaways poster.

Rank employees would wander off to Disney sets to avail themselves of free refreshments – and chaos would ensue. Hugh suggested canteen assistant Margaret be put in charge of the Disney refreshments as she had a photographic memory so would know who was – or importantly who wasn't – on the unit. Anyone who wasn't was sent off with a flea in their ear. All was well and good until one day Margaret refused to serve an unfamiliar gentleman and said, 'You're not on this film, clear off.' The man laughed, and when Margaret demanded to know his name he rubbed his middle finger over his right eyebrow and said, 'Disney, Walt Disney.'

Sadly my South American-set adventure marked Maurice Chevalier's last screen appearance, playing an eccentric professor helping three children to track down their explorer father. Hayley Mills was set to star as Mary (in her third film for 'Uncle Walt'), Michael Anderson Jr as John, and I was offered the role of Hayley's screen brother, Robert.

The script took us through fire, ice and water, where we encountered alligators, jaguars, mutineers and a man-eating Māori dog, across several countries – or so it seemed. The original intention was to visit all of the locations – a bit like *Swiss Family Robinson* did – but in truth, the furthest we travelled from Pinewood was a few miles down the road to Twickenham to use the water tank; otherwise the entire film was shot in the studio – thanks to some clever special effects and excellent matte work. That was really because Hayley's father, Sir John Mills, was travelling around the world filming a lot and he wanted Hayley to be based near home where his wife Mary could chaperone her, hence it was all filmed at the studio with huge sets recreating all the locations. I was there for thirty-two weeks in all, and the production billeted Mum and I in Gerrards Cross at the Bull Hotel in quite possibly their worst room – and me a star, earning £70 a week and with my own chauffeur to take me back and forth including to Abbey Road where we recorded some songs etc. It was all great fun, and I was too young to take it all seriously.

Obviously, I'd learned the script, and, of course, each week we would talk through what we'd be shooting so we could refresh the lines in our minds, as back in *Oliver!* I was performing the same script day in and day out and wearing the same costume. Our director Robert Stevenson was a really sweet, patient and kind soul born in Buxton in the Peak District who went on to greater success in Hollywood with *Mary Poppins*, *The Love Bug* and *Bedknobs and Broomsticks*. In total he directed nineteen films for Disney.

We children, meanwhile, pretty much had the run of Pinewood as the production was based across so many of its stages, and the studio had its own stables too, complete with horses, which we'd take out for a trot around the adjacent Black Park. Along with the fun we had tutors too, of course, to continue our schooling, and A-block at Pinewood became the classroom area. There was even a little lab for the sciences, which always fascinated me, particularly when we were once making something mildly explosive and the tutor had to nip out to the bathroom, telling us not to do this or that – and, of course, we did. There was a bit of a bang, followed by a small fire and the sound of fire engines descending. It really wasn't all that serious actually; far worse was when Hayley decided to dry her trousers out on a heater in her dressing room after we filmed a water sequence and got soaking wet – I remember her coming into the corridor shouting 'Fire! Fire!' as the smoke billowed.

Michael, Hayley and I became great pals and would occasionally go out to the cinema in Gerrards Cross on an afternoon off. We'd be dropped off by car and then picked up afterwards, and being the envy of many a young lad, I thought I might perhaps put my arm around Hayley (who sat between Michael and I) during the film one day, only to discover my co-star had beaten me to it! Quite funny when you think about it.

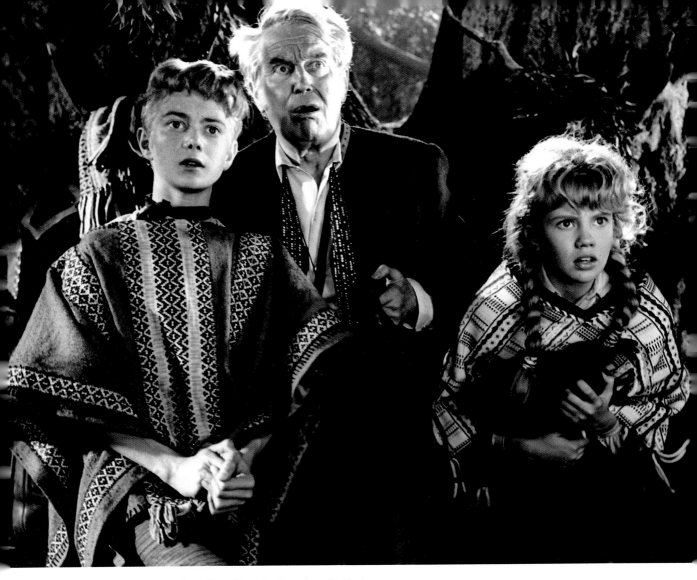

Me, Maurice Chevalier and Hayley Mills in *In Search of the Castaways*.

The plot of our adventure, by the way, concerned teenager Mary Grant, her younger brother Robert and the scientist French Professor Jacques Paganel (Maurice Chevalier) tricking their way aboard the grand yacht *Persevero II* during a bon voyage party to see the owner of the shipping company, Lord Edward Glenarvan (Wilfrid Hyde-White). With the encouragement of his own son, John, Glenarvan's luxurious paddle boat sets sail for the coastal town of Concepcion, Chile, in search of the missing Captain Grant (Jack Gwillim), who was believed to have perished at sea. It was all great fun, and boys' own adventure stuff.

In Search of the Castaways was a great commercial success. Upon its initial release, it earned $4.9 million at the American box office, making it the third most successful film of the year behind *The Longest Day* and *Lawrence of Arabia*. It was one of the twelve most popular movies at the British box office in 1963, too.

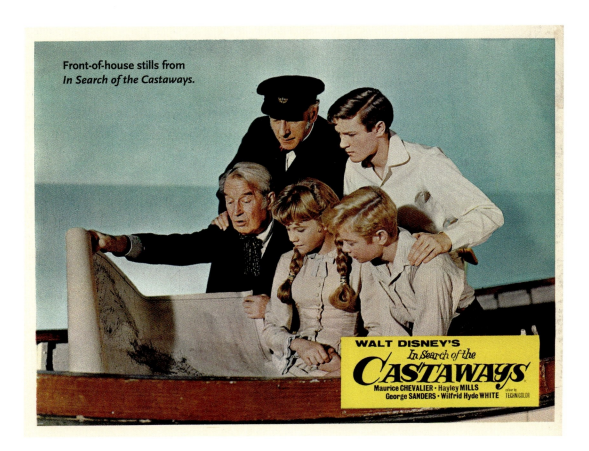

Front-of-house stills from *In Search of the Castaways*.

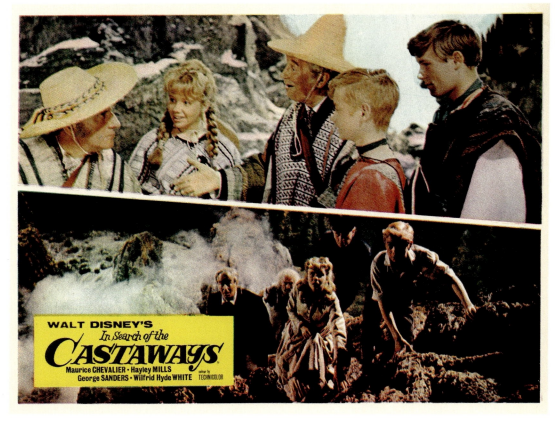

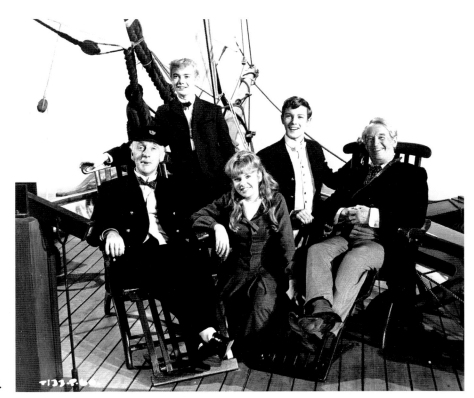

Wilfrid Hyde-White, me, Hayley Mills, Michael Anderson Jr and Maurice Chevalier.

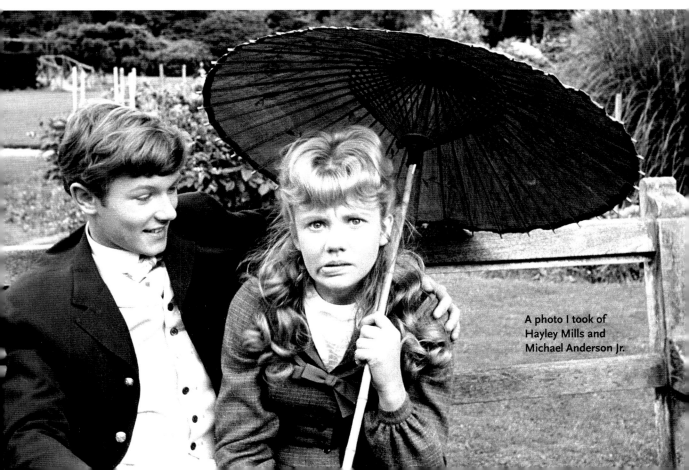

A photo I took of Hayley Mills and Michael Anderson Jr.

Maurice Chevalier on his seventy-third birthday.

I was only contracted for one film for Walt Disney and while their production programme continued in the UK my services were not required again – mainly because they realised I wasn't very good! Well, that's a bit harsh, though I do remember dear Bob Stevenson trying to get me to play down my reactions – you have to remember I was from a theatre background where everything was big and bold, so that the people in the back row of the stalls could see your reactions and hear every word. In film if you raised your eyebrow up half an inch it actually moved 8ft high on the cinema screen, and there's no need to project your voice either as they had lovely microphones just above your head. But it was all new to me and I was still learning.

I was, however, soon afterwards offered another film called *Play it Cool* for director Michael Winner, again to be shot at Pinewood. This was Winner's fifth or sixth feature and he already had a reputation for being difficult, shouting at cast and crew through a megaphone – even if he was just a foot or two away from them – and being generally bad-mannered and ill-tempered.

It was the early 1960s and kids now had a lot of buying power, particularly in music. Anglo-Amalgamated studio chief Nat Cohen decided he wanted in on the contemporary music scene and contracted producer David Deutsch to make a film called *Play it Cool*, essentially about a young chap with a band of his mates playing the coffee bars and nightclubs of London, where he was hoping to find an heiress. It was a terrific cast, headed by Billy Fury (Britain's answer to Elvis) who played struggling musician Billy Universe. In support were Michael Anderson Jr, Ray Brooks, Jeremy Bulloch, Helen Shapiro, Bobby Vee, Alvin Stardust, and Lionel Blair.

Meeting Fury and jamming with him on set during breaks was the memorable part of the

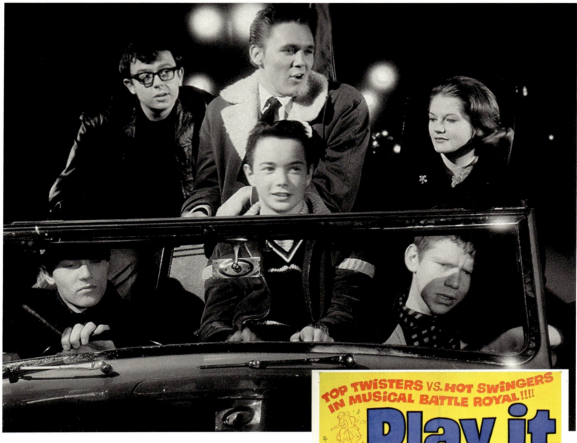

The cast of *Play it Cool*.

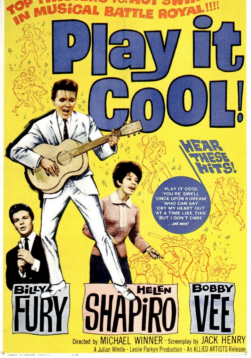

film for me, along with getting a lift off him with Ray Brooks, in Billy's Humber Snipe. I took my own guitar to set, which I had bought a year or two earlier for £10, and received lessons from Allan Hodgkiss, the most brilliant and talented guitarist, who played with Django Reinhardt and the Hot Club of France. One day Billy asked me if I was being paid rental for playing it. 'Paid?' I asked.

So I went over to production manager Donald Toms and mentioned 'rental'.

'Can't do that,' he replied, 'Michael won't allow it,' obviously mindful of other actors bringing in their instruments. Knowing we'd already shot on it, and being a bit bloody-minded at

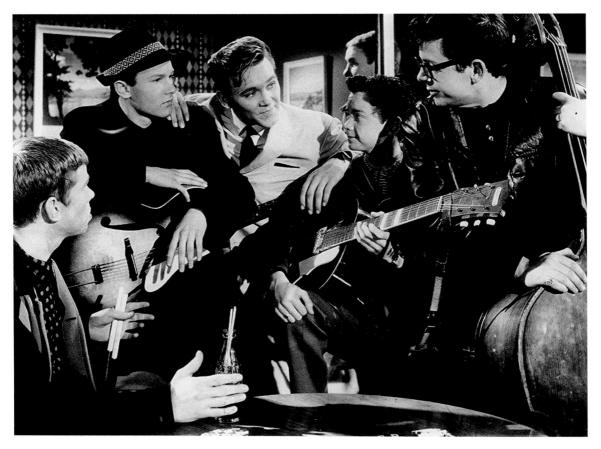

Me on the guitar in *Play it Cool*.

that point, I said in that case I wouldn't bring it in again. The art department had to scramble around to find another similar guitar but if you watch the film closely you'll see it wasn't quite similar enough.

The film was meant to be Britain's first 'Twist' film, but the 'Twist' hadn't come to England in 1961 and so nobody 'twisted'! The few people we found who could do it were brought on as 'twist instructors' and gave us all lessons.

Winner wound everyone up with that damn megaphone, not least the lovely sound recordist Dudley Messenger. On one take Winner screamed, 'Everybody twist!' nearly blowing Dudley's headphones off, so in retaliation, when Winner called for another take, Dudley proceeded to play Brahms through the loudspeakers. On another occasion, when Winner screamed the instruction, twenty-six loud hailers came down from the ceiling on the end of some string, and on yet another occasion the crew creased when Winner put his megaphone down only to reveal a circle of black boot polish around his mouth.

Oh there are so many stories about Winner, though he did at least have a sense of humour, as was demonstrated when one key crew member excused himself from set during a scene shift, but ten minutes later still hadn't returned. Winner was not renowned for his patience, and so, when he was ready to go for a take, demanded to know where 'Sid' was. Someone

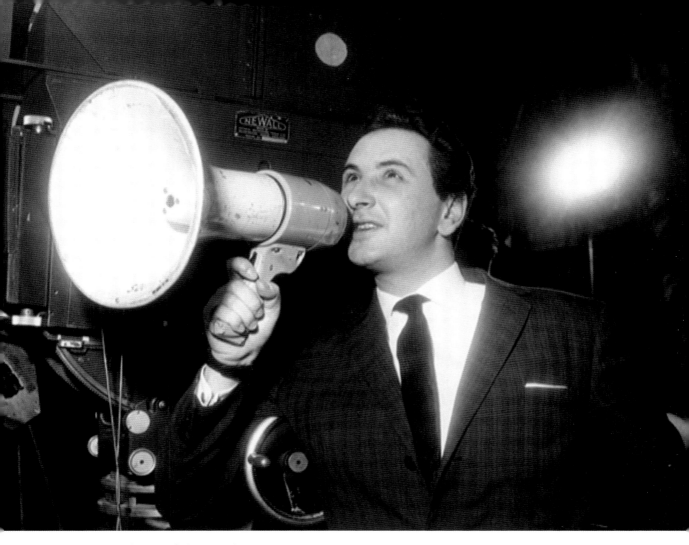

Michael Winner, director of *Play it Cool*.

said he was in the gent's loo. Furious, Winner stormed off the stage and into the corridor where the loo was located, flung the door open and, noticing an occupied cubicle, screamed, 'Sid, are you in there?' A voice came back over the door, 'Michael, I can only deal with one shit at a time!'

Winner fell about.

It was a mercifully short shoot, five weeks in all, with a £72,000 budget, so it wasn't exactly on the same scale as my Disney picture, but then again it wasn't a big financial risk either. But ABC cinemas – then owned by the film's financier Anglo-Amalgamated – refused to play the film! Nat Cohen eventually persuaded them to try it out on three screens, one of which was in Luton – and the cinema was besieged. Kids had been so starved of their own brand of entertainment that they were literally fighting to get in.

I'd also developed – if you'll forgive the pun – a greater interest in photography thanks to Johnny Jay and bought my first camera from him, a Nikon S2. I had unknowingly taken the first tentative steps into the next chapter of my career because the main problem with child actors I discovered is, of course, that they grow up – as did I, and my voice broke.

Nan Munro and Grandpa Thomas.

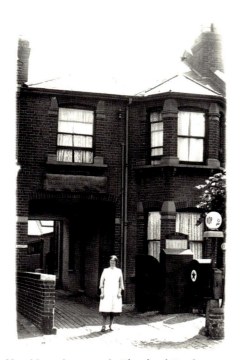

Nan Munro's garage in Cleveland Road.

My family home in Ilford.

Scene 4

INTO THE APERTURE

I went up for a few auditions after *Play it Cool* but didn't do very well, and as I'd had no real formal training in screen acting, I felt it couldn't hurt to get some, so I enrolled at the Stanislavski school in Blandford Street, London.

There were a lot of other hopefuls on the course who were really good actors but had frustratingly not got that one lucky break, and this seemed like their last-chance saloon in many respects.

I enjoyed the course, but probably enjoyed experimenting with my Nikon S2 camera more, and found my passion for photography was beginning to overtake my interest in acting. I started looking around for something to fill in my spare time and to earn a little money to pay the course fees. Luckily I landed a job at Austrian firm Fayers, a high-society photographer based in Grosvenor Street. Initially I did all the lowly jobs such as packing, sending the proofs off and wheeling loads of stuff to the post office, though all the time I was learning the fundamentals and theories of photography from the various departments.

The lady who managed all the processing was Mrs Holland, a very stern-looking woman in green overalls who always sported a cigarette in a very long holder. She invited me into the darkroom to observe film and plate developing, which actually started my steep learning curve in the technical side of photography. Along with film they handled 'whole plates' – 8 × 6 glass – predominantly used in studio portrait sessions, on which I was lucky enough to assist with some of the high-society debutantes of the day. I also learned to load the glass plates ready for one of the main photographers, Mr Westall, and he was particularly helpful and instructive. On one occasion I accompanied him to Downing Street for a shoot, as a helping hand, though I can't possibly talk about that!

Fayers had quite a large retouching and airbrushing facility – as after all, the debutantes needed to look their absolute best – and employed a lot of people, such was the demand to look good.

During my time on the acting course I took on the lead in a Tennessee Williams play, *This Property is Condemned*, at the back of St Martin's Lane in a little theatre, and that was real acting, albeit for a few weeks. My phone didn't ring afterwards and so I concentrated more on my photographic job. Incidentally, Robert Redford took on the same part in the 1966 film.

I'd managed to save a few quid and moved from home to a little bedsit in East Finchley, which was pretty grotty but at least it was mine, and I bought a little car too – a £380 green Mini

van. I'd learned to drive with a chap named Mr Gosling, who had a garage in Ilford near where my grandparents owned a petrol station. My grandfather was actually the first person to convert a car to dual control and had started a driving school that Mr Gosling was involved with. The day I passed my test I drove my Mini up to Grosvenor Street, parked outside Fayers and went to work. Talk about feeling grown up.

I next noticed an advert for a vacancy at Baron's photographic studios on Brick Street in Mayfair, which had been founded by the dance, film and celebrity photographer Baron (born Sterling Henry Nahum). They too were high-society photographers and counted HM Queen Elizabeth II among their clients, employing the likes of Count Zichy, Rex Coleman and a young Anthony Armstrong-Jones (Lord Snowdon).

Baron's started a commercial section and needed staff. I was taken on and one of their first clients was the Freeman's clothing catalogue, so we photographed many of their models with all manner of cardigans, trousers, hats, coats etc. I got more involved in building and lighting sets and going out on locations, plus using 10 × 8 large format, new emulsions and new films on our shoots, which was quite fascinating and exciting.

With nothing forthcoming on the acting front, I advanced to working at an advertising studio in Kensington, and learned even more about print processing and shot material in the fashion and advertising world. I remember photographing 10 × 8 plates of bowls of soup and bottles of whisky for clients, which was actually more involved than it sounds with lighting, shadows and focus, but I picked up so many useful tips and techniques.

It was there I met and became friends with Roger Allan, who specialised in child and baby portraits and was doing rather well. He suggested we might form a sort of partnership in portrait photography and even suggested I move into the flat he shared with his girlfriend in Clapham and rent the spare room. It was quite funny actually as the flat was directly above Clapham South Tube station and quite often when printing I'd have to stop for a minute as everything started vibrating and shaking with the trains passing.

Roger and I really got on well and worked hard on many assignments, making a nice few quid and a bit of a name for ourselves. So much so, a big break came our way when we landed a contract at London department store Derry & Toms to run a new child portrait studio.

We ordered all the kit needed and as the area in the store was being readied for us to start, with various backgrounds and props – pot plants, cushions and the like – a couple of weeks before the grand opening Roger split up with his girlfriend and did a runner, leaving a string of debts behind him, including to Kodak for film stock and rent on the flat.

I had to move out and, not having anywhere to live, went back home to Mum and Dad while paying off some of my partner's debt, which at 18 or 19 wasn't quite the career plan I had in mind. Derry & Toms wouldn't talk to me as Roger had fronted all our negotiations and the paperwork; plus, with me being under 21, which was the age of majority up until 1969, it all fizzled out, much to my sadness.

For the first time in a decade I found myself out of work. I took a train into central London to Tottenham Court Road and started looking for a job in a shop – I figured if I hadn't got one by the time I'd reached the other end of Oxford Street at Marble Arch then I would have to throw myself under a train, well not literally of course.

The first shop I walked into was Paul Fraser Cameras. Alf Nixon was the manager and I asked him, 'Have you got a job?' He had a chat about my interest, experience and knowledge of cameras and introduced me to the other two guys who worked there: Keith Johnson, who ran the hire department including camera equipment and lights (he later went on to form Keith

Johnson Photographic, a massive firm that was later sold and merged with other big firms), and Keith Flack, who went on to form Procter Cameras. Alf suggested I start on the following Monday as a salesman.

I popped up to Burton's Menswear and said I needed a tailored suit, which cost at least £20, or £450 in today's money, but I felt I needed to look the part.

We often played on the fact there were three Keiths. When a customer called asking to speak to Keith we would pass the phone from one to another saying, 'Oh it's not me, must be the other Keith.' Naughty I know, but just a little fun we had from time to time, such as on one quiet day I was standing at the counter twiddling my thumbs when a voice said 'catch this' and a glass eye rolled past me. I couldn't make out what it was at first until Alf picked it up and popped it back in its socket!

I demonstrated and sold cameras from cheap and cheerful to high end, and got to meet the great British public, who generally knew nothing about photography, unlike today where the only expertise you need is to just point and press your phone. One lady, to whom I'd sold an Olympus Trip 35 – which was a pretty straightforward, fail-safe model – came back a week later and presented the camera, asking us to remove and process the film. Something didn't seem right, and I was suspicious that the first frame hadn't gone all the way through. I had loaded it, so I knew it wasn't faulty, but the film came back all blank bar the first frame. So I gave her a free film, loaded it up and sent her off. A few days later she returned and asked for it to be processed, and again it was blank. I gave her another free film, loaded it, and asked her to take a photo or two of me, and with that she pointed the camera, removed the lens cap, replaced the lens cap, and said 'Done'. I asked why she hadn't pressed any buttons, and she looked at me quizzically, obviously having never used a 'modern' camera before.

I really enjoyed my time there actually, though after about eight months I received a call from my old friend Johnny Jay, with whom I'd kept in touch, telling me he was working on a film at MGM Studios in Borehamwood and really needed an assistant, so he'd wondered if I might be interested.

That call changed my life.

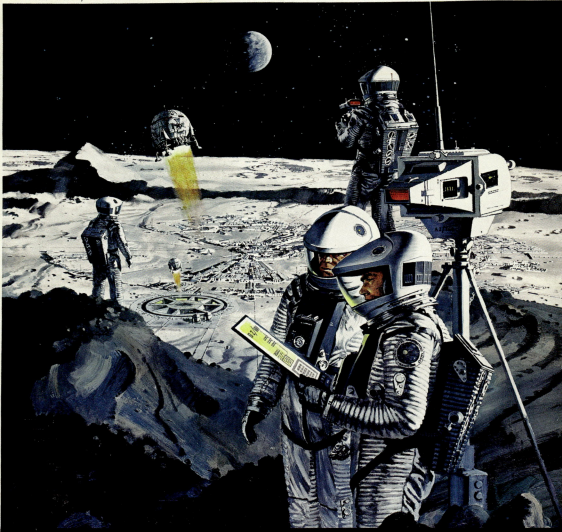

Scene 5

2001: A SPACE ODYSSEY

Johnny explained they were about one-third of the way through production, which in my limited experience I thought meant a month or maybe six weeks. The film was *2001: A Space Odyssey* and I soon discovered that on a Stanley Kubrick picture 'one-third' could easily mean a year!

Johnny was one of the leading UK stills men and Kubrick had chosen him because he liked to employ the best of the best; he had a particular fascination with photography too, so he and Johnny got on rather well, unlike some of Stanley's other colleagues, whom he drove to distraction with his over-exacting standards. But whenever Johnny asked for a still, of say a particular actor on set or a particular set itself, Stanley felt it interrupted the flow so would suggest Johnny 'lift' it from the film negative. You can't really do that all the time, so Johnny had to pick his moment and allowed me on occasions to follow him around with my camera, too. Incidentally, in order for me to work on a film set I had to be a member of the ACCT Union (now BECTU), and as a way of getting me into the union they employed me as a 'Stills Filing Clerk'. After several applications I eventually got my 'union card' and was then left pretty much alone to take on other tasks, such as photographing 10 × 8 plates of sets Stanley needed for the special effects department. One day I was carrying a huge case onto a set, and Kubrick appeared behind me.

'What have you got there?' he asked.

'It's a Sinar 10 × 8 camera, sir, I'm shooting plates.'

'And you are …?'

'I'm Johnny's assistant, Keith.'

'Do you want a hand?' he asked as he opened the stage door for me.

I was actually shooting 10 × 8s of the 'Pod Bay' set and Stanley started to question me about what lenses we were going to use, and if I was shooting or Johnny. I said, 'I'm shooting as I have done lots of large-format photography,' which seemed to intrigue him. We had a very amiable conversation, and he queried such things as, 'How far away will you be from what you are shooting? What's your exposure going to be? Who's lighting it?' and so on. He was genuinely interested and very chatty.

As I started to set up my gear and loaded my slides, Stanley went off in another direction. Whenever he saw me on set thereafter he'd always say, 'Hi Keith.'

I didn't know, at that point at least, just how a big deal Stanley Kubrick was. I was intrigued though as to why he seemed so very frustrated by the occasional 'click' of Johnny's camera on set, to the point he suggested that Johnny 'blimped'

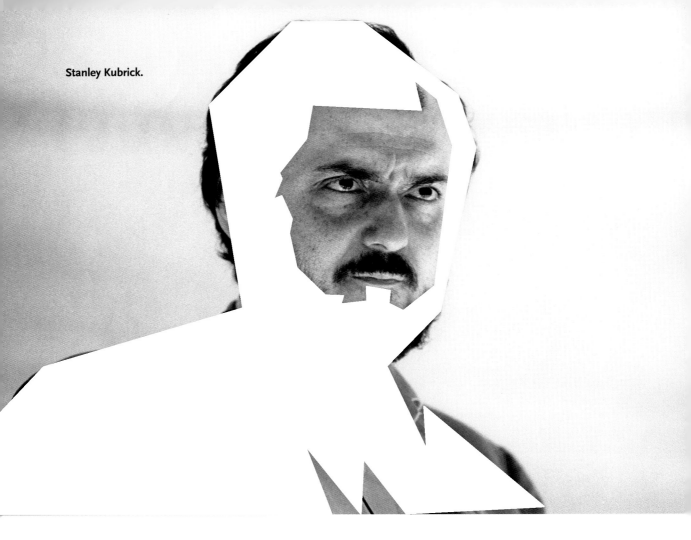

Stanley Kubrick.

his camera – or in other words, put it in a soundproof box. Blimps for movie cameras had been commonplace since the advent of sound but there was no such thing as a stills camera blimp on the market, so Stanley had what I can only describe as a telephone box-type enclosure on wheels with a window made of AA glass, which is absolutely flat. A film set is covered with cables and joists supporting sets and all manner of other stuff, so when Johnny climbed inside it for the first time it fell to me to wheel him round to wherever he directed, while trying to avoid all the hurdles in my way. Of course, Stanley is now legendary for the number of takes he'd go through until he got the exact one he wanted, and quite often actors would have to go up to seventy times or more on a scene until they heard the words, 'Cut, print, move on' from the director.

Upon hearing those words myself I returned to the 'blimp', which I'd manoeuvred into the position Johnny wanted, only to find the glass all steamed up and dripping in condensation but with no sign of Johnny. My eyes moved downwards and there he was, on the floor of the blimp, gasping for air – as soon as I opened the door he took such a long, deep breath of relief. Stanley asked what was going on, so I told him.

'Well put an oxygen cylinder on top of the box,' was his solution.

The prop boys disappeared off to the medical department, returning with a tank of air, which they strapped to the roof of the blimp and told

LIFE THROUGH AN APERTURE

Stanley's blimp.

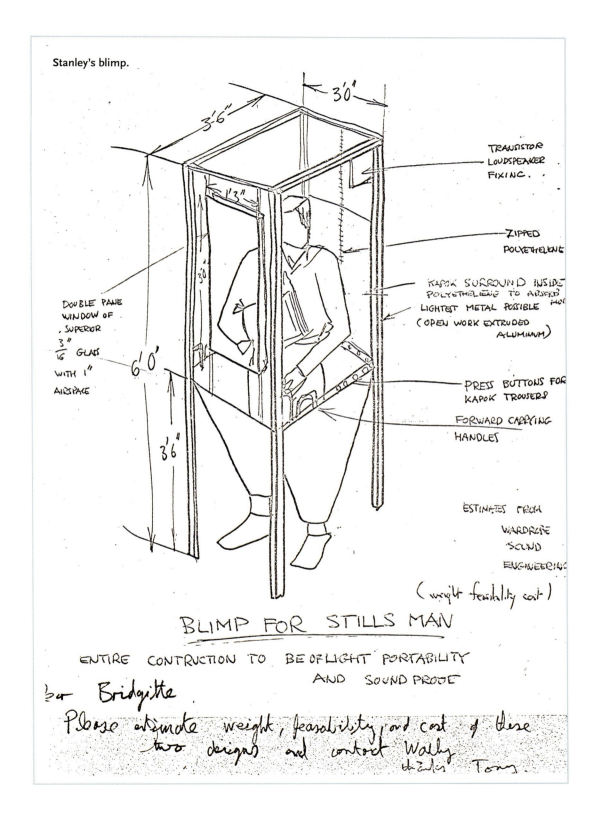

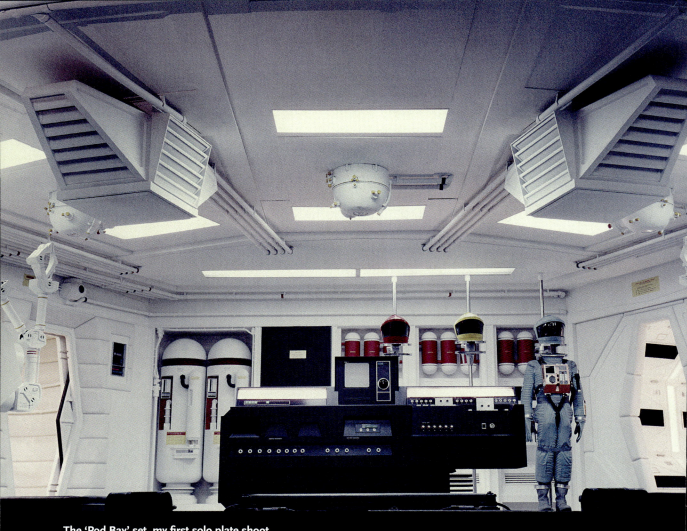

The 'Pod Bay' set, my first solo plate shoot.

The 'Hilton Hotel' set on *2001: A Space Odyssey*.

Johnny it would be fine from then on. The only problem was when Stanley called 'Action!' all we heard then was a faint 'ssssss' noise.

'Cut! Cut!' Stanley shouted, 'get that thing outta here.'

Next thing I knew, our production designer Tony Masters arrived on set with a harness-type contraption and proceeded to strap it on to Johnny's chest and then pulled a tent-like cover over his head – this was Stanley's second idea to silence the stills camera! It was so impractical, though, that that too was given the elbow.

I was often asked to shoot various people in the stills studio and one day received a call from Stanley's secretary, Christine: 'Come to the office with your camera, Keith – Stanley wants you to photograph him with some distinguished guests.'

I dutifully reported and was asked to go over to E stage where they had just finished building the 'Hilton Hotel' set and I was introduced to author Arthur C. Clarke and Fred Ordway, the special technical and space advisor from NASA. Designer Tony Masters was there, too. The set was massive, built across two interlinked stages and covered completely in blue Formica – I couldn't begin to imagine what it cost.

'Well?' asked Tony. Arthur was noticeably quiet and Stanley was stroking his beard. 'What do you think?'

Doug Trumbull and Wally Veevers.

When no one spoke, Tony continued to explain how it was going to be dressed but I muttered, 'Wow it's very blue ...'

Stanley remained silent for a minute, somewhat merging with the set as he always wore a light blue linen jacket, and as he turned to leave said to Tony: 'Make it white.'

The blue set was scrapped and rebuilt in white Formica. Again I couldn't begin to comprehend just how expensive that would have been, but Stanley had an open cheque book with MGM – they wanted 'the next Kubrick film' at any cost. I was finally beginning to realise the power and influence Stanley wielded, particularly as he took over pretty much the whole of the studio (when you could argue he didn't actually need to) and kept other productions out, which contributed to the money woes and subsequent closure of the magnificent complex in 1970.

When principal photography eventually ended, Johnny Jay left to go onto another film. However, Stanley asked if I would like to stay on to shoot large-format plates of the models for the special effects team, headed by Wally Veevers and Tommy Howard. The models created by the art department and model makers were a huge 20ft or 30ft long. Doug Trumbull, another true pioneer and visionary, and his team created many

of the optical effects, including the revolutionary slit scan.* As the 'Dawn of Man' opening sequence was posing logistical and technical issues, Stanley thought I might be useful.

I'd actually been offered an acting role around this time – the lead in a film called *The Virgin Soldiers* – but I felt more excited about *2001*, and to be honest I never really saw an end date in sight. In fact, it was two more years of full-time employment by the time I left. Hywel Bennett, meanwhile, took the part I'd been offered.

Wally Veevers was a short, rotund gentleman and an extremely talented previously matte artist, engineer and special effects man. He was quite stern in his address but had a truly kind smile and always appeared thoughtful. He took a while to get to know, but once you did, his loyalty was unquestionable. Wally had a fully equipped workshop at his home where, to the melodies of his favourite country and western music, he would build or modify camera equipment and synchronised special effects rigs such as his 'sausage factory' repeatable pass effects machine (an analogue motion-control rig), which would prove vital for many of the *2001* shots. It took up the whole length of a stage and consisted of two tracks, with a Mitchel camera on one and the other supporting a dolly with a piece of glass about 5 or 6ft in diameter, which was perfectly flat without any inclusions. Both the tracks could be operated by synchronised motors that would make both the camera and the revolving glass return to the exact same starting point over and over again, which was particularly useful for Wally to photographically overlay exposures repeatedly, to build layer upon layer of effect.

In the camera, just before the first shot, the focus puller would lace** the camera, then mark the frame through the gate on the 1,000ft magazine of film stock with a permanent marker. Shooting would start, and after each pass of the revolving glass and camera, the magazine would be removed by the loader and rewound to the beginning, then reloaded to the exact marked frame before the process started again. The system had to – and did – work perfectly each time and this was long before computers and CGI became commonplace.

I photographed all of the models in large format for Wally, i.e. Orion, Discovery, Aries, and Moon Bus etc., which I printed to be placed on the revolving glass. The edges were blacked and windows cut out with tracing paper in their place. A 16mm Bell and Howell projector was brought in behind and an image projected in the windows, which, when the sausage factory was activated, gave the effect of the actors moving in the Moon Bus. The shot might last a second on screen but took days and a lot of talent to shoot – but such were Stanley's exacting expectations.

Detailed discussions with Stanley were an everyday event. One day he asked how I was going to shoot and light the models I was photographing, and I suggested having several lights reflecting off a large white surface to which he replied: 'Keith, there is only *one* Sun!'

'But how could I light a 20ft subject like the Discovery model with only one single light source on a 10 × 8 plate camera?' I puzzled.

I spent hours with my Bible – *The Dictionary of Photography*, 1965 edition – which I always had by my side, researching emulsions and lenses. I rarely understood the technicalities, but I figured by repeating a few of the technical lines it at least made me sound as though I knew what I was talking about.

'One could try this that and the other,' I'd often bluff – without fully knowing the facts. That was good enough for Stanley. Then if he ever asked, 'What lens here?' or 'What film stock?' or 'What depth of field?' I'd reach down and quote something. In a short time Stanley put me in charge of five darkrooms and three people.

I was shooting a moonscape on one of the stages one day, on a dolly with my 10 × 8 camera,

* A process of animating a ray of light through slits that creates a visual through moving the camera.
** Load the film through the gate of the camera.

Moonscape.

when a stunning girl in a miniskirt walked past with assistant director Ivor Powell on her way to the art department for an interview. Everyone's head turned, all muttering, 'who is she?' Little did I know that she was to be my future wife, Hilary. She obviously had lots of artistic talent as they immediately offered her the job.

By this point in my employment it was quite common for me to attend 'rushes' with Stanley and a few others to watch the previous day's shooting of visual effects to check our work, and I'd like to think I was getting on rather well with him.

Ray Lovejoy, the film's editor, and Stanley started talking about the 'Dawn of Man' opening sequence after rushes one day, and how to film it. I heard mention of South Africa – though Stanley said he didn't really want to travel overseas – and then the discussion turned to how the apes should look. Stanley was particularly keen to achieve total realism.

'Who are we going to get to play the apes?' Ray asked.

Stanley immediately turned, looked at me and said, 'Keith! ... Hey Keith, you used to be an actor, didn't you?'

I gave a little chuckle, but soon realised they were being deadly serious. Next thing he asked me to give an impression of an ape, and while feeling a bit of an idiot, I started scratching my arms and making monkey noises. I walked away thinking how embarrassing it all was, being an actor.

John Alcott and Stanley Kubrick on set.

I returned to the office when the phone rang.

'Hey Keith!' Stanley exclaimed. 'How would you like to play Moon-Watcher?'

He is the alpha male ape in the opening sequence.

I felt I had to go along with what Stanley asked because, after all, he was the boss. Next thing I knew, I was dispatched to meet Stuart Freeborn, the head of make-up and a man often referred to as 'the grandfather of modern make-up design'.

Stuart explained, 'The first thing we are going to do is take a body mould. My assistant Kay is in there,' he pointed to another room, 'so go in, take all your clothes off and lie on the bench.'

Feeling rather embarrassed, I did as Stuart asked and Kay gradually spread warm plaster of Paris all over my body right up to my neck and I had to lie absolutely still until it set hard. A little while later they took the cast off and, as I moved to stand up and put my clothes back on, Kay said, 'Now turn over.'

I had to go through it all again, only face down on the bed.

The following day I was called back.

'Now the face mould,' Kay smiled. That was much worse because she first stuck straws up my nose then covered my head in warm plaster that took twenty minutes to set. All the time I was feeling totally claustrophobic and a bit panicky as I couldn't move or blink and had just those two narrow straws to breathe through. And yes, just as I thought the ordeal was over she then told me

Geoff Unsworth (cinematographer), Stanley Kubrick, Pam Carlton (continuity), John Alcott (cinematographer) and Derek Cracknell (assistant director).

to turn around and did the same on the back of my head.

A temporary suit and face mask were made, and the make-up department worked out the finer dimensions and intricacies of the mouth, nose and forehead in order to make it look more ape-like until we got something together we were all pleased with; and off I went, dressed up like a gorilla-gram, to see Stanley.

I stood in front of him, as if in an examination room, and Stanley started stroking his beard, while talking to Stuart Freeborn, the wardrobe lady and various other people as to what other refinements he felt could be made.

Meanwhile, Wally Veevers, Tommy Howard and Doug Trumbull were asking me to take 10 × 8 plates of the moonscapes and various models, saying Stanley wanted them urgently, to start shooting – and there was I being scrutinised as an ape. Oblivious to me needing to get on with my day job, Stanley told me to go to an address in Belgrave Square, London, and meet an eye

specialist as he wanted to change the colour of my eyes. A chauffeur-driven limousine took me there, and I was asked to sit in a dentist chair and told to relax while they took a mould of my eye.

'How the bloody hell do you do that?' I asked, worried I might see a bucket of plaster of Paris coming my way. The guy put a couple of drops of something into my left eye, explaining it would numb and anesthetise it, and then produced what looked like an egg cup with a funnel coming out of it.

'I'm just going to put this in your eye,' he said nonchalantly. 'Open wide!'

With that, he opened my eye up and forced it in, while I was cringing and pressing myself into the back of the chair.

'Don't move,' he instructed, 'now look up!'

He then poured liquid down the funnel that looked and felt rather like cold cream. He told me to wait a good five to six minutes for it to set and not to move my eye.

What unnerved me most though was when he said he was going to remove the suction 'egg cup' and I could hear sucking and vacuum noises and started to scream in agony as he manoeuvred it around my eye like a dentist trying to extract a troublesome tooth. I jumped out of the chair, said 'thank you very much' and started to run to the car waiting for me downstairs but I heard, 'woah, woah, woah' and a hand dropped onto my shoulder and gently pulled me back inside the room.

'We haven't done the other eye yet!'

'Why do you need to do that?' I queried.

'Both eyes are different,' he answered with a look of glee.

I always think it's worse having to go through something a second time – be it an injection, a filling or anything – when you know just how distressing it was the first time.

I was then driven to a dentist to have my teeth moulded, though admittedly that wasn't as bad.

Suddenly it was show time – dress day. Suits, face masks, teeth and haptic lenses were all lined up for me to get into, and those damn lenses needed suckers to remove them each time. Once dressed I had a slightly unusual 'make-up and hair' session, and was finally pronounced as being, 'Ready for Stanley'.

Stanley appeared, looked me up and down and smiled – he was really pleased.

'What's it like to be inside all this kit?' he asked me.

'Pretty hot actually,' I replied.

'What do you think it will be like at 120 degrees in South Africa?'

'Unbearable!' I suggested.

'OK, this is what we're going to do ...' he called over to one of the chief electricians, 'we just wanna see how long Keith can stand the costume in heat. Can you please put five 10K lamps on each side of Keith, and Keith I want you running up and down in between them for 20 minutes.'

The lamps took the temperature up to about 100° Fahrenheit before I went in running, and I barely lasted four minutes before (almost) collapsing. I went back to the dressing room, changed into my ordinary clothes, then proceeded to get on with my day job ... until Stanley phoned.

'Hey Keith, there's far too much for you to be getting on with, so would you mind continuing with the photography and not playing Moon-Watcher?'

I felt myself smiling broadly, and while feigning a little disappointment I said, 'OK, Stanley, if that's what you want.'

I got on *really* well with him from that point on and he often asked for my opinion on things – as though I knew anything! Then one day he came over and asked, 'What's the largest print you think you could do?'

'How large is a piece of paper?' I asked.

'30 metres long and 52 inches wide, but why don't we try to make a print about 100 foot wide?'

My jaw dropped. 'What of?'

'One of the moonscapes that you shot on 10 × 8,' he replied.

Full of youthful enthusiasm, I heard myself saying, 'Yeah OK, let's see what we can do.'

Tommy Howard, Stanley and I sat around a boardroom table and discovered there wasn't a horizontal enlarger large enough to give such power output to project an image that wide, let alone a place big enough to house it. Stanley said, 'That's easy.' He pressed a button on the intercom and spoke with studio security. 'What stage do we have free at the moment?' he asked.

Security said something or other and Stanley said, 'Right! Let's use that one.' He turned to Tommy, 'What light source could we use that can project an image that wide?'

Tommy looked puzzled for a moment. 'Well the only light source to project that wide would be a carbon arc, but to do that we'd have to black it out, to make it lightproof, which would be a potential fire hazard.'

Stanley shook his head. Further discussion about lenses and projection went on until I suggested we could try some De Vere cathode darkroom enlarger heads with condensers, linked to one of the 240mm lenses from my Sinar kit. I felt it could work and Stanley gave me the go-ahead to put it together on the stage, where I also laid three large darkroom trays on the floor that could take 52in-wide paper, to process it. I needed six people to help. Next I rigged some darkroom red lights up so we could vaguely see what we were doing on this huge stage. We took the two rolls of the 52in paper, attached them to a plywood wall, took an exposure, then had three people on each side dragging the paper through the developing tray, waiting for an image to come up before then running it through the water and the fixer solution. Trying to find a place to dry it all without tearing was another challenge.

Overall, it was a bit of a disaster as the condensers cracked and the image wasn't pin-sharp. But we tried!

Front projection was suggested next, and Tommy Howard was delegated to be in charge and researched it all, reckoning he could make it work whilst we had the apes in the foreground – provding a solution to having the whole unit going to South Africa to film on location, which suited travel-phobic Stanley down to the ground. I, on the other hand, was dispatched to the Namib Desert in south-west Africa to shoot the plates needed for the front-projection images, and Tommy managed to set up a water cooling system for the carbon arc projector so the glass wouldn't shatter under the intense heat as in our first experiments. He also found a way to mount it all on a platform that could be moved around and built 100ft screens plastered in a 3M material – that had recently been employed in road sign manufacturing – giving the most wonderful surface to project on to.

I boarded the South African Airways flight to Johannesburg and was amazed to discover my ticket was first class – I even had a bed to sleep in.

Hilary was at the airport to wave goodbye; we were both a little tearful. I was full of mixed emotions as we had fallen head over heels for each other and always spent what little time we had away from MGM together. Not knowing how long we were going to be apart made me feel rather anxious – how were we going to cope?

From Johannesburg I then flew to Windhoec and was met and flown in a private plane over the Namib Desert – a wilderness that stretched miles – and the Skeleton Coast. We landed at a small airstrip at Swakopmund, where we were met by Andrew Birkin (assistant director), Fred Schmidt (the safari manager) and one of the art directors, Ernie Archer.

This was at the height of apartheid and, having never travelled far overseas, I certainly found it extremely uncomfortable to arrive in this small town where we were separated at every step we took, in restaurants, shops and on buses. There were signs directing 'Whites' and 'Blacks' and you could sense a terribly racist atmosphere.

The next day, with my Sinar 10 × 8 camera and multiple boxes of Ektachrome film, along

A shady area where we set up camp – notice the sleeping bags.

with a few dark cloths, we climbed into our Land Rovers and drove for several hours deep into the desert to start shooting 10 × 8 plates for the 'Dawn of Man' sequence. These areas had already been selected by Stanley from a previous photographer's recce; he had to return to the UK suddenly after having been involved in a road accident. It was extremely primitive: Fred, Ernie and I had separate tents, 12ft × 8ft in size and with a folding canvas bed inside. We had a few local helpers whose job it was to generally assist us and look after things at base such as food and water etc., which at 110° Fahrenheit without refrigeration proved challenging. We had a huge water bowser, and as soon as it had emptied out into a portable tank, one of the helpers would head off to get more water for the following day.

Fred had managed to set up a two-way radio to talk to a radio base in Durban, which in the event produced an extremely weird sound – like an echo through an old tin horn. You could hear the odd word here and there, but it proved tricky to understand sentences. However, it was decreed that the camp master, Fred, had to make contact at every location we arrived at so that Durban would know our co-ordinates in

case of emergency, and to relay any instructions from Stanley.

As we sat down to our first evening camp meal, a hoard of locusts suddenly descended, attracted by camp lights, but the local helpers were quick to use a net to catch them and then eat them – I gathered they were a local delicacy as we were kindly offered some, but I'm afraid after bouncing around in a Land Rover all day my stomach was feeling fragile enough as it was. Luckily, Fred had cooked some stew and potatoes – very English and rather bland – which was just the ticket, along with a beer.

As the sun had gone down I went to my tent to load my slides for the next day's shoot. Just as I'd started, in no time at all, the light increased as there was a very bright moon that night. I had to pack everything up quickly and get Fred to put another canvas tent over my existing one to form a blackout for me to load slides with more confidence.

The next morning we set off to the locations that Ernie had marked with Stanley around 3 a.m., to shoot the sunrise at 4 a.m.-ish. I had a set method of three exposures for the film, using my faithful old Nikon FTN to take a basic meter reading, then proceeded to use my Western to shoot a normal exposure and then another ¾ of a stop up on each setup – each taking 15–30 minutes before we moved to the next area. We'd usually shoot thirty slides (fifteen set-ups).

We'd then return to base camp around midday, settle down for some water/refreshments/light lunch and have a snooze till around 3 p.m. before preparing ourselves for the next day's shoot.

This went on for several days after which my film was boxed up to be put on an aircraft bound for a lab in England to process, in order for Stanley to have a look at. It took about 4 or 5 days for Stanley to see my first day's rushes.

Fred's two-way radio proved useful because I could speak to Stanley via a hook-up from the middle of the Namib desert to MGM in Elstree. We found it was more understandable at night, as the signal was stronger – something to do with radio waves bouncing off the earth's atmosphere more effectively. Stanley seemed quite distant, almost as if he were talking from another world. In a sense, he was. Thankfully, he was very complimentary about the first rushes.

I was out in the desert for about three months, and to relieve some of the boredom I sometimes accompanied the local helpers on their daily trip for supplies, often travelling 120 miles in a day. On one such trip I decided to get out and go for a walk (around 30 miles from where the water would be collected) towards Walvis Bay and civilisation. I spent two to three hours on my own and so vividly remember the eerie silence. A touch of sunstroke ensued. Idiot as I was.

We eventually received clearance from Stanley that he was happy with all the rushes and could head home that Saturday. Again I flew first class and was met on the tarmac in London by the freight agent who whisked me straight through customs and into a huge limo to take me back home.

Hilary greeted me with the biggest smile and our faces lit up; we were both relieved that our feelings for each other hadn't waned – in fact were even more entrenched.

The Namib Desert was an area rich in minerals and old mines. We regularly found odd pieces of gem-like stones, which on examination were mainly silver topaz and tourmaline. Returning to the local town, Swakopmund, with my daily allowance burning a hole in my pocket, one day I had found a jeweller who cut and mounted the stones into rings. When presenting these tokens of affection to Hilary, she selected the silver topaz ring and slipped it on to the third finger of her left hand; it fitted perfectly – and that was that, we were engaged!

On the following Monday I arrived at the MGM studio in Borehamwood to unload my equipment. Stanley greeted me with open arms and told me how much he loved all my material and took me

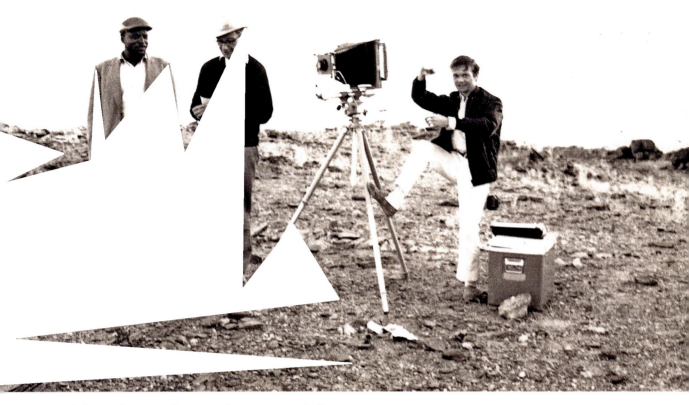

Our helper with Ernie Archer, me and my trusty 10 x 8 Sinar camera.

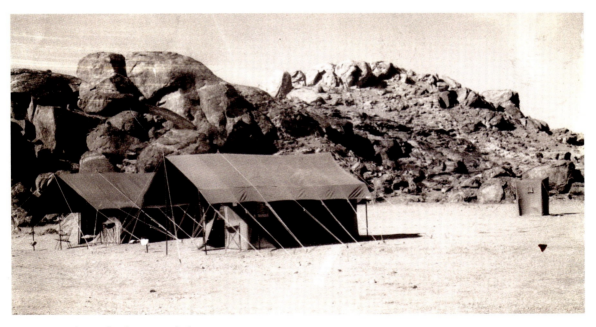

This was my home for three months!

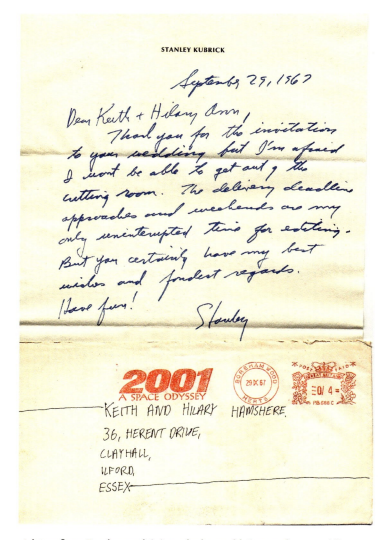

A letter from Stanley, explaining why he couldn't attend our wedding.

onto the stage where they were about to start shooting the 'Dawn of Man' sequence.

Meanwhile, with me proving so invaluable in the desert, Stanley had cast Daniel Richter as 'Moon-Watcher', which was a good move as Dan was not only an actor, he was a mime artist, choreographer and dancer – and he actually authored a *whole* book about his experience.

Hilary and I set a date for our wedding, 21 October 1967, and I naturally invited Stanley to attend as I'd known him for two and a half years by this point. He wrote me a lovely letter back saying he'd love to come and also agreed I could have a week off for the honeymoon. Graham Stark volunteered to be our official photographer, so it was all shaping up.

As the date drew nearer Stanley phoned my office: 'When are you getting married, Keith?'

'The 21st, Stanley.'

'And how long will you be away?' he asked.

'A week,' I replied.

He went quiet for a moment.

'Do you think you could just make it a few days?'

'OK Stanley. OK.'

I knew we were onto the final stretch on the film, and Stanley was mindful he needed to get it all completed, so who was I to argue at this stage?

Later on in the day he called again: 'Can you not have the *whole* weekend off?'

My heart sank.

'Sorry Stanley, but you did agree I could have a honeymoon and John – my assistant – is quite able to stand in for me. He's good. The sausage factory is all finished, and Wally has gone on to *Battle of Britain* so there's not a huge amount to be done, and John is good!'

He seemed to accept my reasoning, but half an hour later called back: 'I really need you in on the Sunday.'

I said I'd think about it though I felt totally deflated.

Being mindful that Wally Veevers wanted me to join him on *Battle of Britain* for process photography, I knew I had a big job on offer so spoke to Hilary and said I felt I needed to hand my notice in, then went to Stanley's office to tell him.

'If you quit now you'll never work for me or MGM again for as long as you live,' he stated bluntly.

'OK. But I've made my decision – I'm getting married and that's that.'

I returned to my office, where the phone was already ringing. I picked it up and it was Ronnie Bear, the post-production manager: 'Stanley wants you packed and off the lot in twenty minutes.'

You have to remember I'd effectively been living there for two and a half years, because of the long hours I was working. I had a dressing room with clothes, a toaster, a kettle and all my equipment in, plus my office with all sorts of things. I literally had to pack everything up and load it into my car. As I drove to the gate the

Our wedding day, with Graham Stark who offered to bring his own camera.

head of security pulled me over and told me he'd been instructed to take a complete inventory with all the serial numbers, which took over an hour, before I could exit.

I was in tears of course, but Hilary was kept on and even allowed a week's holiday for our honeymoon.

Fortunately that other job I had lined up took up another eighteen months of my life, which helped provide a good start to our married life and secure us a mortgage.

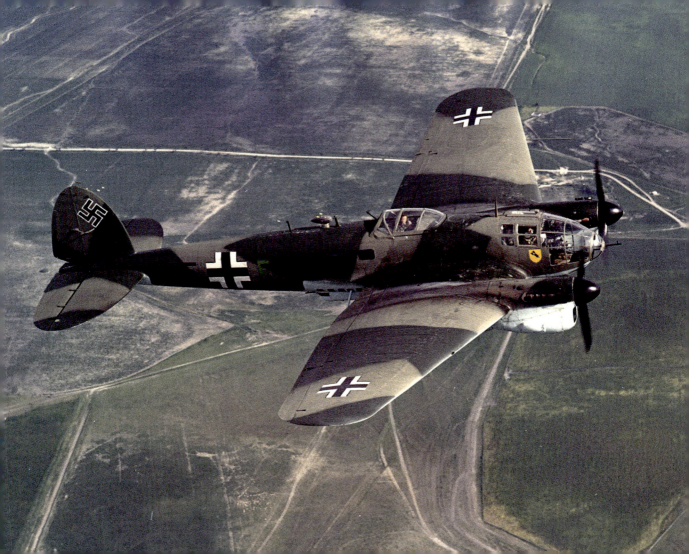

Scene 6

BATTLE OF BRITAIN TO *THE LITTLE PRINCE*

Having been fired by Stanley Kubrick, I joined Wally Veevers at Pinewood on *Battle of Britain* with his sausage factory again, where he said nonchalantly, 'I need 360-degree shots, over and around every single aircraft.'

'Messerschmitt, Heinkel, Spitfire …?' I enquired with trepidation.

'Everything,' Wally confirmed.

I started off in the UK and dispatched to Duxford and into a hangar, where I climbed up into the rafters while a Spitfire was wheeled in beneath me, and there was I with my 10 × 8 camera hanging down photographing the aeroplane as it was rotated and moved back and forth. I then came back down to shoot the underneath, which in the movie is, of course, the angle you see most.

John 'Jeff' Hawke, a well-known American pilot, brought over a B-25 Mitchell bomber that was going to be the camera plane, but wasn't yet dressed apart from a Plexiglass dome where the top gun turret was. This enabled the aerial director to co-ordinate the other aircraft by radio and the action to be filmed along with a platform on the back and side of the plane for cameras. My job was to get in there whenever I could and shoot with a 2¼ square camera (as there wasn't room for a large-format camera) and to photograph flying footage. It was quite magical but very windy because everything was open – and very noisy.

Moving to Tablada airfield in Spain, all the flying action started to take place and, whilst it was very exciting photographing the dogfights between the Spitfires, Messerschmitts and Heinkels, they passed extremely close to us at times, which was a little frightening. The B-25 was now in all its glory painted in dayglo colours (it was affectionately known as the psychedelic monster) to stand out and be noticed by the participating fighters. We were tossed around inside the windy, noisy fuselage, often experiencing negative and positive G-forces, hanging on to whatever we could to stop ourselves from floating out into oblivion. Jeff, meanwhile, was in his element. You could tell by the wry smile on his face that he loved pushing his flying skills to the limit, as on one occasion when he performed a barrel roll just for fun, or by making a low-level pass over the first unit shooting on the airfield – often to the annoyance of the director, Guy Hamilton.

Each day was so eventful and exhilarating that we all climbed out of the B-25 shaken but ready to start a new chapter the following day.

Heinkel plate shot.

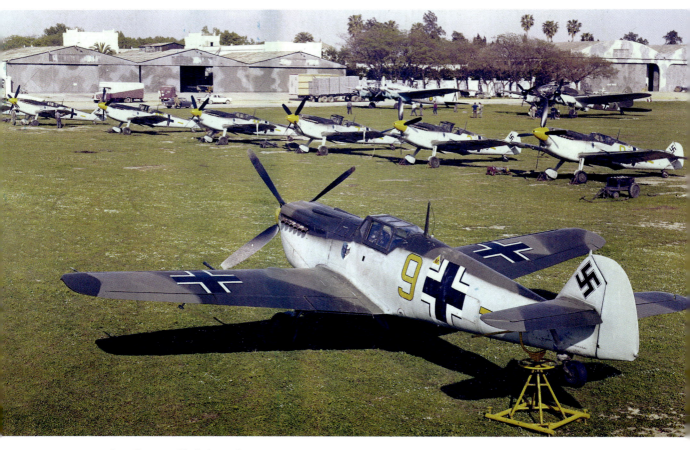

My 109 plate shot at Tablada in Spain.

When I wasn't flying, I was on the ground with my 10 × 8 camera photographing the Messerschmitts and Heinkels (actually Spanish-built Hispano HA-1112 Buchons and CASA 2.111s). I would ask for the tails to be lifted so they appeared level, then Wally would have his art department cut these images out and animate them in his sausage factory.

John Willis was head of publicity and when I returned to Pinewood he got me involved in shooting cast images of Christopher Plummer and Michael Caine in close-up flying aircraft. Assistant director Derek Cracknell was very accommodating in getting me right in there in the middle of the action.

Just when I thought I'd put my 10 × 8 to bed, Wally sent me to photograph plates of all the landmarks of London – St Paul's, the Mall, the Houses of Parliament, Buckingham Palace and Victoria Station, the latter of which was printed on massive 110ft-wide backing to be assembled on the lot of the studio. Off I went with my negatives of Victoria Station to the friends I had made when working for Kubrick, Hunting Photographic, giving them the sizes required. Back at Pinewood a model of a Heinkel was then filmed coming in and crashing, like it did for real during the war. I challenge anyone to spot the joins.

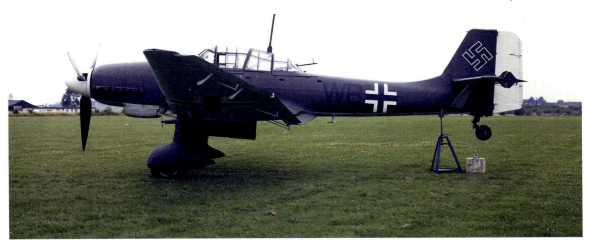
Stuka plate shot.

Skeets Kelly rear camera position in B25.

BATTLE OF BRITAIN TO THE LITTLE PRINCE 57

Spitfires with B25 camera plane.

Trafalgar Square plate shot.

Skeets Kelly in B25.

110ft backing on the Pinewood lot.

A model Heinkel crashing into my photo backing.

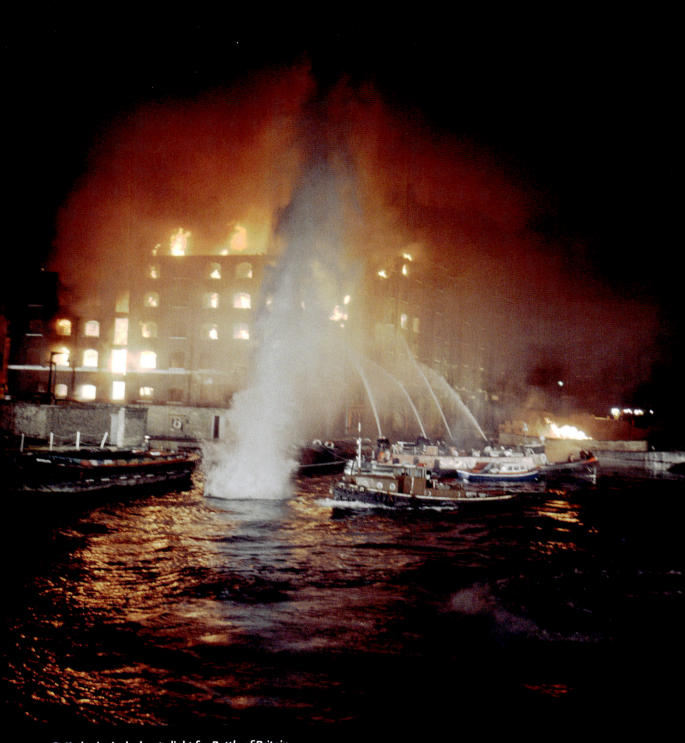
St Katharine's dock set alight for *Battle of Britain*.

I was on *Battle* for around a year in all when my name came up for *Tam-Lin*, starring Ava Gardner.

I'm not sure how I was suggested for unit photographer, as I'd primarily made my name shooting plates for special effects. I was incredibly grateful and travelled up to the location in Scotland. On the very first day a brash American publicist came over to me and started reading me the riot act, 'Never photograph Ava with a drink in her hand' being the first instruction, swiftly followed by telling me 'never to get too close to Ava on set', 'never to get in her eye line' and 'never, but never, spoil her concentration nor make your presence on set obvious' ... and so on, making me really quite nervous of what I could actually do. So much so that by the end of the day I hadn't really photographed anything as, along with all the publicist's dos and don'ts, I was also conscious that my Nikon had quite a loud shutter so I stood behind a tree most of the time, popping my head out to (mainly) take wide shots of the crew and lighting set-ups.

Realising this wasn't the best start to this new era of my career, I plucked up the courage to speak to assistant director Kip Gowans and asked if I could just have five minutes with Ava at the end of the day, and if so would the director of photography Billy Williams kindly leave his lighting set up in position for me.

Kip was so kind and understanding, spoke to Ava and Billy, and told me they had both willingly agreed.

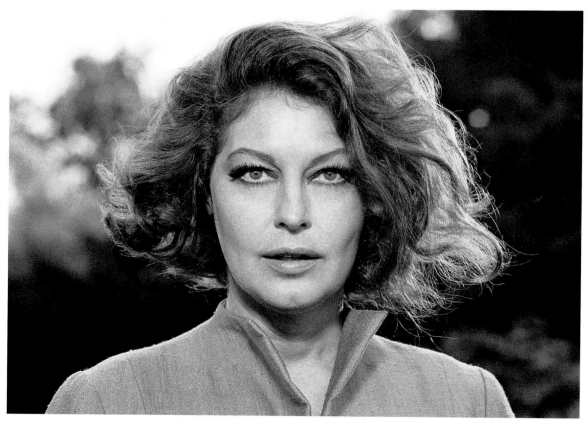

One of my first pictures of Ava Gardner on the set of *Tam-Lin*.

Ava Gardner stars while Roddy McDowall directs.

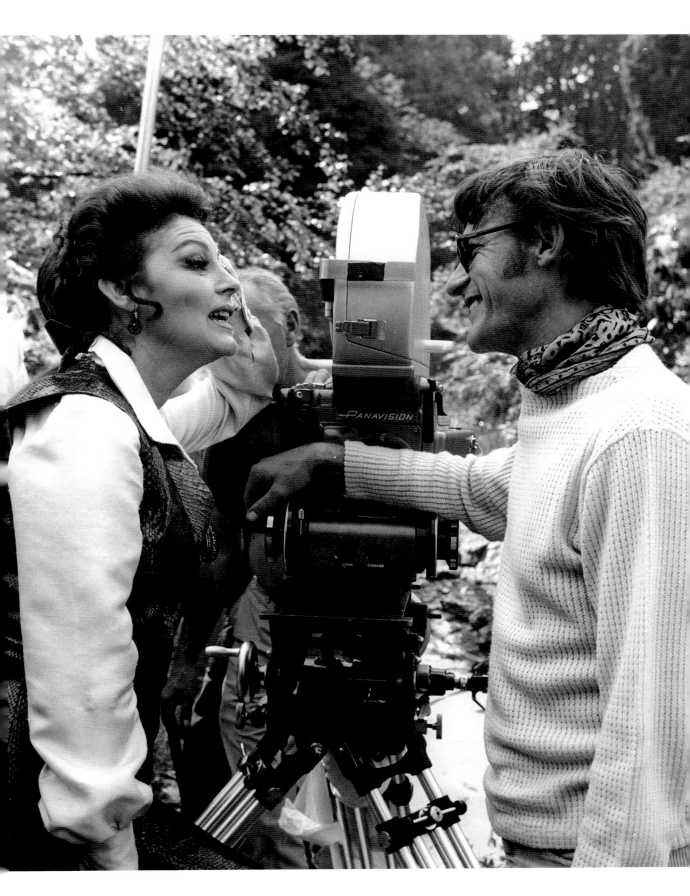

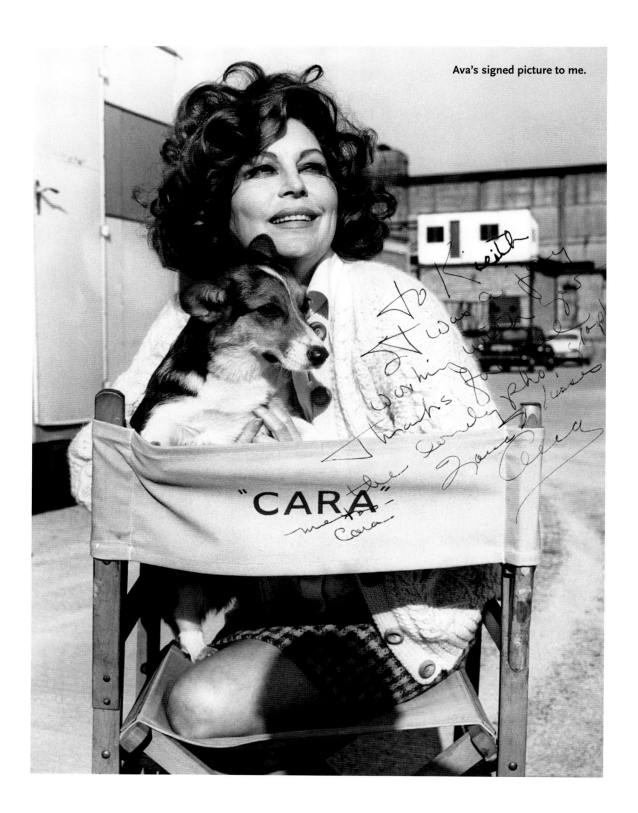
Ava's signed picture to me.

Phew! I shot a roll of film and actually when Ava saw the photos the next day she was very complimentary and friendly, leading me to wonder why I'd been so nervous of her. I then twigged that the American publicist must have hailed from the distribution side of the business and was probably more used to dealing with artists at junkets and press calls where there is so much pressure. So much is asked of the artists in such a short space of time, pulling them left, right and centre, that they invariably get a little grumpy and snap. He'd no doubt encountered the sharp end of Ava's tongue at some point, so assuming it was her usual sort of behaviour, was forever after treading on eggshells around her – and thought everyone else should, too. Fortunately I never saw any of that with Ava; she was a total delight throughout and even invited me to some of the parties she threw at her house in Park Street, Mayfair.

I also got on very well with Billy Daniels, the sound recordist, and was able to test how far I needed to be away from the microphone to enable me to shoot discreetly during actual filming rather than 'call for a still' with the actors at the end of each scene, thereby making myself less bothersome all round by only calling for a few of those.

We were on location for a few weeks and Hilary came up to visit and stay at the Peebles Hydro Hotel, though on arriving she bumped into an American lady who asked if she played badminton, not realising until much later that it was Ava Gardner who was asking her to play.

'Well, I'll have a go,' Hilary replied. 'I'll just drop my bags in my room and will be down.'

Hilary's stay, I should add, led to the arrival of our son Scott nine months later!

I obviously did a fairly decent job on the movie too, as not long after, I received a call asking if I was free to join Dylan Thomas's *Under Milk Wood*.

It had been a great success as a radio play and this big-screen version boasted a cast including Richard Burton, Elizabeth Taylor, Siân Phillips, David Jason, Glynis Johns, Victor Spinetti, Ruth Madoc and Peter O'Toole, among others, as the residents of the fictional Welsh fishing village of Llareggub. (Or spelt backwards, 'bugger all'!)

We headed to Wales for location work, in Fishguard actually, and then back to Kensal Rise in London at Lee Brothers' studio, where Burton recorded his one scene. I shot a couple of pictures of him, but as he was largely on his own they weren't exactly what I'd call exciting. Nonetheless, it was a privilege to meet the great man and just as he was leaving I caught his eye and said, 'You'll never guess what's happening tomorrow.'

He did a bit of a double take, and I continued, 'Peter O'Toole is in bed with your wife,' and rather cheekily added, 'That'd take a great picture – the three of you.'

The very next morning Burton arrived on set, unexpectedly, just as Peter and Elizabeth were playing their love scene; Richard gave me a little wink, so I grabbed for my camera and pushed my way forward, just as he got into bed with them both. I had no say over where the stills were being processed on this particular film, and usually would have recommended the labs at Pinewood, but in this case everything was sent to a lab in central London. Would you believe the very next day my photo appeared on the front pages of every national newspaper! Someone at the lab had sold it.

'Oh they often do that,' I was told, 'and keep copies.' Of course, I had no idea how much money exchanged hands, nor was I established enough to make a fuss as ultimately the production was pleased with the PR, but it certainly made me more guarded in the future. The London lab archive, incidentally, was all sold a few years back after the owner died and I'd liked to have seen what was among that collection.

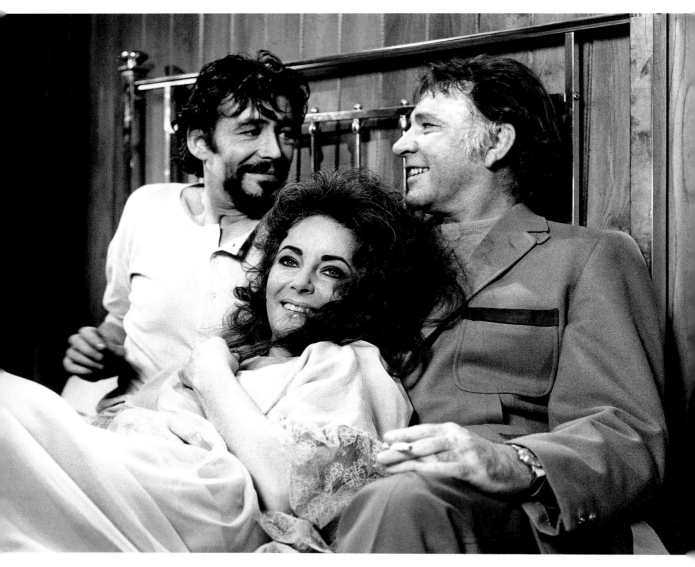
Peter O'Toole, Elizabeth Taylor and Richard Burton in the fun publicity shot I took on the set of *Under Milk Wood*.

Young Winston was next and became my biggest movie to date, with Richard Attenborough directing. Maybe someone thought they needed a young energetic stills photographer (I was the youngest working at the time) to keep up with all the action.

It was an enormous production, shooting on 70mm, featuring Robert Shaw, John Mills, Anthony Hopkins, Anne Bancroft, Jack Hawkins, Ian Holm, and Simon Ward as Churchill. The storyline covered the early years of British Prime Minister Winston Churchill, from his unhappy schooldays to the death of his father, to his service as a cavalry officer in India and the Sudan. Although relatively unknown at the time, I think I'm correct in saying Ward was nominated as the most promising newcomer at the 1972 Golden Globe Awards.

Anne Bancroft had a bit of a reputation as being 'fiery' and so I was a little cautious around her, although when I asked if it'd be possible to set up a family portrait session with her (as Winston's mother), Robert Shaw (as his father) and Simon Ward, she came along quite happily to the set I'd arranged at Shepperton. They all posed for shots, though when I asked Miss Bancroft to change her expression to a 'lighter' one she snapped, 'why?' with great suspicion.

'I just thought I'd try something different, but if you don't like it afterwards it doesn't matter.' I wasn't really used to being questioned as to why I'd asked someone to smile, but it's all part of life's rich tapestry.

Dickie Attenborough was a total joy throughout and incredibly focused. He always threw a little party at the start of shooting so all the crew could come together (though most knew each other already). As long as we were up and reported for duty in the mornings, he never really minded us staying in the bar late and enjoying some hijinks.

So focused was he, at one point in Morocco when he had quite a nasty tummy upset he came on set clutching his abdomen, and he summoned up the energy to call, 'turnover', 'action!' and 'cut!' before almost collapsing into a heap.

I often sat on the camera car with Dickie, travelling at 50mph, as horses and the cavalry came charging towards us. Nowadays I suspect health-and-safety people would likely have a heart attack, but I hasten to add no performers or animals were harmed – it was all very carefully choreographed. At worst a few of us other crew went down with tummy trouble, and I particularly remember a nurse coming to my room to give me a couple of injections, which probably terrified me more than all the action scenes we shot in the desert.

The film received three Oscar nominations: Best Screenplay, Best Art Direction and Best Costume Design.

If ever there was a case study about everything going wrong on a film, my nomination would be for *Murphy's War*. It was an interesting project starring real-life husband and wife Peter O'Toole and Siân Phillips, who, of course, I'd worked with on *Under Milk Wood*. Set in South America during the closing days of the Second World War, the story centres on a survivor of a sunken merchant ship who obsessively seeks revenge on the German U-boat that sank his ship. By all accounts director Peter Yates and producer Michael Deeley passed up on *The Godfather* in favour of making this one – a decision they probably regretted later on.

Deeley said, 'It's not going to be an easy movie, but we're going to be on a luxury Greek liner so all the crew will be able to relax and have fun in the evenings with a cinema, restaurants etc. But the days will be long and tough in the jungle.'

I'm always up for a challenge!

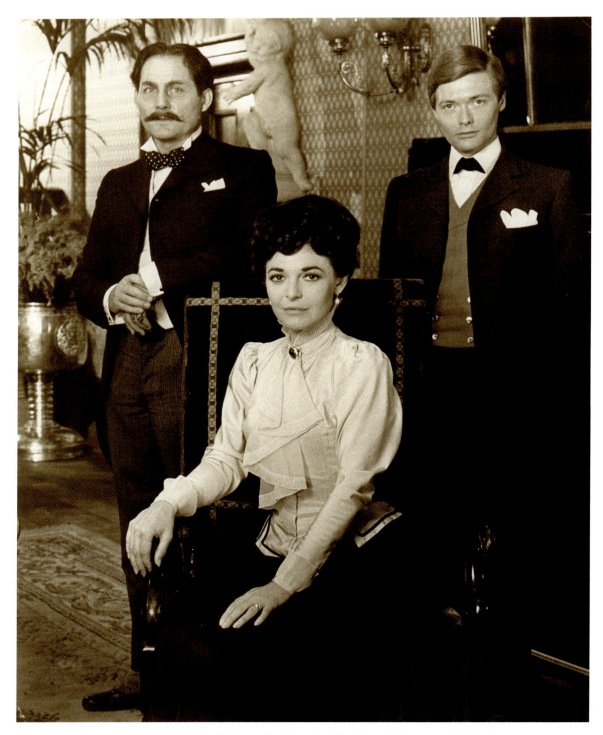
Robert Shaw, Anne Bancroft and Simon Ward in a family portrait for *Young Winston*.

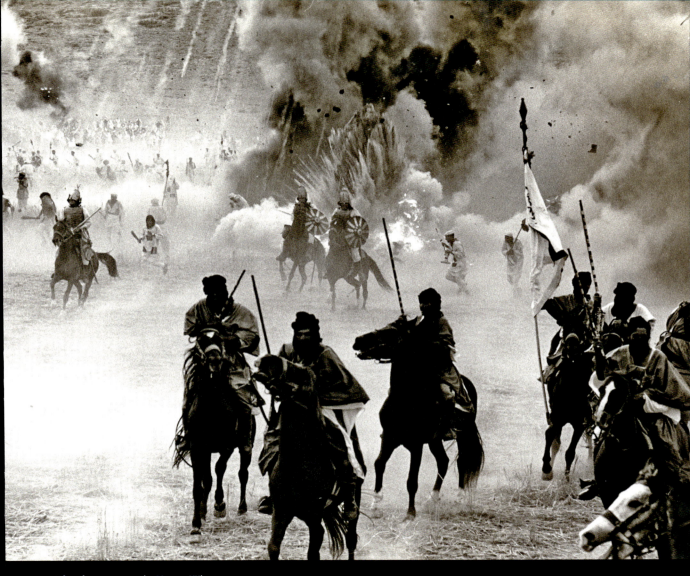

A battle sequence in *Young Winston*.

We were due to be away for several months, so all the crew arrived at Heathrow airport with huge suitcases and equipment for the charter flight to Trinidad. Talk about cramming it into the hold, plus the huge brute lights and cranes were placed in the passenger section of the plane where they'd taken seats out, with us crew huddled together in the remaining seats down the front. It took forty-three seconds for the heavy plane – including 20 tons of fuel – to take off, while clipping the hedges at the end of the runway. No sooner had we got up into the air than the captain said he was unable to make altitude, so he had to fly out over the sea to dump fuel to lighten the load. Then he flew on to Shannon airport to make an emergency landing. There was actually a bit of an investigation, and the pilot was fired there and then for breaching safety rules.

We eventually got underway again, arrived at Port of Spain and took coaches out to our luxury liner. Our location manager Dusty Simmonds was there to meet us with the ship – but he had a long face and looked disappointed as he pointed us towards a converted Irish cattle ferry! So much for a luxury Greek liner, eh? There wasn't even enough room for everyone on board and many of us had to double up, but because I had my cameras, film and processing chemicals I had a cabin to myself, thankfully.

We all congregated in the bar that first evening, and having been given American dollars for our daily allowance by the production, we were aghast when the staff said they'd only accept Greek drachma. Thankfully, they ran a tab until the production was able to smooth things out and we set sail for the Orinoco. After a few days of Greek meals we were all getting a bit fed up and craved our comfort foods – film units march on egg and bacon, steak pie and mash, sausage, and chips etc., so aubergines didn't really cut it. That became the least of our worries though as once at the mouth of Orinoco Delta the captain said that was as far as he could travel due to sandbanks moving, so we couldn't sail to the locations where sets were awaiting us. We had to employ a few little boats to carry the crew out in small groups, in quite dicey conditions with 20ft swells, on a priority basis. I was on the last boat with the lunch parcels, half of which ended up sprawled all over the deck due to the cross-currents. In 100°F heat we gathered for lunch on the jetty before the call went out to start heading back to the liner as it was going to take hours to ferry everyone back in reverse order. Last in, first out. My first week or two was essentially a two-hour return journey with a lunch, and no shooting.

But to top it all, they couldn't find the main supply of film stock as when we were in Shannon someone took it all off to lighten the load!

I finally made my point to the authorities. If I was unable to shoot my stills and just come out for lunch each day they would be very thin on the ground with pictures, and who on earth would publish all the crew sitting on a jetty eating lunch! So it was decided that I could go out to the location on one of the first boats in the morning and test my luck in getting aboard a boat on wrap.

On one occasion I was returning after a really gruelling day with the sound crew in one of the small boats being tossed around in a huge swell. Trying to board the liner was so dangerous that the stunt guys became 'catchers' to help grab on to us and pull us aboard. I waited for my moment, with camera case in hand, to be beckoned by the stunt guys to jump aboard – phew, I made it and was walking up the staircase for a well-earned drink in the bar when a torrent of guys ran down past me shouting 'man overboard'. Don Worthing was behind me and had slipped into the raging water. Everyone was shouting, hoping to see where Don was, but he wasn't to be seen or heard ... until a voice came over the chaos from the other side of the ship: 'Throw me a rope.' He was hoisted up onto the deck, still clutching his Nagra recorder and the day's rushes. It turned out he was an extremely

Peter O'Toole and co-star Philippe Noiret on the set of *Murphy's War*.

strong swimmer and had quickly decided to swim under the keel to the other side of the ship. In an effort to avoid a similar incident, the captain personally decided if and when it was safe to come aboard, so meanwhile a barge was acquired and moved in close to the location in case rough weather made it impossible to return to base, and crew members would sleep in hammocks, which I had to on a couple of nights.

I guess when they did the recces by helicopter they never really thought about the logistics of getting crew and equipment to the locations. I know the producer warned me it would be tough, but when I learned the area had something like 208 varieties of snakes, mostly poisonous, and there were piranhas and crocodiles in many of the lagoons, I was relieved we had brought a full-time doctor with us.

After three weeks we had, not surprisingly, fallen massively behind schedule. A rethink was called for and after a week's hiatus they managed to get a hydrofoil in, thus reducing the journey time from ship to set massively. Although initially very comfortable, when it raised up on its foils and we made speed, the swells smashed the windows and nearly drowned us all!

We spent three months on that damn location in 100 per cent humidity and 120°F temperatures with helicopter crashes, barges sinking, broken bones, a death and just about everything else

Here I am capturing the action on *Murphy's War*.

that could go wrong going wrong. We returned to Pinewood and to the water tanks in Malta, and while it stands as a great movie *Murphy's War* is filled with some pretty bad memories for me, including the company going bankrupt and poor distribution, which all added insult to injury. The only good thing was when I received a call to say my son Scott had been born.

The Magnificent Seven Deadly Sins (1971) was one of only a couple of films comedy actor Graham Stark directed and is notable for a Who's Who of British comedy appearing in it. I'd known Graham for several years, as we shared a love of photography, and as I've already mentioned he was official photographer at our wedding, so I was rather pleased to return the favour and be stills photographer on this one for him.

The movie was essentially a series of seven sketches, all linked by a title of a sin – such as Lust, Avarice, Gluttony, etc. – Graham wrote a few and brought in other big comedy writers of the day such as Spike Milligan, Galton and Simpson, Graham Chapman, Barry Cryer, and Marty Feldman. Graham had actually written and made his directorial debut with a thirty-minute short called *Simon Simon* in 1970 as a supporting film to main programmes. He brought in a load of his mates, from Peter Sellers and Morecambe and Wise to Michael Caine and Julia Foster, in various cameo parts. It actually attracted a lot of interest and, when its distributor, Tony Tenser of Tigon Films, was looking for new feature-length projects, he obviously thought Graham Stark was someone worth chatting with.

The helicopter takes off with the artists after a day's shooting on *Murphy's War*.

Graham in turn pitched the idea of this episodic story inspired by the biblical sins. It intrigued Tenser and he greenlit Graham to direct and produce, craftily realising Graham would again be able to call on many of his mates to work as a favour; in the event Bruce Forsyth, Harry H. Corbett, Stephen Lewis, Julie Ege, Leslie Phillips, Harry Secombe and Joan Sims were just some of those mates who agreed to work for next to nothing in the £116,000 budget film.

As Graham's first film had been a 'short', it didn't present any issues with unions, but now that he was proposing to direct a full-length feature film he needed accreditation from the Association of Cinematograph, Television and Allied Technicians (ACCT) in order to take the helm. He subsequently applied and seconding his application were Peter Sellers and Stanley Kubrick – he was welcomed with open arms.

Graham knew what he wanted and where he wanted to go, even if the script was a bit uneven. I had great fun working on set every day and remained in touch with Graham right up until he died, yet he never ever discussed that film with me again after we wrapped, nor did he ever direct another movie. Maybe he was disappointed at the handling of its release?

I next moved on to *The Tales of Beatrix Potter*, which was a bit of a passion project of producer Richard Goodwin. He had persuaded the Potter estate to grant him the film rights after they had become disillusioned with Walt Disney – feeling he would 'distort' the original books. Goodwin had won them over with his plans to film it as a

Taking a stroll in the Sahara on *The Little Prince*.

ballet and had attracted financial backing from Bryan Forbes at EMI Films despite his boss, Bernie Delfont, asking who Beatrix Potter was.

The comfortable £1 million budget allowed Richard to bring on board dancers from the Royal Ballet, choreographed by Sir Frederick Ashton, and famed film editor Reginald Mills as director.

Mainly aimed at children, the animal-centric stories were mounted as a series of dances, loosely interconnected by the author as a young girl (played by Érin Geraghty) and her active imagination. There are no words, only music and movement – in full animal costumes. I wasn't so much employed as stills man on the film as to photograph plates for the front and rear projection effects to help bring characters, including Peter Rabbit, Jemima Puddleduck, Jeremy Fisher and Squirrel Nutkin, to life against an English countryside background. I travelled to the Lake District to shoot backgrounds, around Lake Windermere, which, of course, is near where Beatrix Potter lived and wrote many of her tales. It was an incredibly beautiful part of the country and I felt privileged to be there.

During my week away I converted the hotel bathroom into a darkroom, assembled my plates in boxes and packaged them all up ready to send down to London to be processed. I suggested I would send them by train, and the production could send someone to the station to collect them.

'Oh no, send them by Royal Mail,' Richard said.

I explained they were quite important and that, 'I've sent these things down by train in the past and it works nicely, and isn't too expensive …'

'Royal Mail will be fine,' he interrupted. You can interpret 'fine' as 'cheap' here really.

OK, I thought, he's the boss. I took them to the local post office and sent them off. And of course, they failed to arrive!

Royal Mail was very unhelpful and didn't want to know, and so the only answer was to send me back up to the Lakes to shoot them all again, though this time I faced solid rain for three long weeks. You'd usually have found me huddled in a tent on a mountaintop, getting soaking wet waiting for the clouds to break – though having seen the forecast each morning for rain, rain and more rain I was feeling increasingly depressed as time went on. When the weather did finally break, the light wasn't as perfect as on my first trip, so I felt somewhat disappointed.

I returned to EMI to supervise the projection, and I also designed the album cover for Decca Records, which was great fun. As I was now on a daily rate with EMI, they suggested – at the same time as praising me highly – that I should send my bill for that to Decca directly, as, of course, EMI didn't want to pay anyone a penny more than they needed to. I duly forwarded my account for weeks of work in photographing all the individual characters, and Decca duly sat on it for six months – not caring one iota that I might actually have bills to pay. *C'est la vie.*

The film went on to be the most successful of studio chief Bryan Forbes's time at EMI and moved handsomely into profit. It was also nominated for design and costumes at the BAFTAs.

Richard Goodwin called the film, 'a diversion ... a soufflé ... it is an entertainment', and he was quite correct as there's never really been anything quite like it before or since.

American graphic designer Saul Bass only made one film. *Phase IV* presented us with a sci-fi horror set in Arizona – though we actually shot locations out in Kenya, with interiors at Pinewood. It was inspired by H.G. Wells's short story 'Empire of the Ants' – and yes it was all about ants, or rather desert ants who formed a collective intelligence and began to wage war on the human inhabitants.

Alan Arnold was the publicist on the movie and I can see him now, announcing his big marketing plan of promoting ant farms to help raise the profile of the creatures and thus the film. It never really took off, you won't be surprised to hear, and let's face it a film about mutant ants is hardly going to endear the insects to the masses is it?

Some of the dialogue was a bit odd and scientifically illiterate, and the 'hallucinogenic' ending was initially removed by Paramount executives as they were said to be completely baffled by the film. Seemingly their PR department was too as the poster declared 'the day the Earth was turned into a cemetery!' Had they seen a different film to the rest of us?

Foremost on my mind, however, was our special effects technician, John Richardson. He was a special effects genius and also a great practical joker and did all sorts of things to crew members such as putting dye in shower heads, insects in their beds, and strapping them (i.e., me!) onto camera rostrums. He even bundled me into a laundry basket and down a hotel corridor into what could have been described as a somewhat compromising position. Now, I wanted my revenge, but I had to be careful and choose my moment, as after all you don't really want to upset the man in charge of all the explosives too much.

We were shooting at Pinewood on a Friday afternoon and John had just bought a brand-new yellow Ford Cortina, which he parked outside our stage in pride of place. I happened to notice the stage adjacent to ours was empty apart from a few Vickers rostra, which were essentially platforms for scenery to be built on that could be moved around sets, raised and lowered. Just in that moment I spotted a mate of mine in the construction department who drove a forklift truck. 'Aha!' I thought.

My mate carefully managed to lift and move John's beloved new car onto one of the

Richard Kiley as the pilot on *The Little Prince*.

platforms on the empty stage. It was only 2 or 3ft off the ground, but when I heard the shout, 'And that's a wrap,' I swiftly made my exit from the studio.

I was reunited with John on the next production, *The Little Prince*, for director Stanley Donen, so I made sure I watched my step around him.

I actually got this job on the recommendation of Stanley Kubrick, and when I went along to see Donen at his swish office in Knightsbridge he immediately struck me as a man in total control, which I loved, as it meant I only ever had one person I'd need to speak with to get a decision.

'Would you like to go out to Algeria on a recce?' he asked. Along with the deserts, he explained it was a country with some quite fascinating moonscape rock formations from sandstone to granite in the south, near Niger, which would look perfect in the movie. I should add Algeria at this time was in a bit of, what you might call, a tricky political situation after its support for Egypt and other Arab countries in the Yom Kippur War. Getting in and out of Algeria was relatively straightforward for travellers, and Donen had certainly done his research. He wanted extensive photography

of the moonscape-type terrain and El Oued, which was known as the domed city as all the buildings had curved roofs to stop the sand from settling.

I flew out to Algiers and crossed the desert to El Oued and Djanet, though I felt a little bit nervous doing all this on my own so I made a point of visiting the British Embassy, where I met commercial attaché Tony Wingate. I discussed my plan with him, as I wondered what potential problems I might face. He expressed great interest in the area himself and, as he was due some time off, was willing to come with me. I quickly phoned the production office, explained I'd met someone who could be very useful to us, and asked if they would be willing to cover his accommodation and travel costs. 'Of course!' Stanley said without hesitating, 'Of course!' You see what I mean about liking a boss who is the boss?

In Djanet, landing quite literally in the middle of the desert, a Land Rover arrived and took us to our hotel, which would struggle to achieve any sort of rating on TripAdvisor. It was a mud hut, without any form of running water (it was drought season in any event) with makeshift bedding and a blanket on the floor. The only food on offer was camel stew – the camels having died in the drought. The driver took us all around the Hogarth Range and I photographed the landscapes and rock formations in great detail to send back to John Barry, our production designer. I'm only saddened that I didn't keep copies as I never actually saw them again.

Stanley Donen was having a bit of a battle with the studio, meanwhile, who were insistent he cast Frank Sinatra as 'The Pilot', which Stanley apparently wasn't too keen about as he realised a whole entourage would follow, and private planes, helicopters and demands for five-star hotels, too. Anyhow, once he saw my photos Stanley sent word he wanted to join me on location to judge how practical it was going to be to shoot in some of these places, but no sooner had he touched down on the desert landing strip there was a huge sand storm. Stanley stood there, surveying the near-zero visibility before him. 'Do you think we could get Frank's helicopter to land here?' he puzzled, while already shaking his head in the negative. 'No, no, no, no!' he exclaimed.

So that was that. Frank was obviously out and it was back to the drawing board. It seemed the couple of months I'd spent travelling around photographing had been a waste of time, and I returned home. A month or so later Stanley managed to get things up and running again with Richard Kiley cast in the role of 'The Pilot', with the main location shooting in Tunisia. Stanley called and asked me to shoot 10 × 8 plates for front projection work in Algeria and the sand dunes, which, of course, were important for the storyline where the Little Prince's plane crash-lands in the desert.

I headed out there for what would turn out to be several months with my assistant Barry Brown and our trusted Range Rover, which I'd driven down to Marseille before taking the ferry to Algeria, where I discovered the customs officers were very anti-French and, once they'd established we were British, wanted chapter and verse on what we were doing there and for how long. I'd already been told by the British Embassy that it would be impossible to obtain any sort of work permit, so not to ask. Of course, they were intrigued by the big coffin-like box I had on the roof rack, which was full of our equipment and a model of the plane that we could use for reference and scale. Before I knew it my assistant was joking with the officers that we were there to play golf in the desert.

Amazingly we were allowed in with everything intact and started our seven-hour drive from Algiers across pretty inhospitable terrain to El Oued, which was to be our base for the weeks ahead in a fairly decent touristy hotel near a huge oasis. I got to know the staff quite well, as did my wife Hilary who flew out from time to time to collect the plates and return with

Steven Warner as the title character, with actor Bob Fosse.

Barry Brown and I take a break in the middle of the desert on the tail-gate of our trusted Range Rover, supporting the 'coffin' on the roof.

them to London. We probably stayed a little too long though because, as we were out every day waiting for sunrise and sunsets with my large 10 × 8 camera, it seems our early-morning and late-night activities were attracting a bit of attention, in particular from a nearby Russian air base. One night – quite literally in the middle of the night – my friend on reception at the hotel called and warned me that the secret police were on the way.

'You need to go. *Now!*' he exclaimed.

Barry and I quickly grabbed our things, chucked them into the Range Rover and went hell for leather up to Algiers. Luckily, I knew my friend Tony Wingate's home phone number and we were able to stop en route to call him and explain. He told us to head straight to the embassy and he'd meet us there.

Tony said we could stay at his flat until he figured out what to do, but we had to keep our heads down. It was apparent we couldn't drive out of Algiers, so Tony arranged to fly us out, with diplomatic immunity.

I honestly felt I'd never see home again, but fortunately we did and thank goodness we'd shot enough material for plates and could make the movie, which turned out to be great fun.

Then came a letter to Stanley Donen from Stanley Kubrick saying I was handing in my resignation ...

Scene 7

MORE KUBRICK, AND *BARRY LYNDON*

Not long after *2001* premiered, Stanley Kubrick started work on *A Clockwork Orange*, and as I was wrapping on *Battle of Britain* I thought I'd write to see if I might work with him again. He seemed true to his original word though as he never replied.

A few years later, in 1974, I was working on *The Little Prince* and Stanley phoned me up, as though nothing had happened.

'Hi Keith, how are you?' he asked in his most charming voice.

'Oh, hi Stanley, I'm fine thanks.'

'Christiane [his wife] has just done some paintings and I'd really like you to shoot some 10 × 8 plates. When can you come ... can you come now?' he asked.

I explained I was on a movie.

'How about the weekend then?'

I duly went over to his house and had a cup of tea before he showed me all his new cameras and lenses, as if we were still the best of friends, and I shot some plates. Stanley apologised he didn't have any money to pay me, even though I'd had no intention of charging, but he did produce £10 from his petty cash tin for my petrol.

I returned to the movie when, a day or two later, production manager Douglas Twiddy asked me if I'd seen Kubrick at the weekend and enquired whether I knew his next film was to be *Barry Lyndon*, based on an 1844 novel by William Makepeace Thackeray and set to star Ryan O'Neal, Marisa Berenson, Patrick Magee, Leonard Rossiter and Hardy Krüger.

'He mentioned it in passing,' I replied.

'Well, he'd like you on it,' Douglas said.

Needless to say I was pleased and said I'd love to work with Kubrick again. The very next day, Stanley Donen came over to me on set, produced a letter and exclaimed, 'You're leaving on Friday!?'

'No I'm not ...' I replied, somewhat puzzled.

'This is a letter from Kubrick,' Donen continued, 'handing in your resignation.'

'What?! No! No! I'm not resigning. All I said was I'd love to do his next movie, but no dates were mentioned.'

'You'd better go and tell him then,' Donen concluded.

I picked up the phone to Kubrick and asked why he'd given my notice in to Donen.

'You're joining me on Monday – aren't you?' he asked.

'Do you know something, Stanley? The first time I worked in this industry was for you

Stanley Kubrick on location shooting *Barry Lyndon*.

– I learned so much from you and the most important thing was that you should never leave a movie before it's finished, and I've vowed never to again.'

'Oh, gee ... when *can* you join us?'

To be fair, he didn't pressurise me but said the job was mine as soon as I was available; I think I joined him about six weeks into production and, wow, what a production – every scene was like a painting. In fact, production designer Ken Adam based the look of the film on William Hogarth paintings, and duly won the Oscar for it.

The whole film was lit with candles and Stanley had special Nikon lenses, which were 0.7 f-stop (the lowest available, and designed by NASA to photograph on the moon), and he shot everything wide, on 70mm stock – making it impossible for a stills photographer to shoot anything remotely useable. I therefore suggested using his old trick of lifting stills from the original film negative and I'd then shoot off-set stuff with the actors etc. at other times. In the event Stanley said I could have the outtakes and footage he didn't want to use, so I went through them frame by frame for him to then approve, ending up spending most of my time in his office at his house.

Location work was to be completed in Ireland, but Stanley became paranoid the IRA might try to kidnap him for ransom! He became so worried that he ordered everything to be pulled back to the UK, which delayed things somewhat. It also presented me with a problem as I'd committed to making a film with Kevin Connor before I started *Barry Lyndon* and had agreed the dates with Kubrick beforehand. But now *Barry Lyndon* was going to overrun ...

I approached Stanley, somewhat warily as I'd already joined the film after it had started and now looked like I'd need to leave before it ended – and that was one thing I'd told Stanley I'd never do again. He was very understanding actually and asked what the schedule was on *Trial By Combat*; I told him six weeks – as Kevin worked fast, six weeks compared to Stanley's eight months on *Lyndon*! – and he suggested I could have six weeks off, work on the movie with Kevin and then come back to carry on with him. Only on a Stanley Kubrick film could you have a break to make another movie.

During my return stint Stanley told me the plan was to premiere at the Dome Theatre in Hollywood.

'I need you to go out there, Keith, do you want to go?'

Did I want to go to Hollywood, all expenses paid? Of course, I did!

'OK. I'll need you to go to the labs there, check every roll of print film for sound sync, quality and colour grading,' he explained.

I flew out to LA, was greeted by the studio chiefs and shown to my cutting room, then taken to my hotel room, given a hire car and so on. I was there for months and welcomed daily to the labs with a 'Hi, Mr Hamshere'. I was forever conscious of being just a young lad from London and found it quite extraordinary that I was so well treated. Then again I was Stanley's eyes and ears I guess.

I spoke to Stanley every single day without fail and would make little comments on the prints, telling the experienced technicians to do this and do that, and report this back to my director. Though as much as the technicians in LA must have resented me, they were actually very kind.

With that side of things looking good, I thought I'd next go over to the huge Dome Theatre to check it out. The size of the place was impressive, and what a place to hold a premiere, I thought, as I chose my seat and settled back to watch a David Niven film. But, just then, my joy turned to horror as I realised just how awful the projection was – it was all flickering and jiggling about, with one projector two stops darker than the other. I phoned Stanley from the lobby.

Barry Lyndon poster.

Stanley Kubrick: portrait of a perfectionist.

'If you think you're opening *Barry Lyndon* at the Dome you're out of your mind!' I exclaimed.

The proverbial hit the fan.

I'm not sure who exactly Stanley phoned but as I was standing in the lobby the film showing was switched off and the cinema was closed. Within minutes MGM lab technicians, a lens specialist and studio executives turned up, and it hit me this was all because I'd suggested the projection wasn't up to scratch. I quietly explained what I thought to be the issue, and they started running the David Niven film again to study it for themselves.

'He's right,' they all agreed, much to my relief, 'he's right.'

They discovered one projector had a glass window in front of it whilst the other didn't – it was missing – and as smoking was allowed in those days, the window was covered in nicotine, which dimmed the light. So that was soon rectified with a bit of soap and water.

I then asked about the jiggling. The film was run again and one of the theatre staff came in, looked at me in almost disgust and said, 'Rubbish, we only checked this a few months ago …' and as his sentence drifted off they could see the film was slipping in the gates. It turned out the gates were so old and so worn, new ones were needed. Now, I wasn't a trained expert, but I could see there was a problem so quite why the theatre staff were so defensive I don't know, but it meant Stanley had little faith in them.

That's maybe why he asked if I'd take Ryan O'Neill to see the film with a mate of his, a young actor named Jack Nicholson. You can understand why I feel going to the cinema seems pretty lame nowadays.

The premiere went ahead and the film was released into the world, though it was not the resounding success they'd hoped for. While quite warmly regarded by the critics, it certainly wasn't loved similarly by the film-going public.

Over the ensuing years it has been re-evaluated and has grown in stature, now rated as one of Stanley's best and most beautiful-looking films.

I remained in contact with Stanley over the subsequent years, though I knew too well working for him was a long-long-term commitment and a 24/7 experience, which I wasn't terribly keen to repeat. Fortunately, I became somewhat in demand as a stills photographer so I wasn't really available for any of his later films – though he only actually made three more before his death in 1999, days after completing *Eyes Wide Shut*.

Stanley was certainly unique. He was a visionary, a perfectionist and some might say a genius. He was one of just a handful of filmmakers who retained total control over all elements of his films, even to the point of never giving studio executives a copy of the script or budget – they just signed the cheques and waited patiently.

I owe my career to Stanley; the knowledge I gained and being given a free rein to experiment at a youthful age was incredible. It also helped hugely in future years when I was asked 'so who have you worked with?' … As soon as I mentioned Stanley's name that was it, the jobs were literally offered there and then. But, most important of all, I met my love, Hilary, through him.

Scene 8

A MAN CALLED OTTO

Director Richard Lester tried to make a film of the first Harry Flashman novel at the tail end of the 1960s but failed to raise the finance. He instead hired its writer, George MacDonald Fraser, to adapt two films based on *The Three Musketeers* – and their success reignited financial interest in Flashman.

Lester felt he had put so much work into the first, aborted film, it was as though he'd actually made the story, so he didn't want to go back to it. Instead he thought the second book, *Royal Flash*, which was set in 1842, was prime material to adapt with the added bonus of it being a less expensive book to shoot than the first one would have been.

John Alderton had initially been cast as Flashman – the unapologetic rogue who'll stop at nothing to advance himself – but the studio wanted a better-known actor, and so Malcolm McDowell was hired. An all-star supporting cast was brought in, including Britt Ekland, Tom Bell, Michael Hordern, Alastair Sim, Alan Bates, Christopher Cazenove, Oliver Reed and Joss Ackland, to name but a handful.

The head of publicity was a gentleman named Gordon Arnell, who I later went on to work with many times, in particular on the James Bond movies. Britt Ekland had stills approval and rather than delegate to a PA or other person, as many in that position did, she liked to look through all the images herself. One day Gordon took a bunch of the original material I'd shot to her dressing room and was quite aghast when she grabbed some scissors and started cutting up the ones she didn't like.

'No!' exclaimed Gordon. 'We might use those for other purposes, don't destroy them.' I'd heard of cutting ones that weren't liked, but not quite that literally!

Location work was mainly out in Bavaria, and Richard Lester found it quite trying, working twelve-hour days in 10 below zero temperatures, with a German crew we were obliged to employ but who Richard didn't particularly get on with.

20th Century Fox cut the final film from 118 to 102 minutes prior to release, which included the entire role of Roy Kinnear, and gave it a bit of a half-hearted release to be honest, not helped by the trailer declaring it 'a terribly funny film', which it wasn't. While not hugely successful, it was the most wonderful opportunity for me to work with Richard Lester – the first of several

Royal Flash **actors Malcolm McDowell and Britt Ekland.**

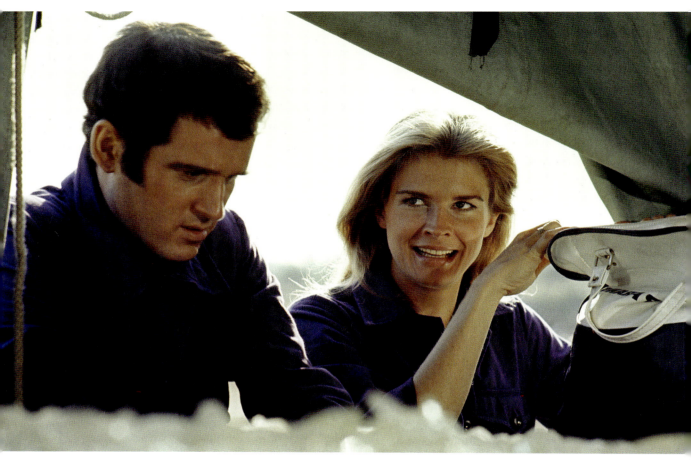

Candice Bergen and photo-phobic Charles Grodin in *11 Harrowhouse*.

times. I found him a total joy, and he was everyone's best mate.

I only wish I could say the same of Charles Grodin, who adapted and starred in *11 Harrowhouse*. Grodin played a small-time diamond merchant who is offered the chance to supervise the purchase and cutting of an extremely large diamond. When it is stolen from him, he is blackmailed into pulling off a major heist at 11 Harrowhouse Street, in the City of London, with the help of his beautiful and wealthy girlfriend played by Candice Bergen.

Initially Charles and I got on really well, but as soon as I appeared on set with a camera he would stop the shooting and ask that I be removed from the stage as he 'found me distracting'. The producer Elliott Kastner had words with him, but Charles wouldn't budge, which upset me as he really made me persona non grata.

I only ever came across him once again in the future when Warren Beatty phoned me personally to ask if I'd work on *Ishtar*, in which Charles had a small part. Once bitten, twice shy, so I kept my distance and didn't attempt to engage him in conversation.

I brushed it off as just one of those things and consoled myself in the knowledge that everyone else I'd worked with to date, on the whole, had

been lovely and that no one could be as bad as Charles Grodin. Oh no? I signed up for my next production, an action thriller called *Rosebud*, for director Otto Preminger – and what a total, total nightmare he proved to be! It didn't help that the screenplay – by Preminger's son – was constantly being rewritten throughout.

Subsequently I learned he was known as 'Otto the Terrible' and 'Otto the Ogre', though some claim his tyrannical and abusive behaviour was calculated to keep his cast and crew under his control and to keep interfering studio executives at bay. Well, he was rather good at it, that's for sure.

It was the most wonderful picture for location work: from several places in the south of France and Corsica to Israel and West Germany. Preminger had cast Robert Mitchum in the lead as Larry Martin, a Newsweek reporter who was secretly working for the CIA along with Israeli intelligence, trying to secure the release of five wealthy girls (played by Brigitte Ariel, Isabelle Huppert, Debra Berger, Kim Cattrall, and Lalla Ward) kidnapped by the Palestinian Liberation Army from the yacht *Rosebud*.

Mitchum was lovely, and while he admittedly had a liking for a drink or two, I always found him hugely professional. We were on the aforementioned yacht on the Côte d'Azur with the delightful actress Brigitte Ariel, who had recently won great acclaim for her portrayal of Edith Piaf, and we were about to film a scene below deck when Preminger appeared with big bulbous eyes and foaming at the mouth, and started shouting at the crew. I obviously got in his eyeline as he shouted at me, 'Hampshire!' as he insisted on calling me. 'What are you doing?'

'Taking stills,' I replied.

'You only take stills when I tell you to take stills!' he barked.

I shrugged and waited.

Preminger then grabbed me by the shoulders, positioned me next to him and said, 'You take your stills from here. Actors! Action!' It was all dialogue stuff, and quite boring. I wasn't interested in taking static images of boring stuff, but that's all Preminger would allow.

He then called for everyone to move onto the deck to shoot a love scene, and the costume designer was called over by Preminger.

'What is Brigitte wearing in this scene?' he asked.

'Nothing. She's in bed.'

'What?' Preminger snapped. 'How can I shoot this if she is wearing nothing? What do *you* wear in bed?'

'I don't wear anything.'

'Not even a paper bag over your head when you are making love?'

Well, the poor costume designer broke into tears and the crew scattered.

Brigitte had such a horrid time with Preminger that she all but retired from acting after this film, which I thought tragic as she was so incredibly talented. But that was Preminger – he didn't care who he upset; he was a hugely selfish and self-centred monster.

As I mentioned, Robert Mitchum was cast in the lead role and was getting increasingly red-faced as the days went by, and increasingly frustrated with Preminger. He started drinking more and was clearly very unhappy. Preminger continued, unaware and uninterested.

We moved from the south of France up to Paris, and Preminger started singling me out, making a point of telling me where and when I could shoot, and I was getting pretty hacked off.

Preminger had a thing about men with beards – anyone on his crew with a beard was told to shave it off – and so by now I'd grown myself a beard in sheer defiance of the man as he continued to rant and rave. Then one particular day I'd had just about as much as I could stand, and snapped: 'That's it. I'm leaving!'

I packed up my cameras and went back to my hotel. The second assistant director Richard Jenkins came to find me to say Preminger wanted to see me. I said no, I couldn't do my job and just wanted to go home, but Richard persisted and

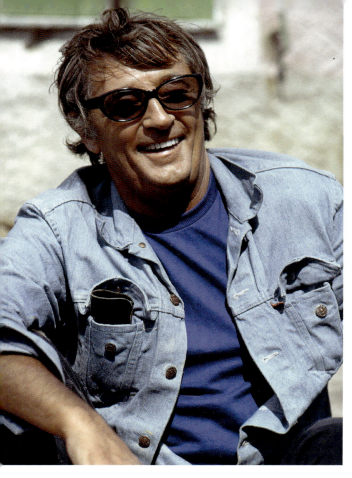

A happy Robert Mitchum on early location for *Rosebud*.

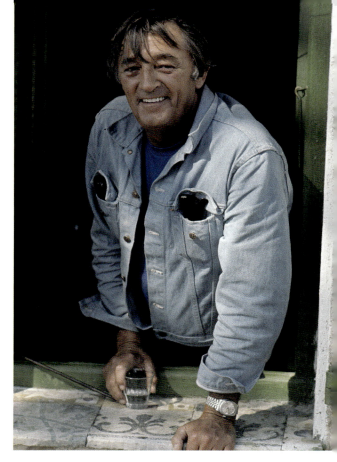

Robert Mitchum on the set of *Rosebud* – note the drink in hand, as things were beginning to take their toll.

asked if I at least would go back to the set to hear what the director had to say. I relented ...

'Hampshire, why are you leaving?' Preminger asked, in total mock surprise. 'And I like your beard. You look very handsome with a beard.'

I'd only grown it to annoy him, so you can imagine how funny the crew found all this. 'You can do whatever you want to do Hampshire,' he reassured me.

With some trepidation I agreed to stay, and the crew dubbed me the 'little hairy polisher' ever after, though that didn't mean Preminger was nice to me or anyone else – he certainly wasn't. One by one everybody reached their breaking point, including the camera operator who, one day during lunch on location, locked the camera car up and never returned.

We next moved to Corsica and were doing some night shooting, and there was a particular tracking shot of Robert Mitchum walking uphill. The director wanted the camera track on the same plain – meaning this huge, 10ft-high, inclined track had to be constructed, with a last-minute call for timber as we weren't carrying that much with us. By 3 a.m. everything was ready to go, Mitchum was called and arrived on set a little worse for wear, and realised the end result of this ridiculous tracking shot would just look as though he was walking on the flat. Words were exchanged, of which I heard many, and essentially he said to Preminger, 'You brought me out at 3 a.m. to watch you build a f-ing track! I'm going to get a coffee.'

Robert Mitchum on a yacht in Juan-les-Pins just before walking off the film.

'You go and get a coffee,' Preminger screamed, 'and I don't care if you go to Los Angeles to get it!'

Mitchum got into a unit car, had them drive him to the airport and did indeed get on a plane to LA – and that was the last we saw of him on *Rosebud*.

We all went back to the hotel and wondered what on earth was going to happen now, as we were a month into production. Preminger duly announced a three-week hiatus while he recast – with Peter O'Toole as it happens – and took us all back to the south of France, where we reshot everything we'd filmed with Mitchum!

Preminger told the press that he'd fired Bob Mitchum due to his drinking but when Mitchum heard this, and the fact O'Toole had been cast, he likened it to 'replacing Ray Charles with Helen Keller'.

Otto Preminger filmed two versions of the five captive heiresses on the deck of *Rosebud*: one containing full-frontal nudity and the other with only rear nudity, to satisfy different markets. This was Kim Cattrall's film debut and she later recalled, 'I was 17 and he said I reminded him of Marilyn Monroe ... for her lack of talent rather than her looks. I literally ran from that experience.'

Didn't we all!

The *New York Times* film critics described the movie thus: 'A suspense melodrama of such ineptitude, lethargy and loose ends that only someone with his arm being twisted would take credit for it.'

Soon after returning home, my friend Richard Lester phoned. A sane voice was so welcome! He was about to start a film called *Juggernaut*.

Peter O'Toole takes over in Juan-les-Pins after Robert Mitchum walks out.

'Do you cut the red wire or the blue wire?' That was the dilemma that faced our hero Richard Harris as bomb disposal expert Lt Cmdr Anthony Fallon. Of course, one rendered the explosive harmless while the other would cause everyone to die in an almighty explosion.

Cashing in on the disaster movie trend of the mid-1970s, with films such as *The Towering Inferno*, *The Poseidon Adventure* and *Rollercoaster*, came this ship-set thriller allegedly inspired by a bomb hoax on the *QE2* a couple of years previously. Freddie Jones played a blackmailer known only as 'Juggernaut' who threatened to blow up the luxury cruise liner if he wasn't paid £500,000.

David Hemmings, Omar Sharif, Anthony Hopkins, Roy Kinnear and so many other great names came on board the once-German liner, which had been sold to the Americans, who then sold it to the Russians, who in turn rented it to us to go chasing Force 10 gales in the North Sea – as the script called for bad weather – and boy were a lot of us seriously seasick. Also bear in mind I couldn't swim and didn't particularly like boats.

We later discovered a journalist had got himself a part as a film extra, obviously thinking a film crew with all these stars would present really exciting and scandalous stories. When he realised it was all pretty unexciting he started sending fabricated reports back to his London newspaper – with tales of orgies, boozy parties, and such like. This resulted in the production office back at Pinewood receiving calls from many furious wives demanding to know what was going on!

When we returned to Pinewood and the paddock tank, we had huge wave machines and troughs emptying tonnes of water over the reconstructed ship set and there wasn't a day when we didn't get soaked or seasick again! Publicist

Juggernaut lobby card.

Gordon Arnell arranged for the Milk Marketing Board to record one of their adverts on this set, which was great PR. Their idea was that David Hemmings, who played bomb disposal officer Charlie Braddock, would run across deck, where he'd be bombarded with waves, abseil down the side of the ship, swim across to a jetty where a lovely pint glass full of milk was awaiting him and say, 'Ah that's just what I need!' before drinking it back.

The only thing was – and remember he'd been thrown about a fair bit, hit by waves and so on – as soon as David drank the milk, he projectile vomited all over the crew!

For someone who doesn't like water or boats, you might think it strange that I chose to go onto another water-set adventure with *Lucky Lady*, but then again how could I resist when Stanley Donen was directing?

Stanley had been involved, for eighteen months or more, with rewrites and the casting of Liza Minnelli, Burt Reynolds and George Segal. By all accounts Paul Newman and Warren Beatty were the original choices but couldn't make the

Lucky Lady director Stanley Donen.

dates work, and Reynolds badly needed a hit after three misfires in a row so happily signed on. George Segal, meanwhile, dropped out and was replaced by Gene Hackman.

The film was shot on location in Mexico, and a lot took place on the yacht *Lucky Lady* and centred on rum runners at the tail end of the prohibition years. Sadly, I couldn't get on board the actual boat most of the time as space was very limited, with actors, camera and sound crew plus tracks and cables, so 20th Century Fox supplied me with a huge 300mm lens with the idea I could be on another boat, or on shore, and zoom in to take stills. The problem with me being on another boat was that I'd be bobbing up and down, while the *Lucky Lady* would also be bobbing up and down at a different rate, meaning my frame of reference was constantly moving. Even when I could take shots I found the crew were also getting in frame. It certainly wasn't an easy way to work.

The production encouraged us all to bring family out with us – after all we started filming in Guaymas in February 1975 and finished in July, and that was with several units running at once! We could hardly nip home for the weekend and, although it was lovely to have Hilary and our two children there, it was an exceedingly challenging time for everyone, compounded by the isolation of the location, poor weather and the fact that so much was shot on water, which delayed *everything*. The budget jumped to $22 million and Stanley stated, quite emphatically, 'I will never make another film on water, I can't tell you how painful it is.'

During post-production Stanley realised the ending wasn't working, as in it Burt and Liza's characters died, which was dramatic and a bit of a tear-jerker. However, he, and the studio, decided the film needed a happy ending and Fox agreed to finance a reshoot. Liza Minnelli was, by that point, filming on another movie in Rome, so Stanley, Gene Hackman and Burt Reynolds flew to Italy in November to shoot their new ending of the three characters in bed together ten years later. With it, the whole tone of the story shifted considerably from the script I first read and, to be honest, the finished product was a bit of a mess. The critics were less than kind.

In the summer of 1976 I was engaged to work on a little period picture entitled *Joseph Andrews*, on location in the Cotswolds. The company suggested that as the Cotswolds were in commuting distance of London (that's a bit of a stretch!) we wouldn't be paid any allowances for hotels. I happened to drive past a caravan sales garage one day early in the shoot and spotted a little caravanette (or motor home) out of the corner of my eye,

Burt Reynolds and Liza Minnelli on the set of *Lucky Lady*, which also starred Gene Hackman.

so pulled over and went to investigate. I thought it would be just what I needed, so did a deal to trade my car in, and bought it – the idea being I could now stay up in the Cotswolds rather than face a two-hour commute each way daily, and as there were lots of nice little pubs that offered overnight parking and washing facilities, I was in my element.

After shooting wrapped I thought it would be the perfect vehicle for a family holiday, so called my aunt in Devon and asked if it would be OK if Hilary, the kids and I pitched up for a couple of weeks in their farmyard. Bear in mind the summer of 1976 was the hottest on record – except in Devon, where it rained solidly for a fortnight. I was determined that we'd have fun in our camper van and resisted all invitations to go inside the main house. I even bought a little battery-operated portable TV – not that we could get any reception on it! – but the kids were getting increasingly fed up, and it wasn't quite the picturesque little getaway I'd imagined. We headed home and I sold the van soon after, which was maybe just as well as I'd never have been able to take it on location for my next movie.

Scene 9

ENTER JAMES BOND

The summer of 1976 had been a quiet time in the British film industry and UK cinema admissions were falling massively – they'd plummeted to 103 million from an earlier all-time high of 1.6 billion. Set against this backdrop was little old me, self-employed with a young family and a mortgage. I was always very anxious when I didn't have my next job lined up and this was one of the most anxious times as I'd been out of work for several weeks following our Devon holiday. Every time the phone rang I jumped up hoping it was word about a job, but invariably it would be a neighbour or friend calling about something quite inconsequential. It got to the point I thought I might never work again.

But then came one call that changed my life forever. A lovely lady named Golda Offenheim was at the other end of the phone; she was a production secretary and co-ordinator of some note, and a really lovely lady, too.

'Keith? Derek Meddings suggested you might come and help us as we need some plates photographing?'

'OK,' I answered, 'and where are you working?'

'At the moment I'm standing near Love Beach in the Bahamas,' she replied.

I think I'd already packed my bags and was on my way to the airport before she'd finished talking! Not only was it to end the temporary drought of work I found myself in, the film was *The Spy Who Loved Me* and marked my first contact with the world of 007 and Eon Productions.

Just ahead of leaving the UK I received a call from Eon's director of marketing, Jerry Juroe, who asked if I'd be willing to shoot some 'offset' material for him to use later on, plus some behind-the-scenes shots of Derek at work. Naturally, I said I'd be delighted to.

I was picked up by a luxury car at Nassau airport, taken to the five-star South Ocean Beach Hotel and was introduced to the hotel manager. I mentioned I needed a room with a large bathroom that could double as a darkroom to enable me to load my slides. They were extremely accommodating and welcoming. Next day I was driven to Coral Harbour, where I met up with Derek. He was filming the models of the *Liparus* tanker and Atlantis underwater base, both so integral to the storyline, and, of course, Bond's infamous Lotus Esprit, which could drive underwater – or at least it could in the film.

Derek asked me to shoot 5 × 4 plates of every conceivable angle and lighting condition of

Atlantis, the underwater base on *The Spy Who Loved Me.*

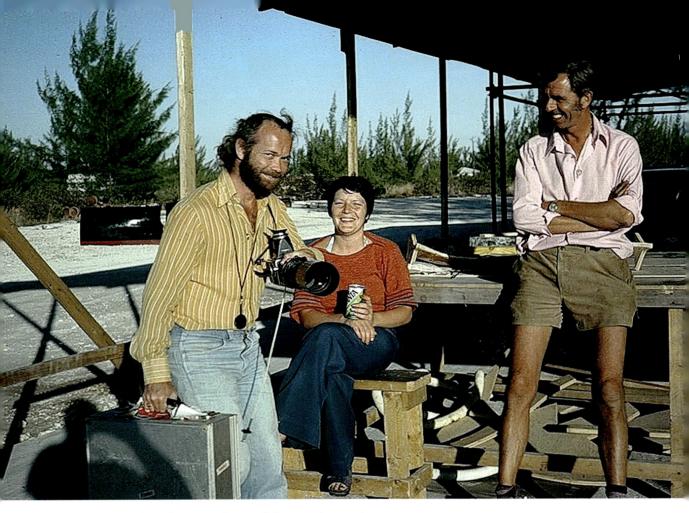

My first day in the Bahamas on the set of *The Spy Who Loved Me*.

Atlantis and the *Liparus* while also taking photos of him and his team at work. The camera crew were based on and operated from a barge with a permanent pot of chowder on the stove in the galley with hot and cold running drinks. It felt a million miles away from sitting next to the phone at home.

One day a young man in swimming trunks appeared on deck of the barge with a Hasselblad camera hung around his neck, so naturally I went over to chat to him. He introduced himself as Michael Wilson, the producer Cubby Broccoli's stepson, and, of course, today the co-producer of the Bond films with Barbara Broccoli. I think it was his first film as an 'assistant to the producer',

having recently lent his legal expertise to Cubby during his fractious split from Harry Saltzman in 1975. Cubby used to produce the Bond films with Harry until he landed himself in business difficulties, unfortunately necessitating his need to sell his shares in Bond.

As Michael and I shared a love of photography we got on like a house on fire.

I was happily based in the Bahamas for many weeks and on my return I handed all the 'off-set' material to Jerry Juroe and processed the 5 × 4s for Derek to work with at Pinewood. The format resembled that used by Wally Veevers in *2001* with animation of the backgrounds and motion control of the models. I hadn't encountered any

Derek Meddings's spy tanker *Liparus* in dock.

of the actors at this point, as it was all special effects and miniatures work, but that joy would come on a later occasion.

I was in fact asked if I might be free to work on the next film, *Moonraker*, but unfortunately I was committed elsewhere and thought, 'Well that's that then, I've turned Bond down so won't ever be asked again.'

At that time most of the work generated in UK studios was from Hollywood as Rank had closed down their production programme in the UK, so you really needed to be known in America to stand any chance of being offered a big film. Fortunately I had a couple more big films come up that made waves in Hollywood, and which helped increase my profile there, and that meant just a few years later I was I back in the fold with 007 – and stayed pretty much so for two decades.

Incidentally, I've mentioned a few times in these pages that stills photographers are always conscious of disturbing an actor in the middle of a scene, and blimps (to help mute the jarring, metallic click of a camera's shutter) weren't readily available, certainly for much of my early career at least.

The camera blimp came about because of one man, engineer Irving Jacobson, when he was put to the test by a photographer friend who explained that he was growing increasingly frustrated by his cumbersome 4 × 5 large-format camera. He explained he needed a separate light source to work in dim conditions, and how particularly fiddly it was to try to manually sync the shutter and flash – it was 'best guess' most of the time.

Irving retreated to his workshop and, using a solenoid that was powered by batteries, he

Jacobson sound blimp.

invented what he called a synchroniser, which fitted perfectly next to the camera body and powered both the light source and the shutter connection simultaneously. It became the must-have device and one that started Irving's life-long fascination with all things camera related.

Film unit photographer Bob Willoughby then came to Irving with his problem of not being able to shoot stills during scenes without his shutter click distracting the director and actors, which in turn often led to him calling for a still at the end of the shooting day, which made him Mr Unpopular. Irving retreated to his workshop and invented the camera sound blimp.

I liked using Leica cameras, but they weren't terribly practical as they were a rangefinder camera and you'd get cross lights and flares but wouldn't realise until the film had been processed, so everyone – including me – really wanted to use reflex cameras, particularly because you could see what you were getting in the viewfinder. However, both cameras were noisy.

The blimps were custom-made by Irving's company JPI and, as they were made in pretty limited quantities, the American market always seemed to nab them all. Consequently they didn't really arrive in the UK until the early 1970s and I acquired my first one in the middle of the decade.

They were a bit fiddly and quite bulky, and not always totally silent, but they certainly allowed me to take pictures in scenarios where I might not otherwise have been able. They were quite simple designs: essentially a metal box filled with foam rubber. I've owned several over the years and each time had to wait weeks, if not months, for receipt from the point of ordering, which demonstrates their popularity.

It's such a shame that JPI has recently closed due to Irving's son, Mark, retiring but what a legacy and what a clever piece of kit!

Scene 10

THE DEEP AND DEATH ON THE NILE

Jaws had been a massive hit in 1975 and the book's author Peter Benchley was suddenly a 'hot' name. The film rights to his second novel, *The Deep*, were bought by Columbia Pictures before it had even been published. Peter Yates was brought on board to direct a most wonderful cast including Jacqueline Bisset, Nick Nolte, Robert Shaw, Eli Wallach and Louis Gossett Jr on location in Bermuda. Jacqueline and Nick played two amateur treasure-hunting divers who have a run-in with local criminals when they inadvertently discover the secret cargo of a Second World War shipwreck. Robert Shaw was a star with increasing influence by this point and, along with being paid $650,000 plus a percentage of the profits, he rewrote much of his dialogue and suggested that the film would be more realistic if the filming all took place underwater. Although some scenes were shot in the Caribbean Sea itself, the majority were filmed in specially constructed underwater sets in Bermuda.

I'd worked with Peter Yates on *Murphy's War*, and he kindly asked for me on this picture.

In early scenes Jacqueline Bisset wore just a white T-shirt and black bikini bottoms in underwater sequences, and accordingly I took a lot of photos of her in the outfit. The studio head of publicity, no doubt encouraged by the producers, placed some of these images in certain men's interest magazines and, when it was mooted this image should also dominate the poster, Jacqueline wasn't so keen and refused permission. Well, you couldn't blame her as it was quite a dramatic part, not just a wet T-shirt appearance.

Nick Nolte and I used to hang out together, although he was staying at the Southampton Princess Hotel, which was a far more glamorous hotel than the one I was staying at – the Sugar Cane Hotel. My hotel came complete with an old creaking sign and a few creaking residents with their nurses in tow. One in particular was the ageing owner of the Bank of Bermuda, who was obviously suffering with some form of dementia as she'd wander the corridors at night, then sit at a piano to play the only tune she knew, 'Abide With Me'. Nick used to liken it to me staying at the Cuckoo's Nest (as in, *One Flew Over*) and on Friday evenings would invariably invite me back to his hotel to play billiards – I think I even woke up one Saturday morning under that table. We'd also go to the Henry V pub, which Robert Shaw used to frequent. While I don't want it to sound as though we were all blazing alcoholics, we did like to play hard after working hard. On one of our outings Nick mentioned the producer was throwing a party and asked if I was going. Well, no, I hadn't actually been invited.

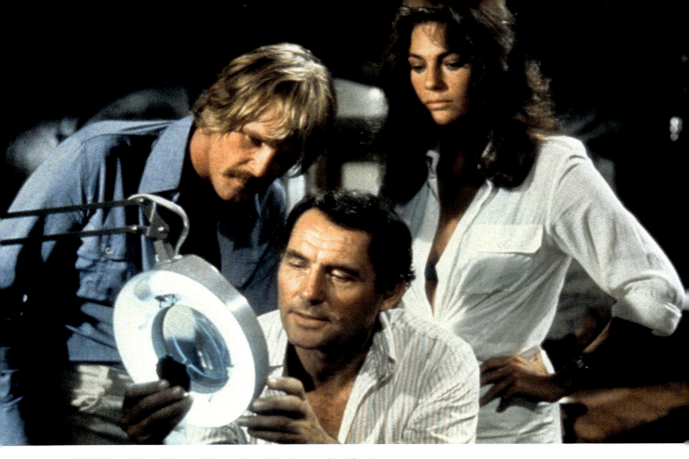

Nick Nolte, Robert Shaw and Jacqueline Bisset starred in *The Deep*.

'Oh you can come with me!' Nick exclaimed.

We went for a few hours, but when we decided to leave couldn't get a cab for love nor money. There was this car parked outside with the keys in the ignition and Nick said, 'Oh here. We'll take this ...'

Nick drove me to the Sugar Cane Hotel and then went back to his hotel.

On set the next day our producer arrived looking pretty angry and told us that his car had been stolen from outside his villa the previous night and the police were investigating. Nick and I looked totally innocent and couldn't imagine who on earth might have done such a thing!

Unfortunately, despite having the best scuba gear, I was unable to do a huge amount of underwater photography alongside the cast in the tank (which was so large it had its own marine biologist to look after it and all the fish). This was because I wasn't able to swim – I just sank – and I wasn't the only one. An enthusiastic publicist arrived from LA with the news he was going to stage a press junket on location, and what's more was going to get all the attending journalists to suit up and dive into the tank, leading a fair few of us crew members to look at one another in disbelief. When the day of the junket arrived, our publicist emphasised what a great idea this really was, and demonstrated to the journalists how easy it was to suit up, strapping weights around his waist. Just before he connected himself up to his oxygen tanks he slipped and fell into the tank – sinking like a lead weight, as after all he had enough of them strapped to him. Well, the journalists and photographers certainly got

Peter Ustinov in *Death on the Nile*.

a story, but maybe not quite the one the PR department had anticipated.

Despite not being able to swim, I went from one film set around water to yet another – this time *Death on the Nile*.

In 1974 EMI Films enjoyed an enormous success with *Murder on the Orient Express*, and understandably wanted to follow it up with another Agatha Christie adaptation. Director John Guillermin, who had just made *The Towering Inferno* and *King Kong*, was signed to direct and Albert Finney was asked to reprise his role of Hercule Poirot. However, having endured several hours in the make-up chair each day fitting prosthetics for *Orient Express*, he was really not very enthusiastic about doing it all again – and especially not in the Egyptian heat. So, rather than emulate Finney, they decided to go in a different direction and cast Peter Ustinov, who was a somewhat warmer Poirot by comparison.

An all-star cast was assembled in support: Jane Birkin, Lois Chiles, Bette Davis, Mia Farrow, Jon Finch, Olivia Hussey, George Kennedy, Angela Lansbury, Simon MacCorkindale, David Niven, Maggie Smith and Jack Warden among them.

As I've said before, I've always found the more experienced people are the best and easiest to deal with, and though Bette Davis had a formidable reputation she proved to be an absolute delight and so full of support and enthusiasm, as were all the others actually. Unlike nowadays where actors disappear to their trailers during the breaks, this cast would sit in their director's chairs on set, chatting with each other and the crew, and everyone would be at total ease – Niven and Ustinov had the most entertaining

Signed photo of the cast.

repertoires of stories, though I suspect some of Niven's were ever so slightly embroidered. But the thing I loved about him was that if ever he was talking to you, he looked into your eyes and gave you his full attention; he didn't start looking over your shoulder like many would, to see if there was someone more interesting or important. No, he was only interested in you – be you a runner, tea boy or movie star – and that really endeared him to me.

We spent seven weeks on location in Egypt in late 1977, four of which were on the steamer *Karnak* and the rest at places such as Aswan, Abu Simbel, Luxor and Cairo. Most of the time the ship was towed along by smaller boats and its engines were turned off because they were so damn loud.

Make-up was often called at 4 a.m. and shooting commenced at 6 a.m. to accommodate a two-hour rest period around noon, when temperatures hit 130°F, but all the cast remained calm and collected. Director John Guillermin, however, was a bit of an oddity. He always had a Heineken lager in his hand – from 6 a.m. onwards – and despite never being drunk, he was rarely seen without a beer, nor could he go a whole sentence without a cuss word. The original first assistant director, who was quite an accomplished and experienced chap, took great exception to this and considered it unprofessional, particularly in the company of such a great lady as Bette Davis, so he resigned. Chris Carreras took over.

Miss Davis made a point of getting to know all of the crew's names, and they all loved her for it. One day, with scorching temperatures and high humidity, Miss Davis was in full period

Signed photo of Bette Davis.

costume while awaiting the scene to be set and John Mitchell, the sound recordist, had a little deckchair with a parasol to shade him from the sun. John – being the gentleman he was – stood up to offer his chair to Miss Davis.

'No thank you John, No thank you,' she said politely, and continued to stand.

After a minute or two, John was quite adamant. 'Miss Davis, please take my seat ...'

'Certainly not, John,' she replied, being the total professional. 'I'm fine.'

Well, another twenty minutes went by, and Miss Davis was still waiting to shoot her scene, and was still standing in the blistering heat.

'Miss Davis, I really must insist!' John said curtly, as he proffered his chair.

'John – I have been married three times and you are the first man to dare tell me what to do. And I thank you for being so thoughtful,' she smiled, and indeed she took his seat until the scene was lit ready to shoot.

Mind you, that isn't to say she couldn't be irascible. When Lord Snowdon was invited on set to take some special shots for magazines, Miss Davis instantly took against him and really wasn't in the mood to co-operate. I'd always found her charming and most helpful in stills sessions but did wonder about chancing my arm by asking if she might sign a photo for me, as I'd heard she didn't particularly enjoy giving autographs. I spoke to her personal assistant, who assured me that would be perfectly fine. So I chose a shot I particularly liked and when I presented it to her, she smiled and wrote the most touching dedication.

Scene 11

AND THE WINNER ISN'T

The Big Sleep, or *The Big Yawn* as the press dubbed this remake from Michael Winner, was a 1978 version of Raymond Chandler's acclaimed novel that had been filmed so successfully in 1946 with Humphrey Bogart and Lauren Bacall – the earlier version is often included in critics' top film lists; the 1978 version is not.

To be fair, the latter did have Robert Mitchum, Sarah Miles, Richard Boone, Joan Collins, Oliver Reed and James Stewart, but with the story's setting changed from 1940s Los Angeles to 1970s London (as it was cheaper!). It had more sexually explicit scenes too, with homosexuality, pornography and nudity being running themes. Mitchum was 60 at the time of filming, as compared with Chandler's 33-year-old Marlowe in the book. But why let accuracy spoil a good story, eh?

In the ten years prior to this, producer Elliott Kastner had enjoyed great success adapting four Alistair MacLean novels for the big screen. He'd now turned his attentions to MacLean's hero, Raymond Chandler, after United Artists acquired the Warner Bros library and obtained the remake rights to *The Big Sleep*, which Kastner in turn acquired from them. He took it to the Rank Organisation, who had recently announced a new production programme and a return to filmmaking, but things moved slower than Kastner anticipated and so he approached Lord Lew Grade, who was ramping up his film production activities with ITC.

An American screenwriter was recruited but did not agree with changing the location of the story to Britain, so Winner stepped in to write it himself, along with co-producing and directing the piece. He was as immodest in his talents as ever.

The plot saw Marlowe hired by a rich, old military gentleman (James Stewart – in his one day's filming) to handle a blackmail attempt, track down some pornographic photos of his daughter, find his missing son-in-law and provide him peace of mind in his dying days.

Though it was Michael Winner, a potential job offer gave me a little peace of mind that I could pay the bills, and so despite my earlier experience of him not being particularly joyous, I went along to his Melbury Road mansion in London (now owned by singer Robbie Williams), with beautiful antique furniture and works of art all over the walls. He was in the upstairs study wearing suede ankle boots, no socks, jeans and an open-neck shirt – his feet were up on the desk when I walked in, hence me noticing his lack of socks. Removing the massive Cuban cigar from

Robert Mitchum in action in *The Big Sleep*.

his mouth, he looked up at me and said, 'I hope you're a better fucking photographer than you were an actor.'

'Only you can be the best judge of that, Guv,' I replied.

That was it. Interview over. I got the job, starting a couple of weeks later.

I'd worked with Mitchum on *Rosebud* of course, until he walked off, and it was good to see him again. For one particular sequence we were on location in Rickmansworth in the afternoon and shot a few scenes, with the final one being Mitchum walking over to a car outside the house, removing his tie and placing it through the filler cap into the fuel tank. He was to light it ... and bang!

Now, Michael liked to work fast – he'd only ever do one or two takes before moving on, and this fuel tank scene was listed as being 'Night' in the script but here we were, all ready to shoot, and it was still light. We were ahead of ourselves.

'Well make it dark. Make it dark!' snapped the director, as the construction guys dashed off to get scaffolding and black drapes to build an awning, and very quickly they managed to black out all around the car.

'Let's shoot then!' Winner called.

'Not yet, Mr Winner, we're still draining the last of the fuel from the tank,' was the response from the special-effects guy.

'Well, we can shoot the close-ups, and do the wide shot later,' Winner advised, keen to get his cameras turning.

'No, Guv, the tank is still running off,' was the response as fuel was running in a little gully away from the car.

'We can shoot. We can shoot! Get the camera ready,' Winner called, ignoring the advice of his special-effects team. With that he took his cigar and threw it in the fuel gully.

Well, it all went up – the car and the awning, the front of the house – and the crew were literally running for their lives, several with scorched clothes. The camera dolly melted in the fire and Winner just stood there looking annoyed before ordering we shoot the next night instead.

We did regroup the following night, and the director was a little less gung-ho thank goodness, but he was getting twitchy and irritable as we were fast approaching midnight and he desperately wanted to get the last shot in the bag. Mitchum was obviously growing a little tired of Winner shouting relentlessly at everyone to get a move on.

'Pity this isn't going to be shot after midnight,' I casually said to Bob, who was standing next to me at the time.

'Why's that?' he asked.

'Well if we go beyond midnight the whole crew get an extra day's pay,' I explained.

Just then, we heard Winner call Bob Mitchum to his mark, swiftly followed by, 'ACTION!'

A moment later, an apologetic Mitchum was fumbling with his tie. 'Sorry, Michael. Can someone from wardrobe help me with this knot? I can't undo it.'

Winner barked at someone, 'Help Mr Mitchum ... OK? ... Let's go again ... ACTION!'

'Oh no, sorry, Michael,' Bob said, as he tripped slightly walking towards the car. Can we go again?'

'OK. OK. ACTION!' called the director.

'Oh, Michael. Sorry, but I think I have some dirt on my trousers here – can we get a clothes brush?'

Well, this went on for about ten minutes with the director getting increasingly red-faced as each minute passed. Just as he was getting ready for yet another take, Bob turned to me and asked, loudly, 'Keith, do you have the time on you?'

'Erm. Umm. Well it's three minutes past midnight,' I blurted.

'Oh gee. Are we into another day already?' he asked mischievously, just as Winner shouted 'ACTION!' one more time, thinking he could get away with it.

108 LIFE THROUGH AN APERTURE

Bob did the take perfectly, turned to me and gave a little wink before saying, 'Goodnight' to all the crew and getting into his car home.

We did get another day's pay by the way, and it made the experience just a little bit sweeter.

Having shifted location to near the Savoy Hotel in London, shooting scenes on the Embankment, Bob beckoned me during our break and asked me to head with him to a little pub called the Coal Hole. We sat at the bar facing away from the customers, but sadly one man spotted him and, just as Bob started to quench his thirst with a nice cool beer, the man tapped him on the shoulder and said, 'I know you ... you're that famous bloke Duke ... bet you got loads of money.' To disturb Bob and his beer was bad enough but to mistake him for John Wayne! I was ready to head out quickly, but Bob calmly turned around, put his hand in his pocket and pulled out a wad of notes. He slapped them into this chap's hand and said, 'Now fuck off!' before turning to me, 'I guess you'll get this round?'

Bob could be mischievous, and I remember during *Rosebud* a publicist from America descended on set with the plan of organising an ad hoc press junket, which Bob wasn't best pleased with at the end of what was already a long day. We were filming on a jetty and the publicist explained the photographers would walk with Bob, take some shots and then he would do some one-on-one interviews on board the boat. Oh yeah?

Bob didn't protest nor say anything; he listened patiently, but just before he took his first steps along the jetty he looked at me and said, 'Watch!'

I grabbed for my camera, of course, as Bob strolled down the jetty with all the photographers in front of him, walking backwards as they snapped away.

Sure enough, Bob led them directly off the end of the jetty into the water!

Winner, meanwhile, remained his usual brusque self throughout shooting, and whilst always laughing at his star's jokes, he could be extremely rude and inappropriate to others on set, even to the point of driving them to tears, yet would then turn around and say, 'Glad that's sorted. Time for tea?' Then he would call for his tea to be served to him in his director's chair from a solid silver teapot, on an ornate tray with bone china cups – a sight quite unbecoming for such an ill-dressed bully.

Though, to be fair, he did always take a joke well, such as when special effects laced his cigars with explosive charges and such like – and believe me, there were many, many attempts to do things to him!

I worked with Winner on a couple more films, for my sins, one being *A Chorus of Disapproval* with Anthony Hopkins and Jeremy Irons on location in Scarborough a decade later, and then in 1990 on *Bullseye!* with Roger Moore and Michael Caine.

I've been fortunate to meet a number a big stars in my time, and as I have said before in these pages, the real Hollywood stars are genuinely the nicest and easiest to get along with as they are real professionals, unlike some of the younger ones who achieve overnight fame and think they're something really special. One of the most beautiful and gracious of all was Katharine Hepburn.

The Corn is Green was a Warner Bros TV movie directed by George Cukor and starring Katharine Hepburn – who was the driving creative force behind it happening. She played a schoolteacher determined to bring education to a Welsh coal-mining town, despite great opposition from the local squire. Talk about Hollywood royalty coming to town – they really were two of the greats, and when you think George Cukor directed such films as *The Philadelphia Story* (1940), *Gaslight* (1944) and *A Star is Born* (1954), and won the Academy Award for Best Director for *My Fair Lady* (1964), I really did have to pinch myself to be sure I was working with him.

Katharine Hepburn in *The Corn is Green*.

A signed photo of Katharine Hepburn in *The Corn is Green*.

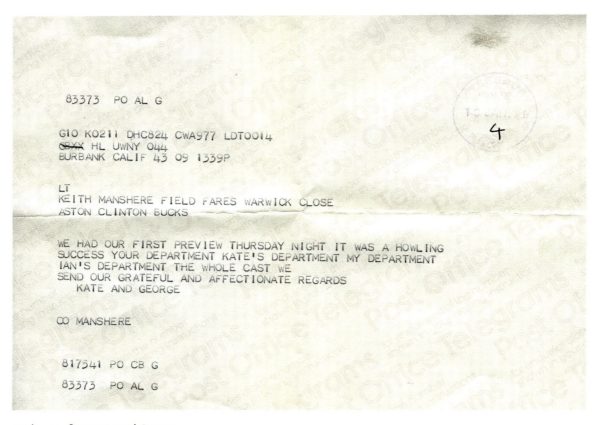

A telegram from Kate and George.

It marked the tenth and last collaboration between the director and actress. We arrived in North Wales to film the location shots in a blaze of publicity and I must say Katharine was a real joy from beginning to end, and treated the whole crew like they were members of her family; so much so that when cinematographer Ted Scaife collapsed on location – it was a one-day thing, with no serious consequences – Katharine was really beside herself with worry. She went to see him at the hospital and seemed so genuinely relieved when he was able to return the next day.

Following a couple of weeks on location we moved back to the studio in Wembley, and one day towards the end of the shoot Katharine's PA asked if I would go to see her in her dressing room, as soon as possible. I scratched my head as to what I might have done to upset our lovely star, as you usually only ever received a summons such as this if there was a problem. As I made my way behind the flats and lights on the stage, wondering why I'd been called, I knocked on her open dressing room door, and Katharine exclaimed: 'Ah, Keith! Now you must promise me you will use this ...' and presented me with a beautiful solid silver salt cellar from Asprey's in Bond Street, inscribed in her own handwriting with, 'To Keith, Love Katharine Hepburn'.

Of course, I've never used it as it's locked away in my special memento cupboard, very safely.

Later on, after she returned to Hollywood, I received a telegram from her: 'Film a resounding success. All put together and looking really good. Love Katharine.'

I thought no, surely she wouldn't send a telegram to the unit photographer? But she had, and not just to me; she had sent telegrams to all the crew. A little later she sent a handwritten card too saying it was wonderful for *her* to work with *me*, the film was a resounding success and that she hoped we might work together again.

Alas I never had that opportunity but was grateful for the one film I did work with her on.

I mentioned that Rank were at one point interested in making *The Big Sleep*, but the producer grew impatient and took it to ITC; well, one of the films that Rank had backed around the same time was a remake of *The Thirty-Nine Steps*, which had met with some success and so they set their sights on a second Hitchcock remake, *The Lady Vanishes*.

Rank had financed the original Hitchcock version of the story and though the film rights had subsequently passed to other companies, with nothing materialising, those rights again reverted to Rank in the mid-1970s, and it was decided to remake the film with a faster pace and modern-day stars, with production company Hammer Films.

George Segal and Ali MacGraw were announced as stars, though in the event Elliott Gould and Cybill Shepherd played the two leads, alongside a Who's Who supporting cast of Angela Lansbury, Herbert Lom, Arthur Lowe and Ian Carmichael to name but a few. On paper it all looked and sounded good, and the PR machine started ...

One leading international magazine contacted the production, keen to do a cover story on Elliott Gould, who had been making quite a name for himself in some recent international films. I arranged a fun photo session with Elliott and the magazine asked we mail them photos and negatives. I felt a bit uneasy entrusting them to Royal Mail and, sadly, I was right to be as they never arrived at their destination in France. It was too late to do another session to make the copy deadlines and the feature was dropped.

I have never mailed photos since.

I thought it was quite an exciting story and plot, set on the eve of the Second World War with an elderly governess named Miss Froy (Angela Lansbury) disappearing on a train to Switzerland with vital secrets that could change the course of the war, but while the Hitchcock version was tense and dramatic, this one was described as being 'about as witless and charmless as could be conceived' by one critic.

A critical and commercial disaster, mauled by the press and ignored by the paying public, this film marked the end of the road for Hammer, which went into liquidation, and Rank totally withdrew from film production.

Meanwhile, there was *Heaven's Gate* – probably most famous for bankrupting studio United Artists, and one I was fired from!

The movie's prologue was set in Harvard University: seemingly an afterthought from director Michael Cimino after principal photography had wrapped and showed two young men graduating in a ceremony full of pomp. James 'Jim' Averill (Kris Kristofferson) and William 'Bill' Irvine (John Hurt) are close friends with bright futures ahead of them, along with three and a half hours' more movie.

Harvard actually refused the production permission to shoot in its grounds, so Cimino settled on Oxford University as a stand-in. The production decamped to England and added another $3 million to its huge and already exceeded $41 million budget.

In the prologue, a band marches (actually playing on a pre-recorded loop of music) under Hertford Bridge as our heroes' carriage comes into frame. The cobbled streets were covered in peat, through which our sound recordist Peter Handford had to feed all manner of cables to connect up to the playback speakers and to the director's headphones.

United Artist's publicity department had called to ask if I would work on the Oxford shoot for a couple of weeks, and when I arrived on location

it was to see Cimino direct a huge oak tree (and I mean *huge*!) into place, having had it dug up to dress his set. There were seven cameras lined up to shoot simultaneously, though this wasn't a complicated battle scene or anything like that, rather a simple shot of a carriage moving along a road from which Kris exited and went into a college building.

I'm told the first cut of the film ran for over five hours, which isn't surprising giving the amount of stock running through those cameras – there was a good movie in there somewhere I guess?

Cimino kept expanding this tracking shot and rehearsed it over and over to the point where the carriage wheels had literally shredded the cables Peter had laid, and as the shot became longer and longer, the cable to Cimino's headphones wasn't long enough to stretch the whole length, which obviously irritated the director hugely. Being the helpful sort of chap that I am, I spotted an extension cable on the sound cart and asked if I could run it over to Cimino. Peter was effusive in his thanks: 'That'd be marvellous if you wouldn't mind, dear boy.'

Just as I was plugging the extension in, Cimino ran past me, grabbed the headphones out of my hands and stomped off, but in all the on-set chaos the cable had wrapped around my leg and when Cimino pulled it taut, I was nearly pulled over. My natural reaction was to tug the cable back to steady myself – duly pulling the headphones off Cimino's ears as I did so. I tactfully made myself scarce for a while, but as soon as Cimino saw me he demanded to know if I was the unit photographer chap.

I nodded yes, to which he responded, 'You're fired!'

I rather solemnly gathered my equipment together and was walking off the set only to bump into United Artists' London publicity office delegation who had come to visit.

'Hi Keith, lovely to see you with us on this. Everything good?'

'Not really – I've just been fired!' I replied to the stunned team.

I drove back to Pinewood to clear my desk and, despite there not being mobile phones on set, everyone seemed to know what had happened. Denis O'Dell, one of the producers whom I'd worked for before, said not to worry and he would ensure I was compensated for the entire two-week shoot regardless. So even though I was fired, happily I was paid.

A poster for *Heaven's Gate* – the film that bankrupted United Artists and from which I was fired.

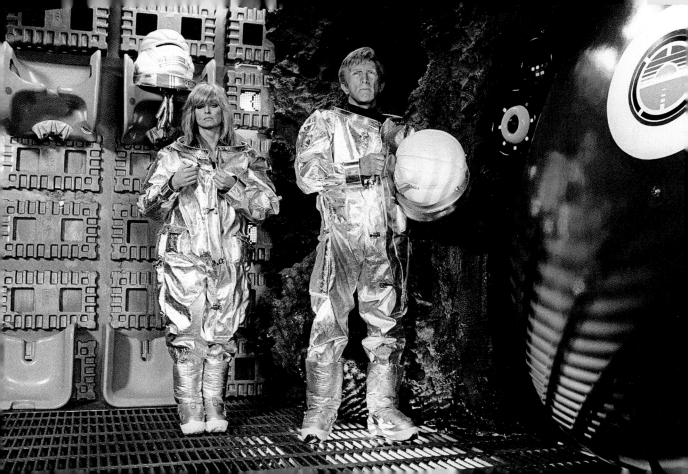

Scene 12

SCI-FI AND *SUPERMAN*

Stanley Donen became involved in a small three-hander British sci-fi movie called *Saturn 3* when production designer John Barry pitched the idea to him during the shooting of *Lucky Lady*.

John had long thought about how the earth was becoming overcrowded and what that would mean in the future. He came up with a story where a couple of scientists are conducting food research on Saturn's third moon when they are menaced by another scientist named Benson and his android, the plan being to replace one of the scientists with the robot – named Hector – which is powered by brain tissue extracted from human foetuses and programmed using a direct link to Benson's brain. Of course, it all goes wrong.

You can imagine this pitch being made in a bar late one night, but Stanley was interested in capitalising on all things space, following the likes of *Star Wars*, *Alien* and *Close Encounters*.

Stanley suggested John should direct and he would produce. Martin Amis was recruited to write the screenplay, and John Barry seemed quite happy with the way his little film was progressing. Meanwhile, Stanley Donen made *Movie Movie* for Lew Grade and consequently gave him a copy of the first draft script to read. Lew took it with him on a plane and loved it, so much so that he passed it to Farrah Fawcett, who was on the same flight, and asked if she'd like to be in it. By the time his flight landed, Lew had agreed to make the film, had cast Farrah Fawcett, and had fixed a release date!

The script went through several rewrites and was then offered to Kirk Douglas to co-star after both Sean Connery and Michael Caine turned it down. Harvey Keitel was cast as the other scientist, Benson, in his first major starring role.

Dear John Barry was a brilliant production designer, and a really nice man. However, he wasn't an experienced director and certainly hadn't ever had much to do with actors, so when he stepped onto that stage on day one at Shepperton Studios with these Hollywood actors, you could tell he was totally out of his depth and extremely nervous.

Kirk Douglas decided John needed some help, and started giving advice about how to shoot scenes, and what the characters should look like etc., and John wasn't strong enough as a director to say how he envisaged everything, and so just went along with Kirk. There weren't any arguments or anything like that, but Kirk was an actor

Farrah Fawcett and Kirk Douglas on the set of *Saturn 3*.

who was used to experienced directors, and soon realised that didn't describe John – so three weeks into the shoot, Kirk spoke to Stanley and said he needed a director to be in charge of the film.

Stanley walked over to John Barry, whom he'd known for many years, and I would like to think was genuine friends with, and in front of the whole crew said, 'This is not working out, John. From now on I will direct, and you, John, will stand by my side calling "Action" and "Cut".'

John was devastated and totally embarrassed in front of the whole unit. He said he couldn't do that and (reluctantly) left the production. I've never understood why Stanley didn't take John to one side privately, rather than address him in front of everyone. As soon as Stanley took over, the script started being rewritten and the story moved in another direction.

Meanwhile, Stanley didn't seem happy with the (then) unknown actor Harvey Keitel, which led to the two men having frosty exchanges. With tensions running high between them, maybe it was my established working relationship with Stanley that annoyed Keitel, as whenever I started taking photos he would call out, 'Get that photographer off the set!'

'He's not harming anyone, why do you want him off the set?' Stanley asked.

'He's distracting me!' snapped Keitel.

Stanley asked that I carry on but keep a low profile, and Keitel really didn't like the fact I was allowed to remain on set.

Fortunately, Kirk and Farrah were absolutely great with me, and I remember when they were shooting a shower scene together, Stanley asked if I'd be OK to take photos. Well, neither of the actors expressed any reservations to me, so I said, 'Yeah, all OK.' They knew I was experienced enough not to shoot anything that would embarrass them behind the steamy glass or otherwise, and that was the difference between them and the other actor – they were experienced and understanding of the need for me to be on set, and the resulting pictures made all the

Farrah Fawcett.

national papers, bringing an important awareness of the film.

Sadly, *Saturn 3* was a critical and commercial flop. The finished film cost a massive $10 million – and remember it was only ever envisioned as a low-budget three-hander – and took fifteen weeks to shoot due to various delays, not least with John Barry leaving, but also the robot didn't work properly either. Meanwhile, Lew Grade's ITC was also producing *Raise the Titanic* at the same time, which was haemorrhaging money, and so pressure was on to make continual cost reductions on *Saturn 3*. That, combined with overruns, an unhappy set and constant rewrites, made it a sad movie for me to end my association with Stanley. He only made two more films.

Clash of the Titans was Ray Harryhausen's last feature film. It came about as an idea of writer Beverley Cross (husband of Maggie Smith), who had developed it with producer Charles H. Schneer, who in turn took it to his long-term home at Columbia Pictures. They'd made most of his films with Ray Harryhausen supplying the special effects, but eventually balked at the $15 million budget and withdrew. Orion Pictures were interested as they were looking for a starring vehicle for new star Arnold Schwarzenegger, but Schneer was unconvinced by him, and instead went to MGM. It agreed to back the production as a UK–US co-production and, whilst having approval of casting, didn't interfere too much.

Schneer made the conscious decision to surround the relatively unknown lead, Harry Hamlin, with very well-known actors playing 'the Gods', which actually only took a week or so to shoot: Laurence Olivier, Claire Bloom, Maggie Smith, Ursula Andress and Siân Phillips being among them, to improve commercial appeal. Given his Shakespearean background, that's probably why director Desmond Davis was hired, though Ray Harryhausen really took charge of all the technical side of the film, long before CGI had been heard of. Commercially it proved a winning formula and was a joyous shoot throughout.

I often went over to photograph Ray at work on his stop-motion sequences at Pinewood, and marvelled at him with his old BNC camera as he opened the gate, frame-marked the film stock, then frame by frame moved the models a fraction before winding the film back in the camera. He then did the same with another model in the same scene, and so forth, until he built up this whole animation sequence, layer by layer. The finished scene consisted of hundreds and hundreds of tiny movements, which was hugely time-consuming but immensely satisfying. Ray really was a genius.

We shot a lot of the live action stuff on location in Spain and Italy at the beginning of the schedule, in which the stunt performers would be closely choreographed fighting Harry Hamlin, mirroring the movements of the scorpions for example. Then, frame by frame, Ray would painstakingly replace the stunt performers with his scorpion models' stop-motion sequences.

I was probably on the movie for about three months between Pinewood and the locations. Charles Schneer was a much-loved producer, but forever watched the pennies. At the end of shooting one afternoon he had a free seat in his car and so offered to take me back to the hotel – he couldn't bear the idea I might order another car. As we passed by a chap spit-roasting chickens in a layby, Charles pulled over and paid a few pesetas before proudly coming back to the car and telling his wife, 'That's our dinner for tonight.' They took it back to their hotel – well, no point wasting good money on restaurants, eh? A kind and caring producer, as long as he didn't have to spend any money!

These two sci-fi adventures really set me up nicely for *Superman II*, for director Richard Lester.

Superman began filming on 28 March 1977 at Pinewood Studios, and by default so did *Superman II*.

Richard Donner was directing both, but soon into production he developed 'tensions' with producers Alexander and Ilya Salkind and Pierre Spengler concerning the budget and production schedule. A few months later, Richard Lester, who had previously directed *The Three Musketeers* (1973) and *The Four Musketeers* (1974) for the Salkinds, came on board the project as an uncredited producer.

Officially it was reasoned that Dick Lester was there to mediate, but in fact he'd won a lawsuit against the Salkinds for money they still owed him from the *Musketeer* movies. However, when they claimed all their cash was tied up and held in the Bahamas, they instead offered to compensate him if he would help on the *Superman* films – in other words add what they owed him from the previous two productions to the budget of these two films!

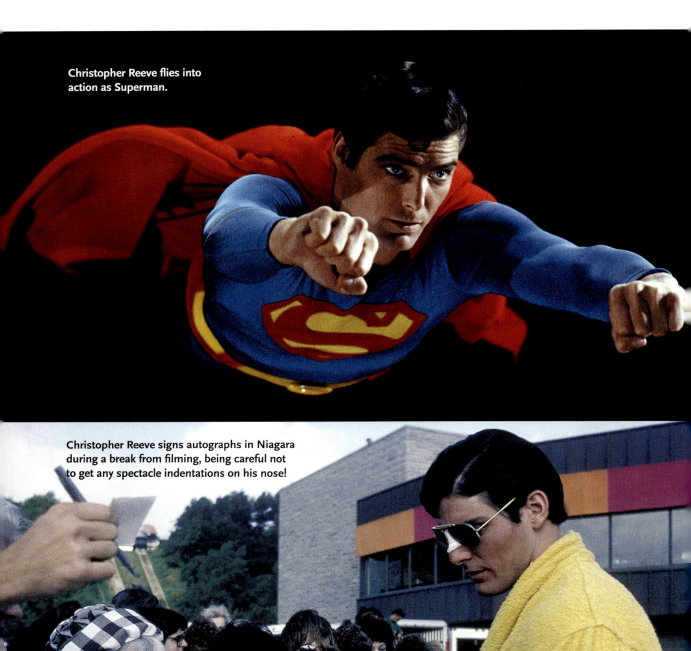

Christopher Reeve flies into action as Superman.

Christopher Reeve signs autographs in Niagara during a break from filming, being careful not to get any spectacle indentations on his nose!

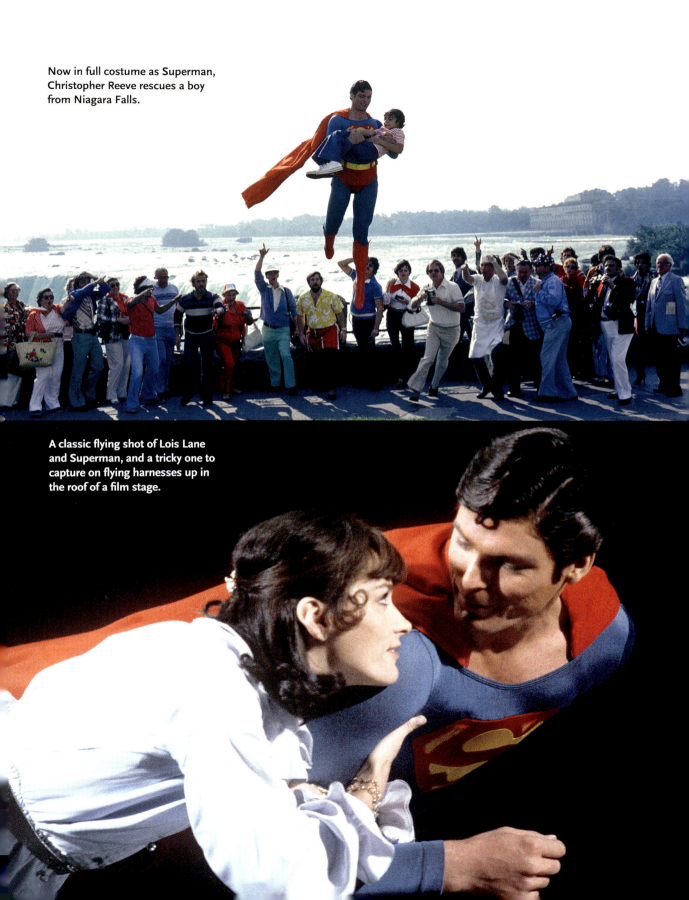

Now in full costume as Superman, Christopher Reeve rescues a boy from Niagara Falls.

A classic flying shot of Lois Lane and Superman, and a tricky one to capture on flying harnesses up in the roof of a film stage.

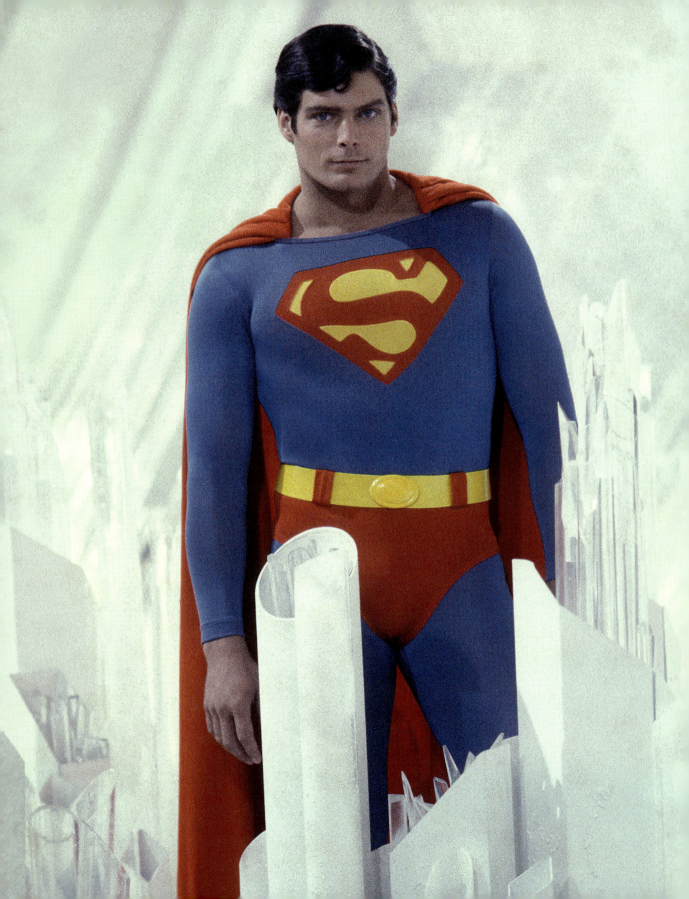

The plan was to shoot both movies simultaneously, but with money running out, the producers drew a halt on the sequel to concentrate on finishing the first film – though Donner had reportedly already filmed 75 per cent of *Superman II*. They meanwhile raised more money by selling distribution rights and fully intended to resume shooting *Superman II* following the release of *Superman* in 1978. Are you keeping up so far?

Relations between Donner and the producers were at an all-time low. Then Marlon Brando sued them for $50 million – his percentage of box office that he claimed he had never received. They paid him $15 million (obviously freeing up some of that money in the Bahamas) but cut the scenes he'd filmed from *Superman II*, fearing they'd also have to pay him the profit share of that film that they'd previously promised. All this without consulting Richard Donner, who was understandably livid.

By the time *Superman II* was ready to begin filming again, Donner had been dismissed, and Dick Lester had been brought in as director. Many crew walked off out of loyalty, including editor Stuart Baird and star Gene Hackman – a stand-in actor and voice double were employed for several of his incomplete scenes. Meanwhile, cinematographer Geoff Unsworth had passed away, as had production designer John Barry, who collapsed on the set of *The Empire Strikes Back*. Matching their look was no mean feat.

Relations with Christopher Reeve became strained too, and rewrites were hastily arranged whilst his contract was renegotiated.

Many scenes shot by Donner were cut into the Lester film, despite some continuity errors, and Dick Lester had to reshoot many of Richard Donner's completed sequences, shot for shot, so that he could be credited as the director with a minimum 40 per cent of the film his.

Talk about a way *not* to make a film!

Richard Lester, as ever, was a joy to be around despite all the politics going on.

We moved out to Canada and shot in Calgary before moving to Paris, Norway and Saint Lucia, with the battle in Metropolis being pretty much constructed on the Pinewood backlot, which was badly hit by gales at one point and had to be rebuilt. Oh and some Idaho scenes were shot on Chobham Common in Surrey.

Dick Lester pretty much ran three cameras throughout all the scenes, which I know sometimes frustrated some of the actors as they didn't always know where their close-ups were coming from.

Chris Reeve was a great guy, very accommodating and very patient, particularly with the uncomfortable flying sequences where he'd be literally hanging for hours on thin wires against front and back projection screens. In fact, that was one of the tricker things: when I needed stills of him flying I had to shoot him against plain backdrops and later superimpose the background images of the sky, buildings etc. that had been projected during filming. It was a bit fiddly at times, and time-consuming. Not as time-consuming, however, as for Derek Meddings having to literally paint out the wires, frame by frame. For example, when Superman was flying over Niagara Falls, Chris was dangling from a crane over the falls on wires. I went up in the helicopter to shoot some plates. Of course, it was pretty uncomfortable for Chris, so he didn't want to be hanging in the air for any longer than needed. This meant we had to be swift, but all the tourists were gathering to watch, and to his great credit, after the shots were in the bag, Chris went over to sign autographs and chat, all in his costume.

You'd often see him in the Pinewood restaurant, in full costume, eating his lunch, which would raise an eyebrow or two from visitors. Oh, and Chris often used to meet up with several of us crew members to play darts twice weekly at

Superman on the huge 007 stage, which housed the Fortress of Solitude set.

the pubs local to Pinewood. Of course, he was out of costume though still caused a few double takes among locals.

Dick Lester did a wonderful job of marrying up shots already in the bag from the first film, though did acknowledge Richard Donner by suggesting they take co-directing credits. However, Donner said, 'I don't share credits.'

Superman III was officially announced at the 33rd Cannes Film Festival in May 1980, several months before the release of *Superman II*, with Richard Lester again attached as director.

Gene Hackman and Margot Kidder both reportedly voiced their unhappiness with the Salkinds and how they treated Richard Donner, so much so that Hackman declined to reprise the role of Lex Luthor, while Kidder's role was significantly reduced. Of course, the Salkinds denied any rift.

Ilya Salkind was around the set, though I never experienced any of the producers interfering and Richard Lester knew exactly what he wanted so was a very capable pair of hands. These were the days, as I've said, where CGI wasn't around and everything was done in camera. There were a vast number of people involved as the end credits roll demonstrated, though Chris Reeve certainly had more of an input on this film – after all he knew the character pretty well by now, so why shouldn't he?

It was really more of the same type of work and fun for me and it felt like an old bunch of mates reuniting. I was only saddened this entry wasn't as successful as the previous ones, both critically and financially, leading the Salkinds to sell out, especially as two of their other productions, *Supergirl* and *Santa Claus: The Movie*, didn't deliver the success they'd hoped for. In the event they sold the film rights to Cannon Films, who went on to make one more *Superman* film – fortunately I wasn't asked to work on that one, as it really was a stinker and sank the franchise for twenty-odd years.

Green Ice, meanwhile, was another Lew Grade production, which Anthony Simmons wrote and was signed to direct. It was announced as one of a new slate of ITC movies that included *The Lone*

Superman's alter ego, the slightly clumsy Clark Kent.

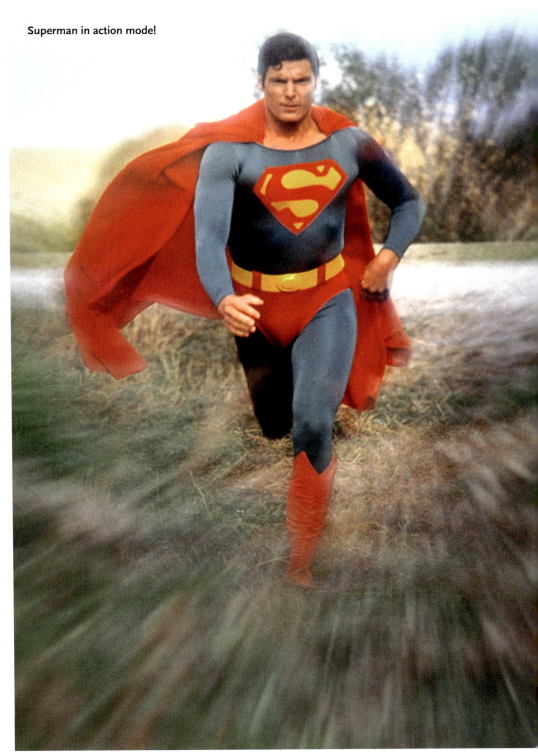

Superman in action mode!

Ranger, The Chinese Bandit, Eleanor Roosevelt's Niggers, The Golden Gate, The Gemini Contenders, Trans-Siberian Express and *The Scarletti Inheritance* – most of which were never made.

In July 1978 David Niven Jr and Jack Weiner, who had just made *Escape to Athena* for ITC, commenced pre-production with original director Anthony Simmons, who had recently enjoyed critical success with *On Giants' Shoulders*.

The budget was set at £7 million, and the writer was Troy Kennedy Martin, who worked on the script and the set action pieces for over a year. Interestingly, Lew Grade had already contracted Anne Archer – on the back of her performance in *Raise the Titanic* – but failed to tell his director who was casting and auditioning for the part. He also vetoed every shortlisted choice, saying they were 'too old' for the twenty-something character. Anne Archer was in her mid-30s.

The movie was set in Colombia but shot on location in Mexico, which was seen as a safer country then, though early on, Ryan O'Neal decided he couldn't work with Anne Archer, stating their 'differences' over the type of film they were making, which spilled over onto the stage floor. That, coupled with the schedule falling behind and an escalating budget, scared Lew Grade hugely. He'd almost lost his shirt with *Raise the Titanic*, remember, and now faced his company going under.

It all came to a head. Lew knew he couldn't risk losing his cast (as he had sold the movie based on their names), so decided either the director or the producer had to go, in the hope it would help restore calm on set. In the event, Simmons left, with his whole fee, and second unit director Ernest Day took over. Anthony Simmons was a very laidback type of character, and on the day he left he came over to some of the principal crew and shook their hands, apologising. Lew meanwhile made a point of praising his cast highly and saying how helpful they were. Hmmm.

Ryan was having an affair with Farrah Fawcett, and she used to fly in to meet up with him at weekends, which was generating a lot of press speculation, much to the couple's frustration. In fact, we were shooting at the Shah of Iran's mansion in Mexico City and during a break Ryan and Farrah were telling me how the paparazzi were becoming a bit of a nightmare, following them and lying in wait at the airport, and asked what they could do to shake them off their tails.

'You have a press call,' I suggested.

'What do you mean?' Ryan asked, his interest piqued.

'You present yourself with Farrah for a photographer, explain she's flown from LA to visit you, give him or her a few shots and then they'll leave you alone.'

'Could you take a picture of us?' Ryan asked.

'Sure, I can then send it to Guy Pearce to write a nice blurb and with your permission he can circulate it – but you're in charge, it'll be a photo you want to see printed.'

That's exactly what we did; it made the papers, and the press didn't bother them again. If you give the press a little of what they want they'll walk away quite happy.

Incidentally, I hadn't been in Mexico since making *Lucky Lady*, and back on that movie visiting productions had to hire in a certain number of local crew. Often we'd have a doubling up of roles, such as with me – there was also a Mexican stills photographer. He was a nice chap and was quite useful in photographing some second unit work when I was with the main unit. But what I didn't mention earlier was that there'd been a break-in at my hotel and all my cameras were stolen. Fortunately, the insurance company stepped in quickly and replaced everything, but roll on to *Green Ice* and one day near our location I spotted another film unit, and being inquisitive I went over to investigate. Who should I see there but my former Mexican photographer counterpart; we greeted each other warmly, and chatted away for a little while but I couldn't help but feel he was a bit uneasy around me. I wondered why. Then it clicked – let's just say the cameras he had around his neck looked very familiar!

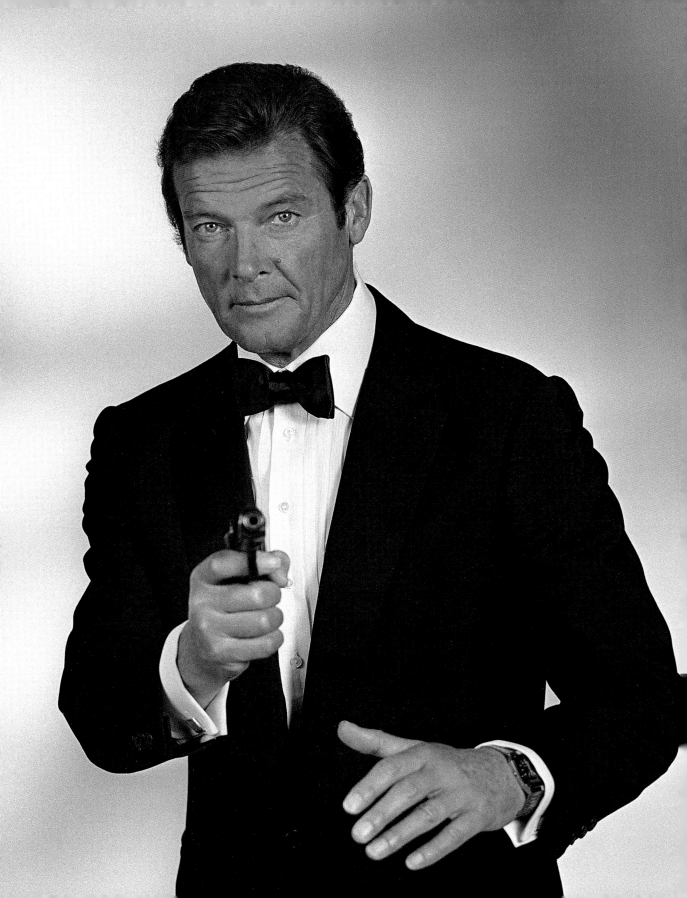

Scene 13

M(O)ORE BOND

Over at Pinewood, other stills photographers on permanent salary including George Courtney-Ward and Albert Clark seemed to get first dibs on any incoming productions. Fortunately, after *The Spy Who Loved Me*, I worked on *The Deep*, *Death on the Nile* and *Superman II* as already mentioned, so my profile was steadily increasing on the other side of the pond and happily Eon's publicity director Jerry Juroe called me offering me the job of stills photographer on the next Bond film, *For Your Eyes Only*, in 1980.

I couldn't quite believe it, as I had to turn down *Moonraker*, and getting a second chance really was unheard of in the industry back then. Having not met him on my previous Bond outing, I was now officially introduced to Roger Moore, although I had met him briefly at Pinewood when he was filming *The Persuaders!* and I was working on *The Magnificent Seven Deadly Sins* for Graham Stark, who Roger knew well, so he came to say hello. I could also swear he was a model back in my early days working on Freeman's catalogue shoots, but he said he'd given up modelling cardigans and donned a halo as Simon Templar.

Roger was incredibly welcoming and receptive, which made it even more nerve-wracking to be honest as I knew the pressure was really on me. Whilst Jerry would guide me as to what he needed, Roger was always positive and encouraging so just left me to get on with my job. I was on set every single day too, which is something I always strived for in my career as often, and particularly in TV, I'd be told, 'Oh we only need you in for two days a week ...' in an attempt to save money I guess. So unfortunately you'd never get to know the artists. Actually some of the most interesting shots came from scenes that many would class as a bit mundane or boring, but you could concentrate just on the main artists and get some good headshots as well as capturing the action. I liked to be on set at call time and would stay until last thing at night because I never wanted to be thought of as a part-timer or as someone who was always going off for an extended tea break. I was there whenever needed and was always poised. After all, being part of a strong and happy crew only comes from working together all the time and I always noticed that with Roger – he wouldn't slope off to his trailer or dressing room in between set-ups, he'd sit on the stage and talk to the crew. He would also be there to feed in lines off screen to another actor,

Sir Roger Moore as James Bond in my first studio session with him on *For Your Eyes Only*, carefully showing off his Seiko watch.

The wonderful Cubby Broccoli with the parrot, which starred in *For Your Eyes Only*, rehearsing the bird's lines, perhaps.

New director John Glen taking a step up on *For Your Eyes Only*.

Titles designer Maurice Binder with Sir Roger Moore, sharing in a bit of the publicity limelight.

rather than have an assistant director do it. You tend to notice things like that as it adds to the positive atmosphere, and everyone talks about 'family atmospheres' on a Bond film; it really flows down from the top.

The director John Glen was making his debut, as was cinematographer Alan Hume and production designer Peter Lamont. With perhaps a little glint of jealousy of these new boys getting a bit of attention, the long-time main titles designer Maurice Binder suggested it might be an idea to perhaps do some publicity with him. I took a few portrait shots and I know Maurice did a few interviews, which pleased him greatly as, despite being a very private man, he did appreciate a little of the limelight and appreciation of his amazing talent.

Our locations on the film included Cortina, Greece and, of course, Pinewood. In addition to being on set every day and capturing the fun, drama and action in my lens, I also had photo sessions in my studio with all the lead actors, embracing their characters for the front-of-house and publicity stills. These are released throughout the production to news outlets to tease and preview the new Bond film in the days long before the internet. It was my job to make the actors look good, and it was always nice to be appreciated, such as when, weeks after production wrapped, a huge delivery of grapefruit arrived at my home from Topol, who played Columbo in the film.

Jerry Juroe co-ordinated news crews and journalists from around the world, visiting locations and the studio throughout every day of the shoot and making sure they all had time with the lead cast and creatives. They banked stories

Producer Cubby Broccoli watches filming on location in Cortina.

that would be held back until nearer the release date of the film, thus unleashing a tsunami of publicity pending the premiere. All journalists received press packs and images giving an outline of the story and characters sufficient to tease readers and viewers, and Roger would charm everyone with his self-deprecating wit and inject little fibs into his interviews to relieve the monotony – such as how he liked to steal hotel towels, and insisted his cigars were part of his contract. He also answered, with great charm, questions he'd heard a hundred times before as though it was the first time anyone had thought to ask him.

After completing *For Your Eyes Only*, Roger Moore was initially reluctant to commit to another Bond project, although when the possibility arose that Sean Connery was about to reprise the role in *Never Say Never Again*, producer Cubby Broccoli made it clear that this wasn't the time to start thinking about recasting and so a deal was signed with Roger to help head off the so-called 'Battle of the Bonds'.

Jerry Juroe said he'd like me to return for Roger's next, *Octopussy*, but I'd just been offered *Superman II* and, being mindful of my mortgage and family, I had to be pragmatic and commit to the film that started first. Bond was definitely going, but there was no firm date, whereas *Superman* had a date fixed, and the production office sent a contract over there and then. I phoned Jerry and explained, and to be fair he completely understood. Although he never said anything, I got the feeling I'd blown any future chance of working on a Bond again, feeling I'd been disloyal. Frank Connor became stills

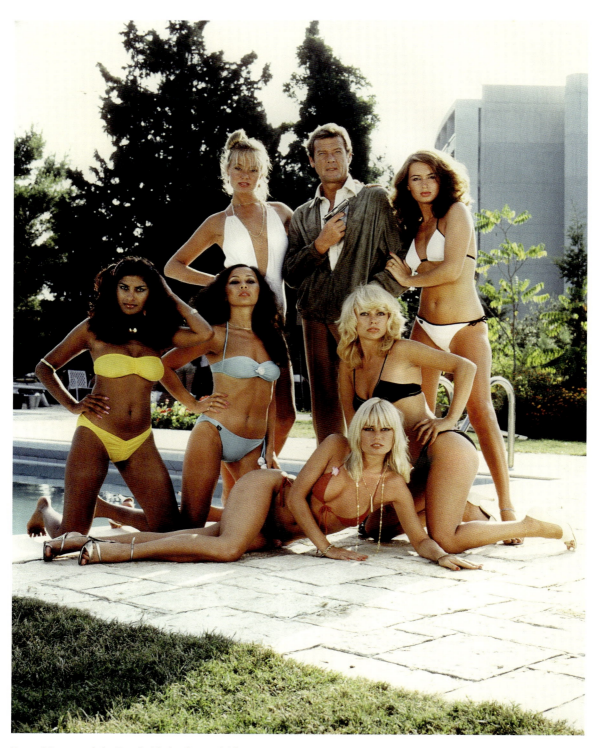
Roger Moore and the Bond girls by the poolside.

Just ahead of *A View to a Kill* starting photography, the newly rebuilt 007 stage was opened at Pinewood.

photographer on that one and did a wonderful job of things, but to my total surprise Jerry did call after *Octopussy* to say they were setting up *A View to a Kill* and asked if I was available. They had firm dates and sent me a contract over.

Disaster struck though when, ahead of filming, the huge 007 stage at Pinewood caught fire and literally melted in the heat. Cubby wasn't to be fazed, however, and ordered the stage to be rebuilt in time for the production. An opening ceremony was arranged to rename it the 'Albert R Broccoli 007 Stage' in Cubby's honour, with stars from the film in attendance. Jerry asked me to photograph the event – an emotional moment for posterity.

Roger always used to play little games with me when it came to product placement. He knew that various companies had paid to place their merchandise in the films – champagne, watches, cars, pens, electric shavers etc. Obviously there was a bit of a hierarchy in the deals as if 007 handled something personally then it was worth a few more dollars to the production than just having the item on a bar in the background.

When it came to the more 'valuable' products, Jerry Juroe would say, 'Keith you've gotta get a picture of Roger holding such-and-such' as, of course, the production was obligated to show it off and help in their marketing.

My much-missed friends: head of publicity Jerry Juroe with unit publicist Geoff Freeman.

I'd duly try to get a close-up of Roger with 'it' in the scene, but he'd deliberately turn slightly or move his hand so as to obscure the item from me, while he carried on delivering his dialogue. He did it every time, knowingly teasing me and then asking if the scene was good for me. The sod! Although ultimately he would smile widely and, of course, give me what I needed.

Similarly with Pierce Brosnan, I always made sure we had good close-ups of all the products and whenever I did portrait shots of him, he'd tactfully pull his shirt cuff up to expose his Omega watch. He was a great ambassador for the brand. One day, publicist Geoff Freeman said to the marketing lady from Omega, 'Keith always gets you these lovely photographs for your campaigns, yet I never see him wearing one of your watches.'

Next thing I knew, a box arrived with a lovely Omega watch inside. That was truly kind of Geoff to mention, and very sweet of them to gift me such an unexpected bonus.

A View to a Kill was Roger's seventh and last Bond adventure. It was a happy reunion for many of us, including director John Glen, production designer Peter Lamont and cinematographer Alan Hume. Many cast members returned too, including the lovely Desmond Llewelyn as Q and Lois Maxwell in her last appearance as Miss Moneypenny. Roger made no secret of the fact he was feeling his age, particularly when cast opposite leading ladies that were young enough to be his daughter, and then, of course, there was Grace Jones.

Grace had been scheduled to shoot stills with me in Pinewood's pool studio as per her contractual obligations for publicity and marketing. Cubby's daughter Barbara was an assistant director on the movie and was assigned to look

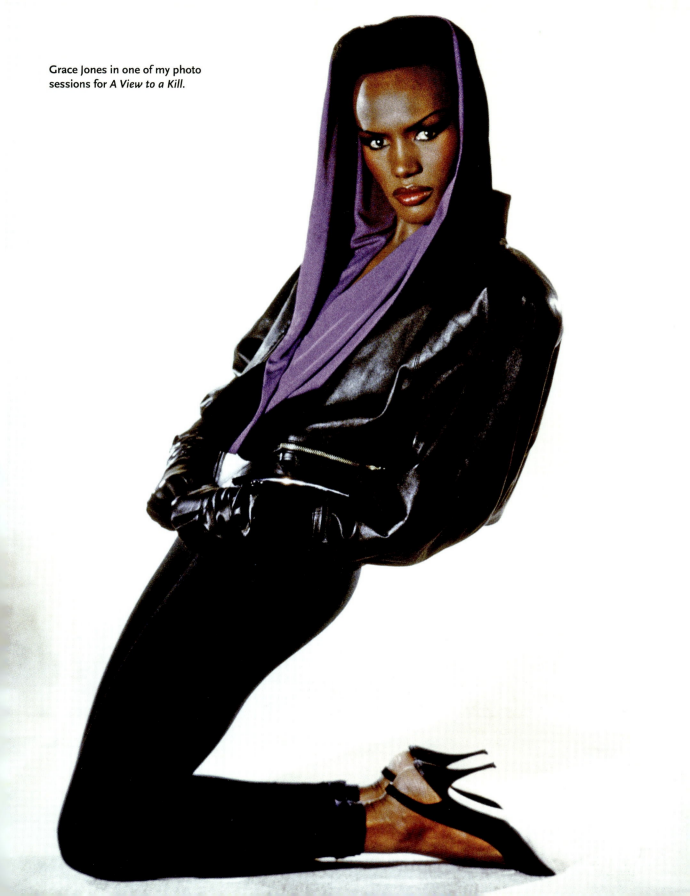

Grace Jones in one of my photo sessions for *A View to a Kill*.

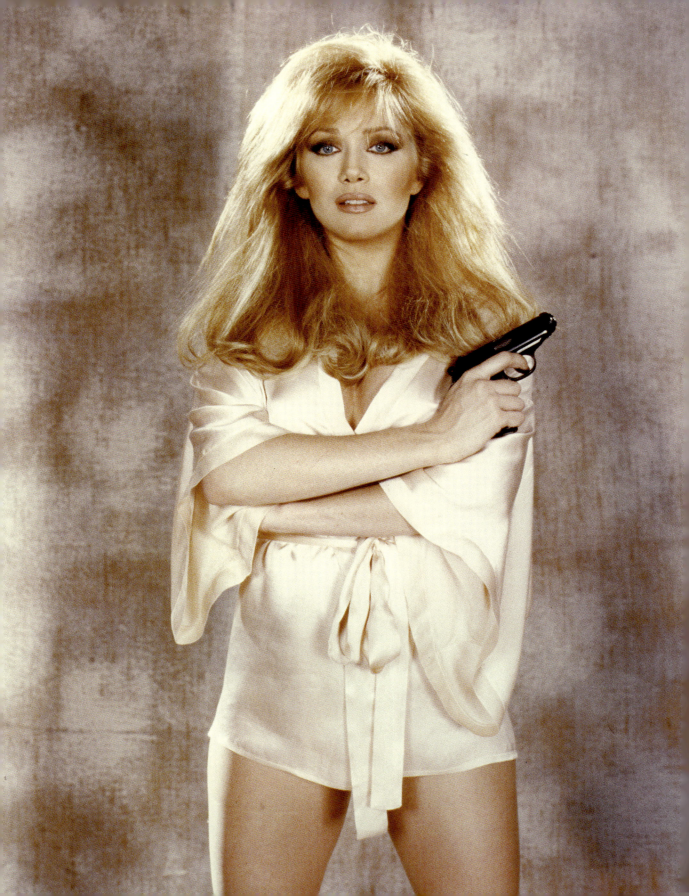

after Grace and essentially ensure she was brought to the studio each day. I was aware Roger had expressed some less than gracious words about his co-star after she continually wound him up by playing loud music in her dressing room next door to his, so was mindful she could be a bit unpredictable.

I was set up with a crew of electricians, hairdressers, make-up and props ready for 1 p.m. Sandwiches, tea and coffee were laid on, along with a couple of bottles of chilled Bollinger on standby as props that were to be featured in some of the stills to fulfil marketing obligations. But there was no sign of Grace. Eventually she arrived at 6 p.m., having kept us all waiting, with Barbara looking very frustrated. Though to be fair she was actually fantastic and very professional once she arrived and worked hard to give me some great pictures of her in character, but I could certainly see her way of working was quite different from Roger's approach.

A few weeks later I was called by the production accounts department.

'Your stills session with Grace was quite expensive, Keith?'

'Well, yes, we overran ...' I began explaining.

'But a whole crate of Bollinger?' they asked.

'I never had a crate, I ordered two bottles!'

Apparently, and allegedly, that crate 'disappeared' into Miss Jones's car on the way home!

Roger's other female co-star, Tanya Roberts, had a similar shoot with me towards the end of her stay in the UK, and just ahead of returning to the USA asked if I'd mind taking some of the photos for her to see at her Belgravia apartment in central London. So I packed my bags and went over to her luxurious flat, only to find the front door open. Tanya called for me to come in – and there was she with her husband in bed. It was very embarrassing for me as Tanya was quite blasé, didn't have any clothes on other than a flimsy and open sort of dressing gown, and asked me to sit on the end of her bed with my lightbox to show her all the images.

Just then there was another knock at the door, and she called for them to 'come in', and a delivery guy with a mink coat she'd ordered appeared. She disrobed and slipped on the coat in front of me, asking what I thought. I now know where the expression 'all fur coat and no knickers' comes from!

It wasn't the first time, either, that she was divested of undergarments, as during filming at Amberley chalk pits she had to climb a ladder at one point and the camera team below couldn't quite believe she wasn't wearing anything under her dress. I often wonder if she did it on purpose to provoke a reaction, or just didn't think. No wonder Roger admitted he found his final 007 outing a bit of a trial.

Christopher Walken played the main villain Zorin, and, coming in to an already well-oiled machine, he was very accepting of everything asked of him, including publicity and stills. He fitted into the flow of things nicely, yet curiously when I went on to work with him on another film later on he was less tolerant and even asked me to leave the set at one point, saying I always seemed to get in his eyeline during a take and it irritated him. It's funny how actors and crew coming into a long-established series are wary of rocking the boat, yet when they come into a new production they seem to want to be more assertive.

Throughout production Roger was a delight, as always. He and Cubby ran a book on each Bond film, playing backgammon. It was the prop boy's job to bring a table and board to each and every location in readiness for the two to start playing. They set up in some interesting locations, some of which I managed to capture on film.

Each day with them was a joy.

Tanya Roberts in her dressing gown.

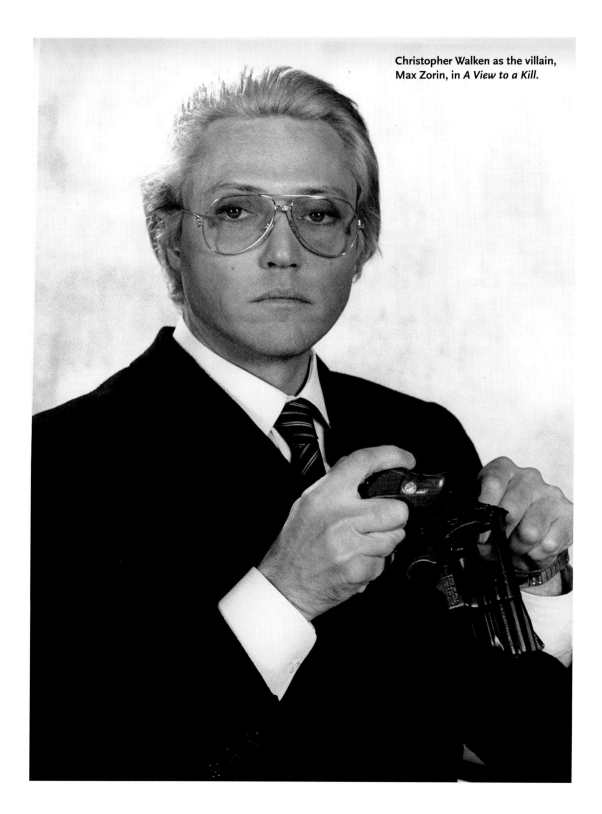

Christopher Walken as the villain, Max Zorin, in *A View to a Kill*.

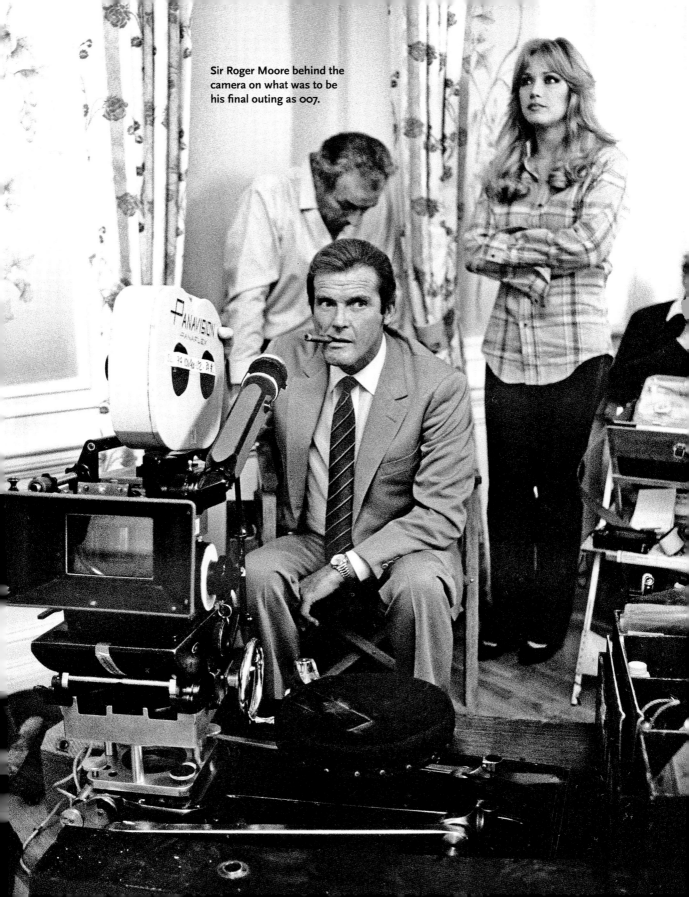

Sir Roger Moore behind the camera on what was to be his final outing as 007.

The backgammon table made it everywhere.

Roger and Cubby play backgammon in Meteora during the *For Your Eyes Only* shoot.

As mentioned, this was to be Roger's final outing. There was no bargaining or negotiating to be had this time as Roger was 57 and was spending more and more time in make-up and hair. He'd had a great run of thirteen years and seven films, and it was time to hand over his Walther PPK to a younger man.

Around this time an upcoming actor named Pierce Brosnan had been making his mark in an American TV series called *Remington Steele*. I'd met Pierce on the set of *For Your Eyes Only* when his then wife, Cassandra Harris, was cast as the ill-fated Countess Lisl. He was pretty unknown at that point, but that one TV series had changed everything dramatically in the space of a few years and, in particular, had put him on the casting director's radar as a potential new 007. Other actors had been considered as a new Bond in recent years, partly as Roger kept producers hanging as to whether he'd return, and I was often asked to come in and shoot sessions with the likes of Timothy Dalton, David Warbeck, Michael Jayston, Sam Neill, James Brolin etc. This time, it was Pierce Brosnan in pole position and when he was eventually offered the role he even posed for photos with John Glen outside the 007 stage at Pinewood, sealing the deal. The standard screen test for any potential 007 was to have him arrive on set in a tuxedo, walk, turn, introduce himself and then recreate a love scene as featured in *From Russia with Love*, which was felt to offer a well-rounded audition piece. The team constructed a full set, lit it very nicely and relaxed the actors into the part. Pierce did particularly well in his test and his wife Cassie was so very keen for him to get the role. Unfortunately it wasn't to be, as when the producers of *Remington Steele*, which had recently been cancelled by NBC, picked up on all the buzz around him being the new Bond, the broadcaster decided to invoke a clause in his contract, at the eleventh hour, to resurrect the show. Cubby was adamant he wasn't going to

Pierce Brosnan's first wife, Cassandra Harris, as Countess Lisl in *For Your Eyes Only*.

Pierce Brosnan on the set of *Mister Johnson*.

share his new 007 with a TV series and backed out, instead approaching Timothy Dalton.

I worked with Pierce a few years afterwards on a film called *Mister Johnson* in Nigeria when Cassie wasn't very well. Pierce was still quite devastated about losing out on Bond and I often played backgammon with him on set. One day he told me that he'd heard the results of the medical tests Cassie had been having – her cancer had now been diagnosed as terminal. Devastated wasn't the word, and quite how he was able to go on acting and complete the film was inspirational to us all and showed what a huge professional he was. I'm so pleased to have worked with him and got to know him better when he did get the role a decade later.

Meanwhile, Timothy Dalton had now won the part and wanted to play it very differently from Roger – Tim wanted to go back to the Fleming books and play Bond as a darker, slightly more serious character. Being largely a stage actor, he wasn't terribly used to nor keen on publicity junkets. I worried he might not be as receptive as Roger so felt I needed to win his confidence from the outset as I'd never worked with him before, only meeting him briefly at the screen tests. Jerry Juroe said they were going to reveal the new Bond to the world in Austria on 6 August 1986, where location

filming was scheduled to take place. The reprise of the Aston Martin was to be the centre of the press call, so thousands of photographers were scheduled to attend and would all be jostling for position. I wanted them to get their photos to place on all their front pages, so I kept my distance a little and gave Timothy a bit of space as I could see he was nervous, and I think he appreciated I didn't ask anything of him that day. I just observed and photographed him at opportune moments.

On the first day of actual shooting Jerry said to me, 'He wants to be different. I need a teaser poster. Take him to one side to do something "different" would you?'

When a request is presented to you at a moment's notice, it certainly makes you think on your feet. With little time to set anything up, I noticed Tim was wearing a leather jacket and thought, rather than have him in a traditional dinner suit, this could be my shot – a casual, but business-like Bond. It was too good an opportunity to miss, so I took him to one side, asked him to pose with the Walther PPK in front of a wall and that was it, the teaser poster shot that was used all around the world.

If I'd had a week to plan and set up a studio, I don't think I could have bettered it.

Timothy settled into the character as the film progressed, and when his second Bond was announced as being *Licence to Kill* I think he was happier with the script as it was tailored specifically for him and took the character back to basics even more. It was a tougher, darker and more brutal Bond, leading the British censors to demand some cuts to pass it as a '15' certificate.

Cubby was keen to set the story in a country the series had not yet visited, plus the recent UK Films Act had made it less attractive for filmmakers to shoot in the UK. It was difficult, particularly for foreign artists who were taxed heavily at source; for example, Jack Nicholson had recently shot *Batman* at Pinewood and said he'd never make another film in Britain because of these new tax laws.

China was suggested as being an intriguing and exciting location but then *The Last Emperor* was released and through extensive filming removed some of the mystique of the country, so it was eventually decided to shoot in Mexico. The script was initially called *Licence Revoked* because of Bond going rogue against orders in his pursuit of drug baron Franz Sanchez on behalf of his old friend Felix Leiter, whose new wife he had murdered. It was later changed by the marketing department to the more widely understood phrase *Licence to Kill*.

In a 'blink and you'll miss it' moment I was offered a cameo part in the opening sequence, the wedding of Felix and Della playing, of course, a photographer. Did I hanker after resurrecting my acting career? No, I was quite happy as I was, but it was fun to be on the other side of the camera again – for a morning at least.

Timothy was very co-operative and workmanlike. He didn't revel in doing interviews as I've mentioned, but was hugely professional and accommodating to me and our lovely unit publicist Geoff Freeman, who fielded so many requests for interviews. Of course, not everyone could get the 'exclusive' they craved, but Geoff was rather good at welcoming journalists and sitting say half a dozen of them around a table with the lead talent, allowing them to chat, then fifteen minutes later moving them on to another table to chat with other cast and crew etc. They all left feeling they had exclusive interviews whereas in fact they all had the same interview, though as they came from different continents there was no chance neighbouring publications would carry the same content.

We fully expected to move into a third film with Tim, and I know story ideas were being worked on. At the Cannes film festival in 1990 the Carlton Hotel's frontage was given over to Tim's image as 007 stating, 'The 17th James Bond Film coming summer 1991'. However,

 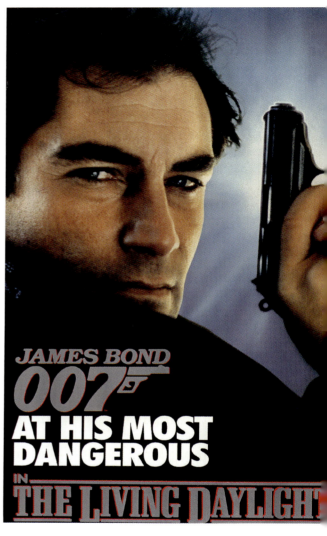

The photo I took of Timothy Dalton, which became the teaser poster.

there was a sudden uncertainty about backer MGM's future with some rather dubious financial goings on following Pathé Entertainment moving to acquire the legendary studio, offering up the TV rights to Bond and other properties belonging to MGM in order to finance the purchase. Essentially they were trying to mortgage the family silver. Cubby filed a lawsuit stating they were acting in violation of his distribution agreement with MGM/UA and a six-year hiatus followed while legal wranglings continued.

By the summer of 1993 everything was resolved, and things were up and running again. Tim Dalton told the *Daily Mail* newspaper that production on the next film would start in early 1994. He was keen to do one more film – and that became the snag. Cubby was conscious after such a long hiatus that the fans needed continuity in

the role and therefore wanted Tim to commit to three or four more films, but Tim felt unable to commit to such a long run and officially stepped down as James Bond in April 1994.

The hunt was on again for a new actor to pick up the Walther PPK and the firm favourite was none other than ... Pierce Brosnan.

Jerry Juroe called asking if I was available – happily, I was, though there was a problem with Pinewood Studios as it was fully booked for the year ahead with a production called *First Knight*. There were only really two large studios available in the mid-1990s, Pinewood and Shepperton. Unfortunately Shepperton was fully booked too, he told me. Cubby had been quite ill and was taking more of a supervisory role while his daughter Barbara and stepson Michael took over the producer reins. They decided that if there wasn't a studio available then they'd have to build one – so they whittled down a shortlist of facilities to a former Rolls-Royce aero engine factory just outside Watford. Director Martin Campbell signed on the dotted line and work started to construct 'Leavesden Studios', where the wide, tall, and open aircraft hangars proved uniquely well suited to film stages.

Workshops and offices followed, and a huge runway proved to be a unique backlot as it had a totally clear and natural horizon. We had, essentially, a whole huge studio to ourselves.

Jerry Juroe decided to step down but continued in a supervisory role, while Gordon Arnell took over as marketing director. Gordon was a dear friend of both Geoff and me, so we were looking forward to a seamless transition in our department.

On 8 June 1994, Pierce was announced to the world as being the new James Bond at a London hotel press conference, promising to peel back the layers of the character to see what lay within, in *GoldenEye*.

I had a great stills studio at Leavesden that Gordon and Geoff helped me to construct. Gordon said he wanted portraits of all the main artists before shooting commenced, which I'd never done before as traditionally those pictures come later on, when the artist has pretty much finished shooting their scenes and the pressure is off. But I guess a new Bond, and the six-year hiatus, meant Gordon needed extra ammunition earlier on to start generating the all-important PR.

I planned a traditional sort of publicity shoot, not least because Gordon cautioned me, 'You can't play around too much with what the fans are expecting.' But I did feel I'd like to do something a little different to introduce a different 007, so wondered about the background. Rather than shooting against a plain white wall, I went to see special effects supervisor Chris Corbould and asked, 'Would it be possible to have a sort of 10ft high wall of flames behind the actors for my stills session?'

He didn't say no, but gave a curious, ponderous smile, adding, 'Let me think about it.'

A little while later Chris called and asked me to go down to one of the stages where he'd had flame bars especially constructed for me, with high gas pressure that produced *really* high flames. I took Christian Moore (Roger's son, who was working on the film) along and asked him to stand in front and to let me know how he felt about the heat as a fireman watched on. He seemed pretty OK with it, and realising I needed to sustain the flame for a little while, I did a few test shots over five or ten minutes. Chris seemed happy too, and, as long as I went along with his health-and-safety guidelines, said he'd be OK about Pierce coming in to see how he felt. Pierce actually loved it and was egging me on to 'shoot it! shoot it!' Well it took a bit of arranging with the production office to find a date and time in the schedule, but a day or two after the initial tests we cleared the stage, had the stunt team and fire team on standby and, once make-up and hair were happy, I did indeed shoot Pierce with him in classic 'Bond' poses – in his tuxedo with the gun, plus some in an open-neck shirt and waistcoat and every other combination you can imagine.

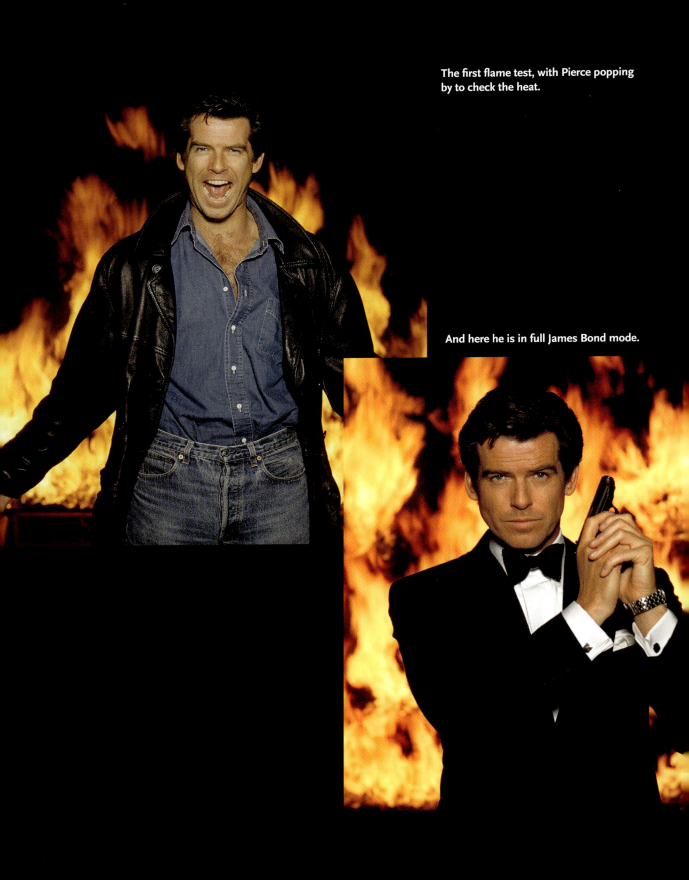

The first flame test, with Pierce popping by to check the heat.

And here he is in full James Bond mode.

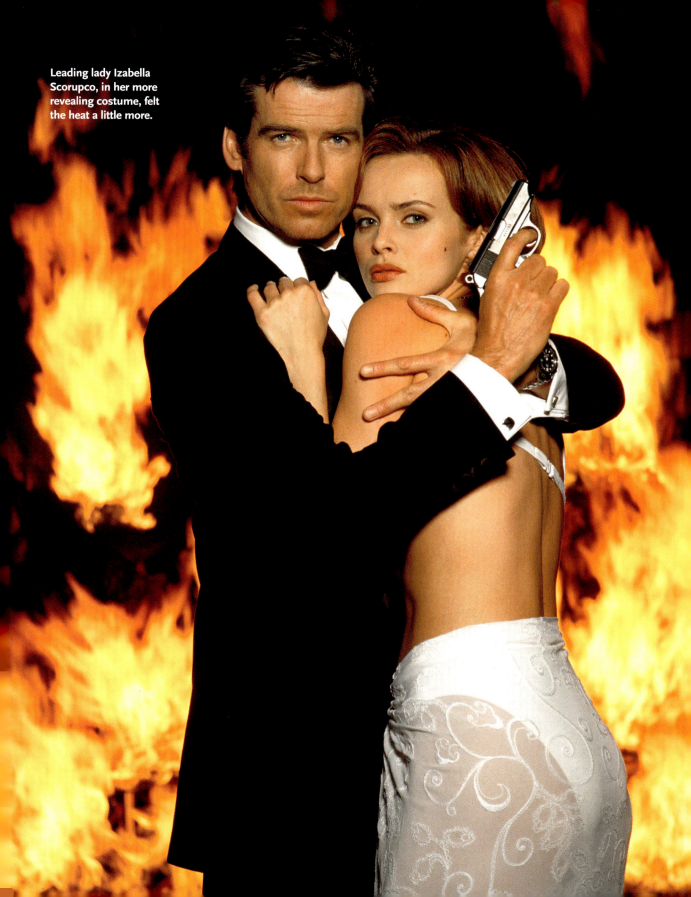

Leading lady Izabella Scorupco, in her more revealing costume, felt the heat a little more.

Once Izabella Scorupco saw Pierce enjoying himself she was up for it too, although as she was wearing a more revealing costume she had a layer of fireproof gel applied to protect her bare back and arms. Barbara Broccoli was on set supervising and made sure everyone was happy, and if I do say so myself it was a lovely twist on a traditional stills session. I think you can see the fun in Pierce's face! Those shots were released around the world and are some of my favourites of any film.

However, after all the hours we spent planning and shooting those classic images I was somewhat staggered, and a little upset, to see one of the big British magazines use it as their cover image having stripped the flame background out and replaced it with a nondescript white wall!

I remember that on the first day of filming Pierce was so excited. I set the backgammon table up for him on the side of the stage, though I never said anything as I thought he'd see it and feel a bit of familiarity. After the first scene was in the can Pierce came over to me and asked, 'How was it?' I couldn't quite believe the leading man was asking the stills photographer for his opinion, but I guess I was a familiar and friendly face. I smiled and nodded to the table. 'Backgammon?' I asked. He grinned broadly – and thrashed me at a game.

Martin Campbell, the new director, was a hyper character yet very friendly, though as a number of crew had been used to working with John Glen, who was a lot more laidback, the atmosphere felt a little bit more pressured, albeit in a good way.

Locations moved from Switzerland (where the pre-title bungee jump sequence was filmed at the Contra Dam) to Monte Carlo, Russia (where reference footage for the tank chase was shot and then rebuilt at Leavesden) to Puerto Rico and, of course, London, where the real MI6 headquarters were used for external views of M's office. Oh, and yes the armoured train sequences were filmed on the Nene Valley Railway.

Meanwhile, Pierce filmed the tank chase sequence at Leavesden Studios and pulled me to one side, asking if I'd go back to his dressing room with him. 'And bring your camera,' he suggested. He wanted to show me a painting, a self-portrait, of him with earplugs in (dodging the bangs on set) and it was one of his first efforts at being an artist, which he said relaxed him between takes when sets were being prepared with lights, cameras, effects and so on. He's since gone on to receive huge acclaim for his many paintings and I'm really quite chuffed to think I was there at the start of his second career.

Incidentally, 17 May was Pierce's birthday and he invited Hilary and I to his rental house in Hampstead, north London. It was a beautiful place with the garden dressed in fairy lights and looking just like a film set. I guess there were about forty of us there when Pierce introduced an Irish band. After a while, people (neighbours?) started popping in to say hello and 'happy birthday'. Suddenly one chap I knew I recognised arrived, walked over to the band, and asked, 'Do you know Brown Eyed Girl?' No one seemed fazed as I guess they were all just as famous as him, but my mouth dropped open as this great singer performed a few feet in front of me and the penny dropped – it was Van Morrison. It was a 'pinch me' moment and even now, after fifty-odd years in the business, I still honestly cannot believe my luck. I mean, not only was I at Pierce Brosnan's birthday party with all these famous faces, but Van Morrison too! Wow.

Though perhaps topping everything was when Hilary, our daughter Tansey and I were invited to attend the film's premiere *and* walk up the red carpet outside the Odeon Leicester Square. I considered it a huge honour, in fact.

Pierce the painter in his dressing room.

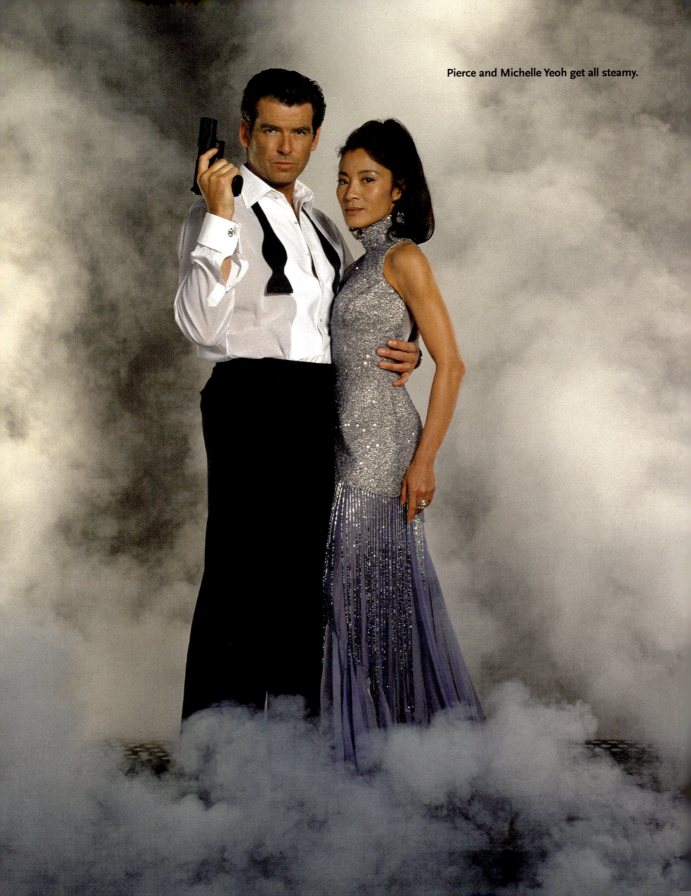

Pierce and Michelle Yeoh get all steamy.

Afterwards there was a party at the Imperial War Museum, and we were all transported to this truly magical venue that the production art department had quite literally transformed. Pierce came over to me looking hugely relaxed and happy, beaming with the biggest smile imaginable. He obviously felt proud, relieved and excited in equal measure.

However, as is often the case with big parties, the number of people attending slightly outweighed the number of tables and chairs, so Hilary and I grabbed some food, found a corner of the room that seemed a little quieter and sat on the floor like a couple of excited schoolchildren tucking into a feast. Just then I looked to my right and saw another lady sitting on the floor doing similar – it was Tina Turner, the singer of the title song. I was quite dumbstruck (again) and still have to pinch myself now just thinking about it.

There had been a lot riding on *GoldenEye*, including whether James Bond was still relevant. As Judi Dench, the new M, said, 'I think you're a sexist, misogynist dinosaur. A relic of the Cold War, whose boyish charms [are] wasted on me ...' That was a concern many shared actually, but they needn't have worried as the film grossed $350 million on a budget of $60 million and proved a huge success and a total joy for me to be involved with.

Sadly, Cubby passed away a few months after the release of *GoldenEye*. He always spoke of us as his family, and it *was* a huge loss to us all. He did at least get to see the series was in safe hands going forward, and such was the good feeling at MGM about this film, they green-lit a second outing for Pierce right away.

Tomorrow Never Dies was that next film and, with the popularity of rolling TV news channels and their increasing influence, it seemed a promising idea to base the story around a fictitious villain and media magnate, Elliot Carver, owner of the newspaper *Tomorrow*. The planned title for the film was to be *Tomorrow Never Lies*

My mate Pierce.

but a fax to MGM contained a typing error and it became *Tomorrow Never Dies* – a title MGM loved, so stuck with it. The pressure was on to prove *GoldenEye* wasn't a fluke and that 007 was back to stay.

Roger Spottiswoode joined as director and, as MGM had already set a release date of November 1997, he had to start work immediately on a new script as the initial draft was set around the handover of Hong Kong in June 1997, which it was felt could date the film. News that Pinewood was fully booked again caused a few headaches and, worse still, Leavesden was now a

Pierce looking dapper.

fully functioning film studio with George Lucas firmly booked in to shoot *Stars Wars: Episode I*, meaning the filmmakers had to find another new home. They eventually settled on a 12-acre former supermarket in St Albans (Frogmore) and converted it into Eon Studios, although we did use the 007 stage at Pinewood.

Pierce was totally settled into the role by now, having made it his own, and I again got on well him and all the new cast. Mind you, I've always been conscious that I am dispensable, and there are plenty of other photographers out there, so I try to get on with everyone, though Roger Spottiswoode was a bit 'Marmite' – you either liked him or you didn't. He was a quiet man and you had to get to know him really, as otherwise you might not quite appreciate his more subtle approach, unlike Martin Campbell who was quite the opposite type of character. That difference actually led to the script supervisor, a veteran of many Bond films, falling out with Roger early on and leaving the picture, which I think upset a number of the crew and tainted their view of Roger – quite unfairly actually.

You see, I saw him in another light fairly early in the shoot where our female lead Michelle Yeoh was filming a sequence in a fairly small set, and I was photographing. But as the film camera panned across the set I was sure it caught the end of my lens in the very corner of its frame – I literally had my back against the wall with nowhere to go. Even so, that's a big no-no in my job; rule number one is that you never get seen in shot. I asked the camera operator, and he confirmed that I may have *just* crept into the corner of the frame at the very end of the scene. I went over to Roger to apologise profusely and explain he might need to 'go again' on the sequence, while realising he would have been quite within his rights to tear me off a strip and even fire me for costing the production tens of thousands of pounds. However, he very calmly said, 'Oh, OK,

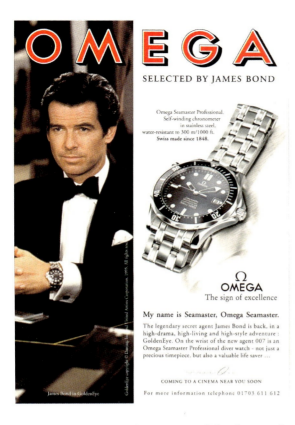

we'll go again.' I was forever grateful to him and respected him immensely from that point on.

We were filming on location in Phuket and had a sequence scheduled to shoot in and around Phang Nga Bay where James Bond Island, as featured in *The Man with the Golden Gun*, is located.

Pierce was really excited about heading there, and the crew were all psyched up for it, as we were retreading a bit of Bond history really. Us crew members arrived by boat at the location early in the morning, when we saw the most beautiful Sunseeker launch coming around the headland with James Bond music playing, and there was Pierce at the helm smiling broadly.

All the crew were on chug-chug boats that took about forty-five minutes to reach the island from Phuket and that was to be our way back at the end of the day, too. It had been a long and sweltering day, and as Pierce departed on his luxury boat we queued up on the jetty awaiting our flotilla of chug-chugs to board on a first-come, first-served basis. Just then, a rubber dinghy pulled in with stunt man Dickey Beer aboard. He came right up to me and signalled that I should hop in.

'Pierce is waiting for you, jump aboard,' he said.

I felt hugely embarrassed in front of everyone and, of course, had all my camera gear with me, so I shrugged apologetically. But he gestured again for me to hop in. Geoff Freeman said, 'Keith, go! I'll look after your gear. Go!'

OK, I thought, why not? I hopped aboard and we zoomed to meet Pierce, who pulled me aboard his Sunseeker to have a beer and listen to music as we enjoyed the end of the day, heading back to our hotel. It was really idyllic ... until all of a sudden the boat juddered.

'Bit of a sandbank,' said the skipper. But then we hit another sandbank and this time got well and truly stuck. How embarrassing for James Bond, I thought. If only I had my camera, eh?

We calmly radioed ahead for assistance when just then a little chug-chug boat came towards us with Geoff Freeman and all my camera equipment.

He was laughing his head off. 'Want a lift?' he asked with a big daft grin on his face.

Meanwhile, back at Frogmore I had a lovely stills studio and thought back to *GoldenEye* and the flame background I used, wondering about doing something similar – yet different – with steam. I tentatively approached Chris Corbould with a smile, and he asked, 'Now what?'

'Any chance of a boiler outside my studio?' I asked. 'I want to envelope the artists in steam.' Despite a raised eyebrow or two, the very next day a boiler was positioned, pumping steam up through grilles on the floor, giving me a great background for the shoot with Pierce, Michelle and the BMW motorbike from the movie. However, I got a bollocking from the costume department as I hadn't realised that the steam

had an adverse effect on their outfits! Well, you live and learn …

Filming had actually commenced in January 1997 for the pre-titles sequence in the French Pyrenees, helmed by second unit director Vic Armstrong, but with script and scheduling changes, the main unit photography started later than initially planned, on 1 April 1997. I was slightly worried that I'd committed to start *Star Wars* in the June, having fully expected to wrap on Bond before then, but Gordon Arnell was very understanding and allowed me to leave the picture a little early to honour my contract with George Lucas.

Tomorrow Never Dies wrapped in September, just a couple of months before it was due to premiere, and it was said to be quite a tense period – then again when the release date is set before the script is even finished it doesn't exactly make for a relaxed shoot.

Its box office success meant MGM were keen to move into their third 007 film with Pierce – he'd been contracted for three with an option on a fourth. Michael Apted was brought on board to direct and proved to be a terrific choice and a really nice guy, too. He would always listen to the crew and ask for their opinion, not that he was insecure, but he had a brilliant way of getting everyone right behind him and thus had their full confidence and respect from the outset. I certainly got on well with him, so much so he asked me to visit him at Elstree Studios when he was setting up *Enigma* a couple of years later to invite me to join the production, but alas they didn't have exact start dates and I had another film on the horizon that then confirmed, meaning I couldn't work with Michael. T'was ever thus …

The World is Not Enough, meanwhile, was booked into Pinewood early on and marked the full return of Bond to his spiritual home. Despite me having left the last Bond film early to fulfil my obligations to George Lucas, I was delighted to receive a call checking my availability.

I was at the studio when they were screen testing for the leading lady and had worked with one of the candidates, Sophie Marceau, a year or two before on *Firelight* and *Anna Karenina* with my publicist friend Geoff Freeman, who was also back with me for this Bond. We both agreed she was an absolute joy so kept whispering to Barbara Broccoli, 'Sophie. Go with Sophie.' Not that Barbara would be influenced by us, but we were really thrilled when Sophie was cast as Elektra King.

There were some particularly impressive sets on this film, including the huge 'Caviar Factory' on the extended paddock tank at Pinewood. Walkways and ramps were constructed along its full length, to accommodate the huge plant, which was then completely surrounded by giant black backing for night shooting – and lots of action with helicopters, buzz saws and a BMW Z8.

I'd always been interested in virtual reality and had done a little bit of work in this field on *The Mummy* with 'virtual tours' by photographing the sets extensively from every conceivable angle and putting it all together in a QuickTime movie format. When you clicked to move from one area to another the clips ran, submerging you in the set and allowing you to move left, right, up and down within them. Each clip consisted of thirty-six pictures, painstakingly stitched together with software I helped develop. It was early days for this type of technology, and I also used it on the Caviar Factory to be able to let the Hollywood executives tour the set from their offices in LA. Of course, nowadays anyone with an iPhone could do that, but back then it was quite pioneering.

The pre-title sequence showed off much of London along the River Thames, though the powerful speedboats racing past the Houses of Parliament caused some MPs to complain. Thankfully the Home Secretary made a statement saying that, after all James Bond had done for the world, the least they could do was put up with a bit of noise for a few days.

Pierce Brosnan as 007 makes his escape from the 'Swiss bankers' in *The World is Not Enough*.

I thought the film had a strong storyline and particularly strong female characters. It performed very well at the box office and so the pressure was on to top it for the upcoming fortieth anniversary year in 2002.

Pierce had honoured his initial contract of three films and said he'd like to make a fourth. *Die Another Day* was the twentieth Bond film in the special anniversary year and so the writers weaved in some nods to earlier adventures. We fully expected Michael Apted to return but new management at MGM had grander ideas that never quite worked out, and he went on to another movie, thus being unavailable when they invited him back. In the event New Zealander director Lee Tamahori was signed to the helm. He brought a keen sense of humour along with lots of enthusiasm and excitement.

On 11 January 2002 there was a press launch on D-stage at Pinewood, featuring the vehicle stars – an Aston Martin Vanquish and Jaguar XKR – along with the main cast to be introduced to the world's media: Halle Berry, Rosamund Pike, Toby Stephens and Rick Yune,

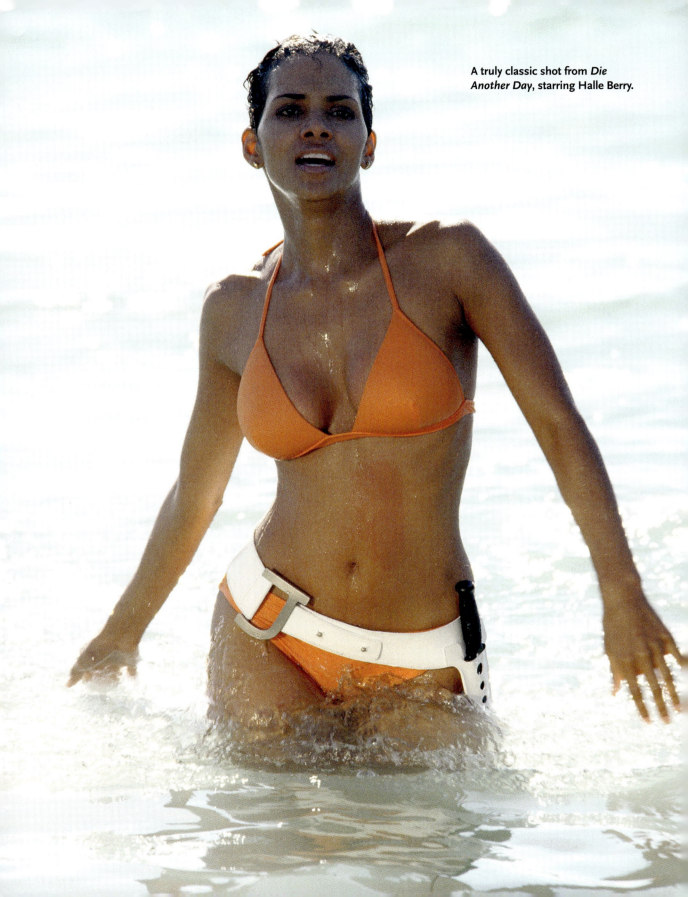

A truly classic shot from *Die Another Day*, starring Halle Berry.

Geoff Freeman with Halle Berry.

ahead of principal photography beginning later that same day. Pierce suggested he'd be open to making a fifth film, although I don't think he was quite as enchanted with this film in the end as he had been with his earlier ones – in particular the CGI para-surfing stunt, which, to be fair, pretty much everyone has seized on as looking poor.

A month or so after we'd started shooting Halle Berry had to dash off to LA for the Oscars as she had been nominated for her film *Monster's Ball*. Happily, she won the Academy Award and returned triumphant to the studio, where we threw a little party for her. Actually *Die Another Day* was shot largely at Pinewood, apart from a few days in Spain (doubling for Cuba) and Iceland for the car chase sequences. The ice palace was recreated on the Pinewood backlot and 007 stage, which so impressed Lee when he saw it for the first time he asked production designer Peter Lamont if he could adapt it to house a full-sized car chase – a few weeks later they were shooting it.

The royal premiere was a lavish affair at the Royal Albert Hall, dressed as an ice palace, ahead of the worldwide release. The film performed very well at the box office too and I am proud of the publicity campaign we put together. It turned out to be Pierce's last film, which saddened me as I felt he was ageing into the part beautifully. Sadly, my dear publicist friend Geoff Freeman fell extremely ill not long after *Die Another Day*, and passed away just a few months later, leading to a restructuring of the publicity team at the same time as a rebooting of 007 himself with *Casino Royale*. It may have marked the end of my time with 007, but over twenty-five years I'd had the most amazing experiences and made some lifelong friends, so I can only ever be grateful.

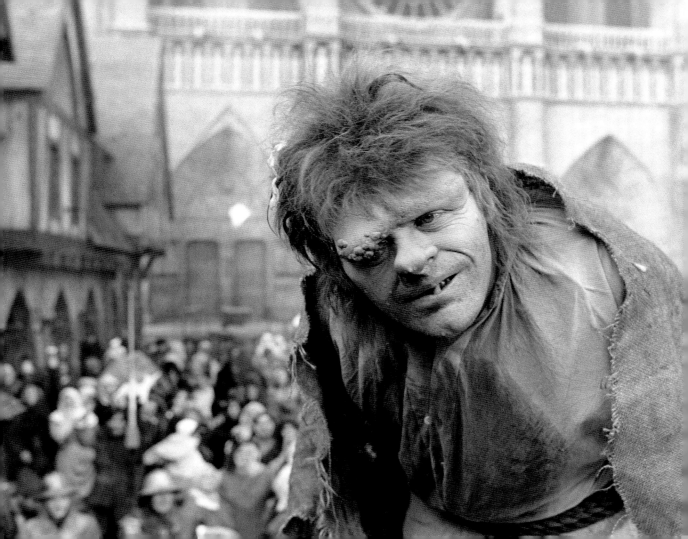

Scene 14

ENTER LUCASFILM

With the UK film industry and its studios being in one of its slump periods, I turned my lens to television. I joined the seven-part $40 million production *Winds of War* during the show's UK shoot. Based on the early years of the Second World War, it was perhaps most significant for reuniting me with Robert Mitchum, which was a delight, and especially without having Michael Winner around! Then came a Hallmark TV movie from producer Norman Rosemont, *The Hunchback of Notre Dame*, starring Anthony Hopkins as Quasimodo. Hopkins's prosthetics and make-up took five hours to apply, and he was required to report to the set at 3 a.m. Mostly filmed at Pinewood, with some location work in Paris, it was the first of a few TV films I worked on for Norman, including *Master of the Game* starring Dyan Cannon, who I don't think got on terribly well with Norman. One day he went into her trailer to sort something out and, after voices were raised, he re-emerged with spaghetti hanging all over his head.

A few years later Norman popped by my office – I think I was working on a Bond at the time – and asked if I'd like to go for a bite to eat. We duly took our seats in the Pinewood restaurant, and I ordered sausage and mash, or whatever the dish of the day was, from Joyce the waitress, whilst Norman asked if he could just have a ham and cheese sandwich as he'd had a breakfast meeting where all manner of food had been laid on. A minute or so later Joyce returned from the kitchen and said the chef refused to serve a sandwich in the restaurant. Talk about a snooty chef! Norman was quite upset and said, 'Come on, Keith, we'll go to the pub.'

A short time later he moved out of his offices at Pinewood in response to 'sandwichgate' and refused to ever return.

Roll forward to 1991 and Norman was producer on a film called *Ironclads*, which centred around a naval battle in the Civil War, and it necessitated a week or so filming on the Pinewood paddock tank. Always keen to be a peacemaker, I contacted a friend of mine at the trade newspaper *Screen International* and asked them to run a little story saying, 'Welcome back to Pinewood, Norman Rosemont.'

Pinewood was enduring a dry spell of movies and desperately needed the business, so I thought with a little goodwill Norman might consider returning with some of his projects. Alas not. The magic and romance between him

Anthony Hopkins in *The Hunchback of Notre Dame* on the Pinewood backlot.

Norman Rosemont and special effects Martin Gutteridge on Pinewood's tank for *Ironclads*, but 'Sandwichgate' lingered in memories.

and the studio had seemingly gone as stale as that sandwich.

Back to movies, and the sci-fi epic *Krull* came along with my old friend Peter Yates directing.

A great crew was assembled including first assistant Derek Cracknell, cameraman Peter Suschitzky and production designer Stephen Grimes. Yates said he felt 'intrigued' by the script, and I was excited by the prospect of joining Peter again on what was to be a very visual project with such talented cast and crew. It centred around a prince and his companions setting out to rescue his bride from a fortress of alien invaders and had hints of *Dungeons and Dragons*.

However, that intriguing script then went through multiple more drafts before we started shooting and had transformed from a medieval-style story into a pure fantasy. Only a few locations in Italy and England were used briefly as the majority of the film was shot across ten stages at Pinewood, but because of the continual rewrites and subsequent set rebuilds the budget escalated massively.

Peter wanted to devise new futuristic weapons that he felt would give many of the fight scenes a swashbuckling feel, and choreographed it all very precisely in rehearsals. However, when shooting was about to crank up, costumes for the Slayers literally just arrived at the studio and it was panic stations. The costumes were so large and heavy that they limited the actors' movement so much that the majority of the exciting and complicated fight choreography had to be abandoned and totally modified into something much less exciting.

Lysette Anthony and Ken Marshall with an optical effect for *Krull*.

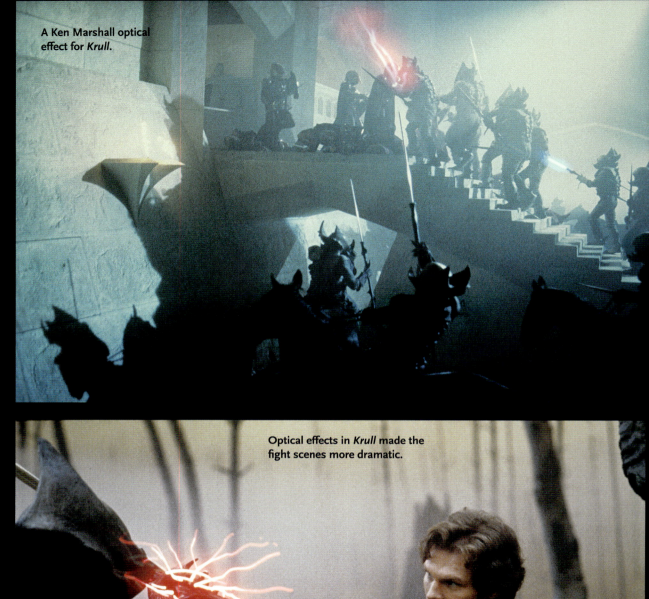

A Ken Marshall optical effect for *Krull*.

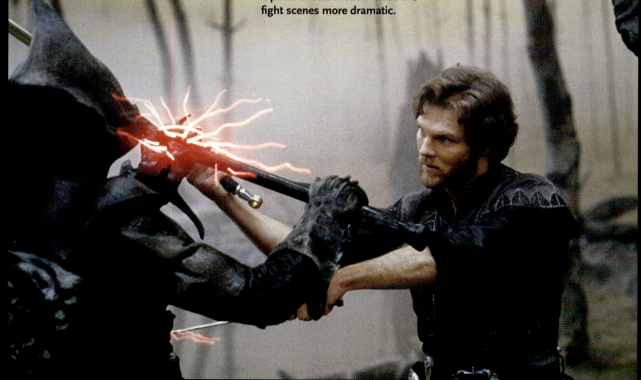

Optical effects in *Krull* made the fight scenes more dramatic.

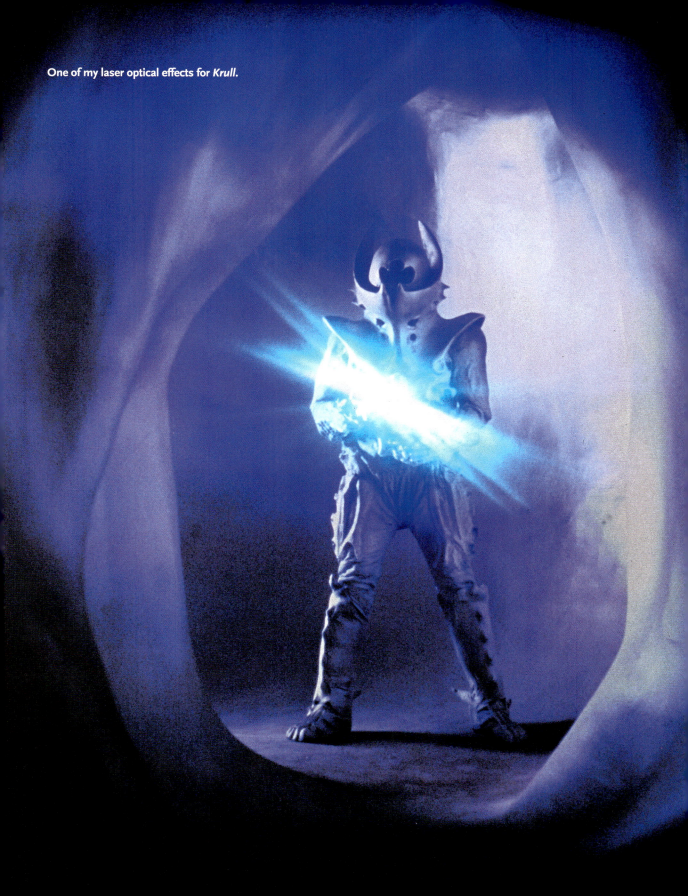

One of my laser optical effects for *Krull*.

The large 'swamp set' was constructed on the cavernous 007 stage, and as we were shooting during one of the coldest winters in memory the water was literally freezing and naturally the actors complained of feeling so cold and so exhausted that days had to be cut short. On top of that the special effects department created a quicksand mire (consisting of 4 tons of painted cork) that many of the technicians found themselves up to their necks in, while Peter had to balance on a raft. His camera operator donned a wetsuit to immerse himself in one the larger pools adjacent to get the particular shots Peter wanted. It wasn't easy.

We had some lovely actors including Ken Marshall, in one of his earliest leading roles (and one he hoped might be a career booster), Alun Armstrong, Freddie Jones, and in early roles for them, Lysette Anthony, Liam Neeson and Robbie Coltrane.

Sadly, Lysette discovered she'd be dubbed in post-production – by Lindsay Crouse – as Frank Price, the president of Columbia Pictures, felt an unknown American actress would help stateside ticket sales better than an unknown English actress! Robbie Coltrane was also dubbed because of his thick Scottish accent, by English actor Michael Elphick.

Among the many sets I was fascinated to see Vic Armstrong training Clydesdale horses to walk and gallop on rolling roads – like huge treadmills – with back projection giving the impression our heroes were racing across the sweeping countryside.

As a promotional gimmick for the film, the publicity department – in their infinite wisdom – launched a competition in the USA for people to get married dressed in costumes from the movie. A dozen lucky winners were married in a 'one-day only ceremony' in 1983, though since no additional press coverage for the film was generated they didn't repeat the idea in other countries.

Sadly, I think it's fair to say we probably had more fun making the film than people did watching it.

However, better things were around the corner – for me at least – when I was invited to join director Steven Spielberg on *Indiana Jones and the Temple of Doom*, which was positioned as a prequel to the hugely successful *Raiders of the Lost Ark* a few years earlier, primarily so the Nazis weren't the main villains again. Made by Lucasfilm, it was a totally joyous time with terrific crews and actors, many of whom were drawn from the UK as production was based at EMI Elstree Studios, following producer George Lucas's happy time there making *Star Wars*.

Initially, plans to shoot location work in China were mooted and were to involve a chase across the Great Wall, but the Chinese authorities were really not keen to have a Western production company shooting in their country. So plans switched to India, that is until the government there demanded script approval and insisted on having 'final cut' of the picture, which was something Spielberg wouldn't have ever relinquished to anyone, let alone a government. That's when production designer Elliot Scott suggested Sri Lanka would make a good stand-in and what they couldn't find there he would build on the stages at Elstree. That's exactly what they did, with Douglas Slocombe's skilful lighting making it a real challenge for anyone to spot the difference between studio and location.

Sri Lanka was really, really hot, with temperatures regularly well over 100 degrees Farenheit. It was so punishingly hot one day, with truly little natural shade, that when Spielberg came across a stone hut near where we were shooting, he took a break and called George and co-stars Kate Capshaw and Harrison Ford to join him – as I captured in a lovely fun photograph.

I think this was one of the first times I'd seen the Steadicam used on a movie. Its inventor, Garrett Brown, came out to help shoot a few sequences, including the action on an old rickety wooden bridge that spanned a gorge. When the bridge collapsed and the bad guys fell to their death they were actually all dummies,

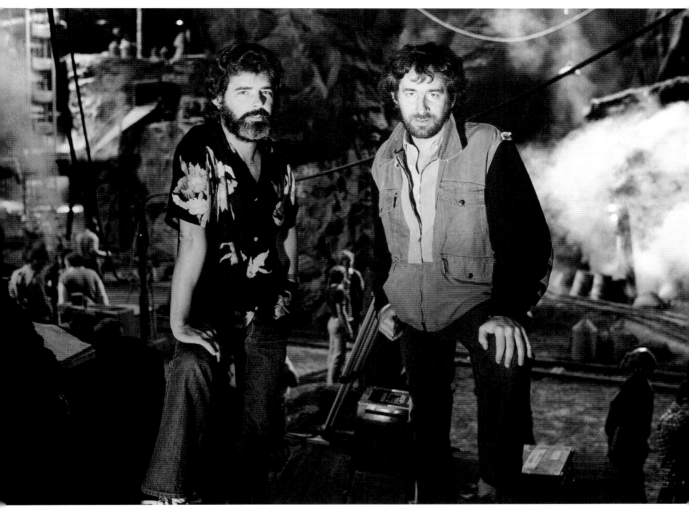

George Lucas and Steven Spielberg reunite on *Indiana Jones and the Temple of Doom*.

designed by George Gibbs, with mechanical arms and legs that moved about and looked very realistic. In fact, so talented was George in his work on this film that he went on to win the Oscar for visual effects.

Harrison Ford did a lot of his own stunts throughout, just as he did in the first adventure, but he suffered a spinal disc herniation during the scene with an assassin in Jones's bedroom when he performed a somersault – and could barely stand up afterwards. But being the trooper he is, and despite being in agonising pain, he turned up every day to continue shooting. Without any real improvement several days later, and with other stunts and action work coming up in the schedule, the producers flew him to Centinela Hospital in California for treatment whilst his stunt double Vic Armstrong took over, spending five weeks as a stand-in for all the sequences they could shoot without Harrison in close-up, and I'd challenge anyone to notice that it wasn't our star.

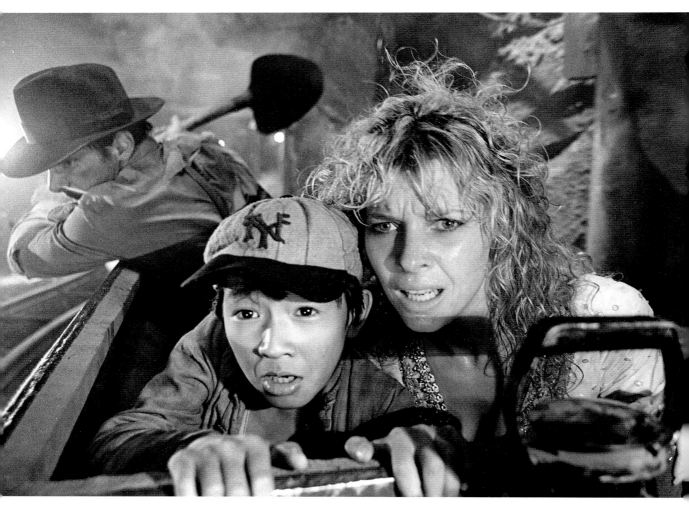

Harrison Ford, Ke Huy Quan and Kate Capshaw in the studio or on location, you guess.

Harrison had approval over stills used, and asked me, 'How should we handle this?' He was conscious the publicity department and studio were keen to get his approval as soon as possible, so I suggested he came over to my office after shooting one afternoon where I'd set up a projector and we could run through all the shots from the previous week that had arrived back from the lab. He did just that, and over a convivial glass of wine we sat down together chatting and he'd say 'great' or the occasional 'hmm' as we went through everything. It was a really jolly hour or so, and we did this a few times throughout the production – we called it 'work', but what very pleasurable work it was!

Steven Spielberg is an incredible director to watch at work, and particularly in his preparation. George Lucas (the executive producer and originator of the character and story) was on set often and very obviously had a great relationship with Spielberg. I loved witnessing them batting ideas back and forth on how to best approach certain sequences, such as the mine cart scenes, for example, in the exciting underground chase;

168 LIFE THROUGH AN APERTURE

Kate Capshaw, Steven Spielberg, George Lucas and Harrison Ford enjoying the shade in the 100-degree heat.

it was a circular mine car track running around the perimeter of the stage with a circular camera track inside. By filming from certain angles, which the duo worked out, it looked like they were on a very long and very straight track. Their collective enthusiasm for making movies was really infectious and made for such a happy and exciting set.

I soon realised that once Spielberg felt happy about a sequence, he'd want to get on and shoot it straight away. Whilst some might say he could be impatient, I'd actually say once the muse was with him, that's all he wanted to focus on, and right away. I was therefore reluctant to interrupt his flow and call for a still, but there were one or two occasions I felt it quite imperative I do just that – one being in Sri Lanka when our heroes emerge from the mine having rescued the children, and the villagers gather at the exit to the mine all cheering and waving with joy as our guys walk through. I approached the assistant director David Tomblin and explained how important a shot I felt it was to capture, and how I could not get into a suitable position.

Filming on the rickety old bridge set on the lot at Elstree.

Harrison Ford on that rickety bridge.

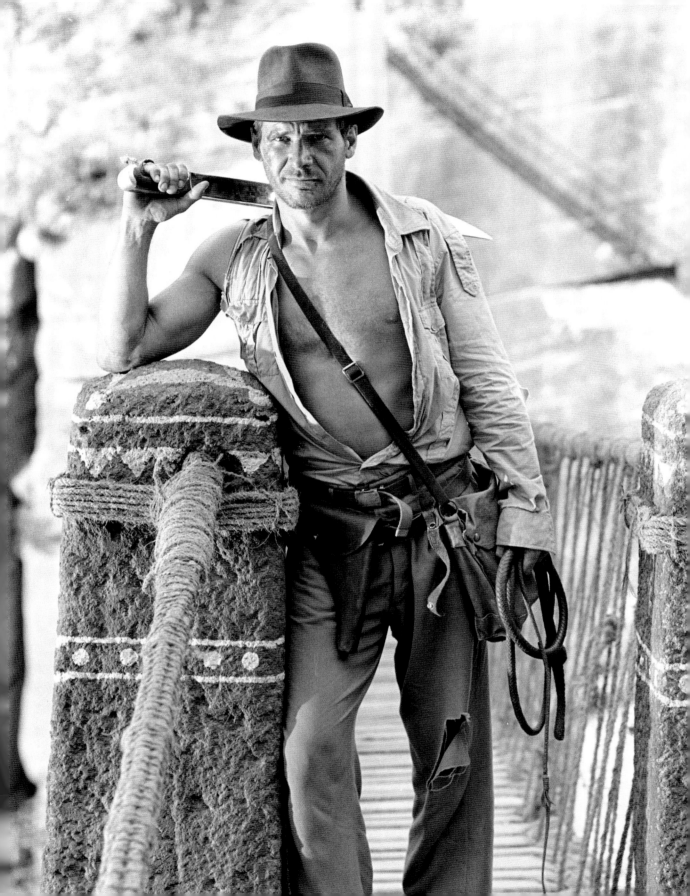

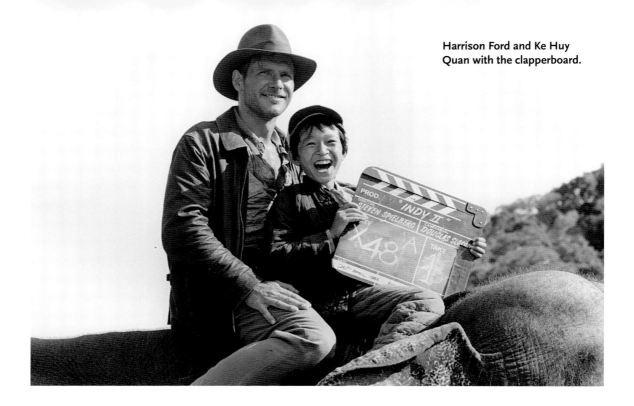

Harrison Ford and Ke Huy Quan with the clapperboard.

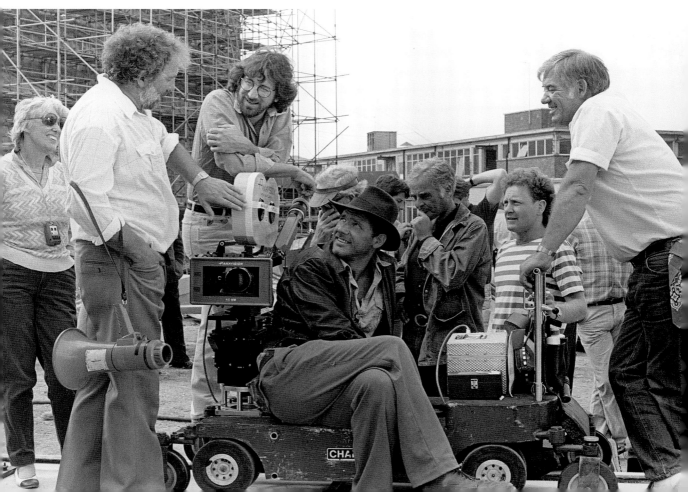

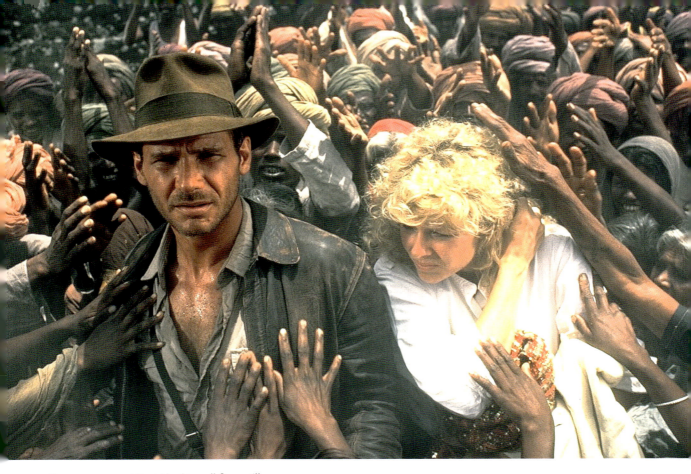

One rare moment that I had to call for a still.

While Spielberg was keen to move on after calling 'cut', David had a quick word and right away Spielberg agreed and called the artists back to their positions. Two minutes later I had my shot, and it was used everywhere in publicity. It proves you must pick your moment but also to stand up and shout if you feel it important.

Without wanting to blow my own trumpet, when my stills arrived back from the lab, they all went over to Spielberg's office for him to review, and I got a big thumbs up and smiles from him; in fact, when shooting wrapped I received a telegram from Sid Ganis, Lucasfilm's publicity director, saying 'Bravo. Bravo'. Mr Spielberg asked me to work on his company's next film,

Young Sherlock Holmes, but I had already committed to an American spy comedy film directed by John Landis and, of course, having said 'sorry I'm not available' to Spielberg, I was never at the top of his list for future projects. That goes to underline what I said about the Bond films and how delighted (and somewhat surprised) I was to be asked back again after being unavailable for *Moonraker*. It rarely ever happens after you turn someone down in this business, much like when someone asks you out on a date.

As I was working abroad more, I thought it might be an idea to get myself an agent. Maureen Moore at London Management took me on, helped negotiate my contracts and fielded

Steven Spielberg and Harrison Ford by the camera on the Elstree backlot.

enquiries. Crucially, she ensured I was paid on time, too.

Next came *King David*, or as I like to describe it, 'kin David'; Richard Gere dancing in a loincloth in the streets of Jerusalem. Australian Bruce Beresford directed this biblical epic about the second King of the Kingdom of Israel, as recounted in the Hebrew Bible. Apparently it came about when Michael Eisner of Paramount Pictures became attracted to the story because of its parallels to *Star Wars* – David being the 'Luke Skywalker' of the movie and Samuel (played by Dennis Quilley) the 'Obi-Wan Kenobi'. You do have to chuckle, don't you?

Bruce wanted an unknown American actor in the lead, but producer Martin Elfand chose Gere for box office appeal, as they'd just collaborated very successfully on *An Officer and a Gentleman*. I think it led to a little friction between the star and the director as Bruce knew he had to go along with his casting and Richard knew he wasn't the director's choice.

Bruce had a Bible expert on set every day, telling him how situations would have played out, though I'm not sure how qualified he was as I'd often hear Bruce disagreeing and raising his voice, 'No it's you who are wrong, it's in the Bible, it's in the Bible!' as he wiggled a copy under his advisor's nose.

It wasn't an easy shoot as we travelled to several quite remote locations in Italy and Sardinia where accommodation was pretty dismal, and endured some terrible weather along the way, leading to the 'extras' going on strike for more pay. When you've got 2,000 supporting artists, and suddenly it starts snowing, there's nothing you can do apart from return another day. This meant everyone wanted another day's pay, which the producer was not keen to agree to.

Inevitably, the film with its unfathomable script ended up as a multi-million dollar turkey with some terrible reviews. It cost $22 million to make and pretty much lost the lot. It spelled the end of the biblical epic – for a while at least.

Sid Ganis's telex.

The aforementioned John Landis film *Spies Like Us*, which arrived at Pinewood ahead of locations in Norway and the Sahara, was initially pitched as a homage to the famous Bob Hope and Bing Crosby *Road to …* film series, about two inept intelligence agents sent to the Soviet Union, starring Dan Ackroyd and Chevy Chase. There was a bit of 'whispering' going on about the director as a couple of years earlier actor Vic Morrow and two child extras died during a helicopter accident on an episode of *The Twilight Zone* that he was helming. Although Landis was acquitted of the involuntary manslaughter charges brought against him, Steven Spielberg publicly ended his friendship with him. Of course, when Spielberg heard I couldn't work on his Sherlock Holmes movie because I was going on to a picture with Landis, you can imagine how my copy book had been blotted in his eyes.

That's me! Holding up the battle on the set of *King David* in 1984.

Personally, I didn't get on with Landis very well. He was a bit of a shouter, quite demanding, very impatient and reminded me a lot of Otto Preminger. I'd like to think I did a good job in producing the visuals, but it wasn't an experience I was keen to repeat, nor it would seem were the viewing public on its release.

Half Moon Street starred Michael Caine and Sigourney Weaver. It was billed as an erotic thriller about an American academic working at an escort service in London who becomes involved in the political intrigues of one of her clients. Michael Caine had been around pretty much my whole career, and my only advice going in was 'don't chew gum around him' as he found it very distracting when filming. If you were standing behind the camera chewing it looked like you were talking, and that's very off-putting, I agree.

One day we were shooting a simple 'walking shot' with Michael and Sigourney against a large brick wall (which had been built at the studio), and I was there to take a few photographs when I eventually spotted my home telephone number graffitied on the wall with 'If you want a good time call ...' scrawled above it. I turned to see assistant directors Lee Cleary and Michael Zimbrich both sniggering in the background, obviously having taken bets on how long it'd be before I twigged! That was the sort of fun we used to have, and which sadly seems to be missing from filmmaking nowadays. By the way, I never did get any calls ...

ENTER LUCASFILM **175**

Lucasfilm next shot *Willow* in Snowdonia, North Wales, and Elstree Studios with a spot of location in the South Island of New Zealand. All these years later it spawned a TV series, too.

Directed by Ron Howard, the film was executive produced by George Lucas and based on a story he'd devised. It starred Val Kilmer, Joanne Whalley, Warwick Davis and Jean Marsh, with Warwick Davis portraying the title character – an aspiring magician who teams up with a warrior to protect a baby from an evil queen. It's all good vs bad fantasy stuff. Lucas was around the set a lot and, a bit like with Steven Spielberg, his friendship with Ron Howard went back many years and they were great collaborators to watch at work.

Val Kilmer was not generally regarded as an easy person to work with, and the rumours of on-set bust-ups were legendary, but I actually got on well with him. We shared a mutual interest in computers as he'd just acquired one and I was a few months ahead of him so was able to help him set his up and show him how to use it. He and Joanne met on this film, fell in love and became engaged. It was very much love at first sight.

Unexpectedly, Val asked if I'd be willing to fly to Santa Fe and take the wedding photos. 'Well, yes,' I said, 'that'd be nice but it's a heck of a long way to fly for a couple of days.'

'Come for a week,' Val added, 'I'll sort your flight, hotel, a car and anything else needed.'

So I did, and had a fun time over there. The young couple seemed so excited, which made it all the more disheartening when eight years later, with two children together, they split up.

Then, in a move from movies into television, came *The Young Indiana Jones Chronicles* series from Lucasfilm. It was set around the backstory of the intrepid hero and starred both Sean Patrick Flanery and Corey Carrier (as Indy at different ages), with George Hall playing a 93-year-old Indy 'bookending' most episodes.

George Lucas wrote a timeline for the character and assembled about seventy outlines,

Spies Like Us **camera crew and me on the camera car.**

starting in 1905, and leading all the way up to the theatrical movies. Each story was conceived as being educational for children and teenagers, centring on historical figures and notable events – cue lots of guest stars, and locations worldwide. Catherine Zeta-Jones, Daniel Craig, Christopher Lee, Clark Gregg, Vanessa Redgrave, Elizabeth Hurley, Timothy Spall, Jeffrey Wright and Max von Sydow all popped up among many others, and characters included Ernest Hemingway, T.E. Lawrence, Charles de Gaulle, Leo Tolstoy, Woodrow Wilson, W.B. Yeats and so on.

The series actually shot twenty-eight episodes and four TV films, with many directors, ranging

Director John Landis, camera operator John Palmer and actor Dan Akroyd on the set of *Spies Like Us*.

from Nic Roeg to Carrie Fisher, Vic Armstrong to Terry Jones, naming but a few; the initial twenty-eight were designed to be broadcast as one-hour episodes or joined to make two-hour TV movies.

I was asked whether I'd cover the series – and, of course, I knew the Lucasfilm team well by now – but rather than be on set every day of every episode, it was agreed I'd drop in for a few days here and there, which not only assisted with their budget but meant I could take on other projects and have Indy ticking away in the background. For one episode I'd just arrived in Ventura, California, and took a bath at my hotel when the next thing I knew I'd been thrown into the air and on to the bathroom floor – it was a major earthquake! That was quite a memorable trip.

It proved an expensive series to produce and I don't think the fans of the films revelled in seeing their hero as a 93-year-old with a walking stick, and ultimately it was cancelled.

I thought it a great shame as they were terrific 'boy's own adventure' tales with high production values and I'm sure today one of the streamers would have loved to have had the idea and run with it for longer – maybe it was just ahead of its time?

Val Kilmer and Joanne Whalley in *Willow*.

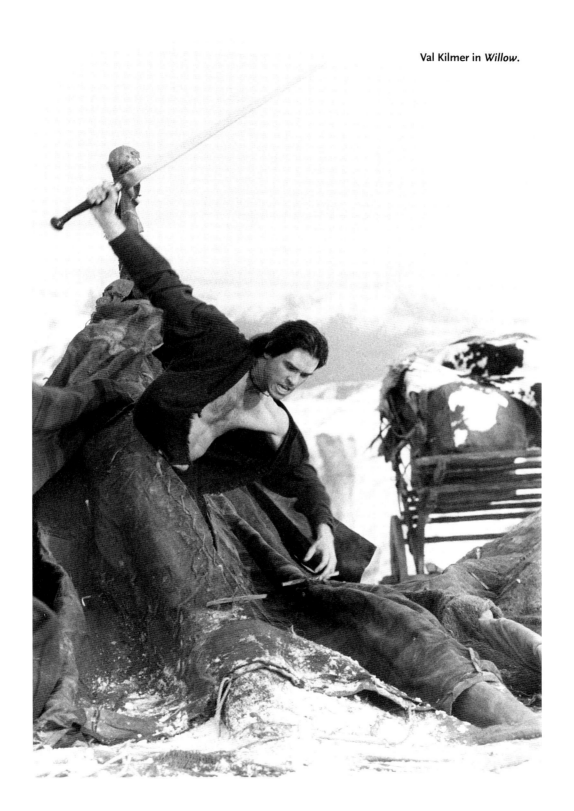

Val Kilmer in *Willow*.

George Lucas and Rick McCallum on the set of *Young Indy*.

George Lucas and me.

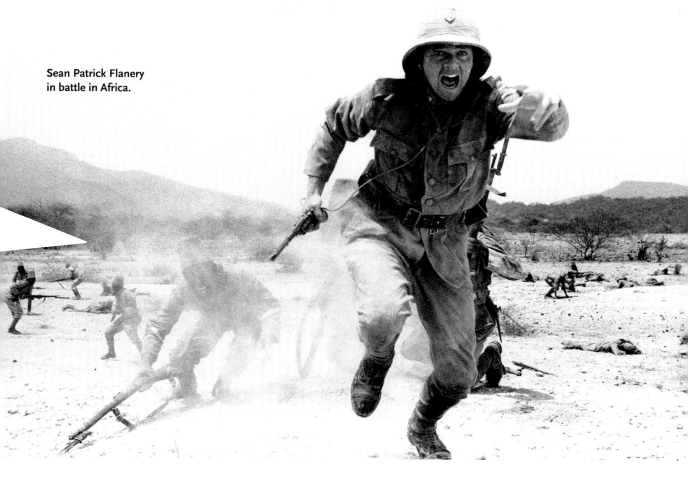

Sean Patrick Flanery in battle in Africa.

George Lucas on the set of *Young Indy*.

Sean Patrick Flanery on the set of *Young Indy*.

Corey playing a Gameboy overlooked by Maasai people off set on *Young Indy*.

Scene 15

NOT EVERYONE'S A WINNER

What can I say about *Ishtar*? How long have you got?

I was a bit taken aback when I received a personal call from someone claiming to be Warren Beatty, asking if I was free to join him on an upcoming production. I thought it was assistant director Lee Cleary having a bit of fun again, but no, the caller was quite insistent it was Warren Beatty himself, in person. He obviously had a great personal interest in the film and high hopes for it.

I'd never worked with Warren so was a bit mystified as to why he had called me personally, that is until I discovered I'd been personally recommended by Stanley Kubrick. I was actually on another film with two more weeks to go and Warren said, 'That's OK, we'll get someone in temporarily until you can join us.' I was quite pleasantly taken aback.

I remember flying to Marrakesh, travelling straight to the set from the airport to meet everyone and receiving big hugs from most of the cast and crew – that is, apart from Warren, who simply said 'hi' and carried on with whatever he was doing, despite having been so keen to have me on the film. Ah well ...

Elaine May was the director. I later learned she had written a couple of scripts for Warren Beatty (including the Oscar-winning *Reds*) and he wanted to find a project that she could write and direct. Furthermore, he reasoned, if he also starred and produced then he'd be able to give her the break he felt she deserved and protect her from any meddling by the studio executives. She in turn was (another one) keen to emulate the *Road to* ... comedies of Bing Crosby and Bob Hope, and suggested setting it in the Middle East.

The two lead characters are a mediocre singer-songwriter duo who are offered a gig in Morocco but then accidentally get caught up between the CIA and a local left-wing guerrilla group in the fictional country of Ishtar. Beatty had persuaded Dustin Hoffman to play the other lead role, and then took it to Columbia Pictures. After a bit of persuasion they agreed to finance the movie and pay the director and stars $12.5 million from a budget of $27.5 million overall. Coca-Cola, which owned Columbia Pictures at the time, had earnings blocked in Morocco and, in order to release some, suggested the production be based in the Sahara

Warren Beatty and Dustin Hoffman head the cast on *Ishtar*.

Warren Beatty and Lee Cleary in the Medina.

Desert for ten weeks before returning to New York. That was fine, but the production cranked up against a backdrop of heightened political tensions in North Africa with Israeli warplanes bombing Palestinian Liberation Organization headquarters in Tunis. Seven days later, the Palestine Liberation Front hijacked a cruise ship, the *Achille Lauro*, murdering an elderly Jewish American. Then there were rumours they might even try to kidnap Dustin Hoffman!

Morocco has since become a favourite place to film, but in the mid-1980s it wasn't used to accommodating a major Hollywood production; there were many frustrations that things never turned up when ordered and conversely that calls for local extras led to thousands of people showing up!

When the film's animal trainer sought out a blue-eyed camel in the Marrakech market and found one he considered perfect, he returned later on to do the financial deal only to find the owner had since eaten the animal.

Meanwhile, Elaine May was extremely uncomfortable in the desert environment and spent much of her time under a large parasol, wearing large sunglasses with a thick Arctic-type of coat in 100°F heat, with her face smeared in cold cream and wrapped in a white gauze veil, to the point that her appearance was compared to the *Star Wars* Sand People.

She was a little eccentric in other ways, too. When the location department searched for sand dunes she specifically requested to shoot a sequence in, they found the perfect spot only for May to suddenly decide she now wanted a flat landscape instead. It took them ten days to level an area of a square mile to suit her new demands.

She became increasingly aloof as the shoot went on, frequently falling out with crew members, and shot an alarmingly huge amount of film on what were fairly straightforward scenes. She was likened by the studio to Stanley Kubrick at one point, although I don't think it was meant as a compliment.

The budget was certainly running away, and a further example of this was when news broke of a virus that had entered the country. May and the two stars demanded that there be *three* Boeing 707 jets permanently on standby at the airport in case they needed to leave for LA quickly to escape it.

Dustin Hoffman argues with some neigh-sayers!

There was another incident in Marrakesh, involving me, I should add. We were in the Medina shooting our two heroes walking across the almost-deserted square when a police car screamed into shot and two policemen got out and grabbed me, bundled me into the back of their smelly, dirty car and sped off. Now I wasn't very keen to end up in a Moroccan jail and so started pleading with the officers that I hadn't done anything, and that I was merely doing my job. Just then I looked outside and there was Lee Cleary laughing and waving. The sod had set me up!

With the end in sight, the climactic battle scenes were all important. But Elaine May felt out of her depth and told Beatty to shoot it. With his producer hat on, Warren realised it would spell disaster if he took over as director now as he'd surely have to then complete the film. So instead he struck a compromise by scaling back the sequence for her to feel confident enough to shoot.

When they shipped back to New York there was a fairly simple scene involving Dustin and Warren walking down a street, turning left and disappearing out of sight. It was a second unit crane shot really but May was there to supervise, and when 'cut' was called (as the duo disappeared around the corner) she started jumping up and down, demanding to know why they'd stopped shooting.

'Well, they've gone around the corner,' was the response of the cameraman.

'Yes,' she reasoned, 'but they *might* come back!'

Oh dear ... had she not read the script?

At this point, Warren told Columbia he no longer had confidence in May but equally he refused to fire her and furthermore stated that, if

Ishtar features on the cover of *Life* magazine – featuring a camel that obviously wasn't eaten by its owner!

the studio fired her, then he and Hoffman would leave the incomplete film!

His solution was that they should further indulge her and shoot every scene twice, his way and then May's way. That, of course, doubled the time and doubled the cost, but no matter, they'd finish the film and he'd have fulfilled his promise to give May a break. However, when I heard the final series of rushes ran for 108 hours I thought, 'Well I suppose there is a good movie in there somewhere.' It was just a case of trying to find it.

Meanwhile, in Hollywood, a new head of Columbia was appointed in the shape of British producer David Puttnam, who had previously been critical of both Hoffman and Beatty and the excesses of Hollywood budgets, and now he had *Ishtar* in post-production haemorrhaging money on his watch, and a star/producer and director fighting over the editing.

Beatty publicly criticised Puttnam for leaking negative stories to the media in response to trade newspapers referring to the film (in the vein of the Hope and Crosby comedies) as *The Road to ... Ruin*. The film missed its Christmas release date because of all the disagreements and was pushed back to the spring, but despite all the bad press to date the studio opted to throw everything at it to try to save face (at least with Warren Beatty). A vastly increased $51 million production budget was added to with $20 million on prints and advertising, but even so it became synonymous with the phrase 'box office flop'.

I was lucky in getting lots of good images, and with the very initial buzz of the project I helped secure some good press, including the cover of *Life* magazine, but then stories of things going wrong seemed to take over.

When I next worked with Dustin Hoffman, some years later, I suggested he might not

remember me from our last film together as it wasn't what he'd probably call a success story.

'Why? Why? Why do you say that?' he asked. 'I bought my house in London on the back of *Ishtar*!' Well, at least someone came out of it with a positive experience.

Bruce Beresford next directed *Crimes of the Heart* and fondly remembered me from *King David*, so personally invited me to join him in America. Although the film wasn't particularly notable or important, it was actually my first US-based feature film and the production company arranged the necessary work permits, though on condition I supplied a few references. Fortunately Harrison Ford, Cubby Broccoli and George Lucas wrote lovely letters recommending me. It certainly opened the door on more US-set adventures later, but before those I was shipped out to China to do some special photography of the locations used in what was to become a great Oscar-winning movie, *The Last Emperor*, directed by Bernardo Bertolucci and independently produced by Britain's own Jeremy Thomas.

Bertolucci was given complete freedom by the authorities to shoot in the Forbidden City, which had never before been opened up for use in a Western film, and that's why I was there. In fact, the first ninety minutes of the film is pretty much just showing off the splendour of the magical location. Yet it wasn't as problematic filming in China as some of the other more liberal countries I've worked in – once the authorities read the script and made a few notes on what they felt could be improved(!), they welcomed us with open arms.

Funnily enough, it wasn't so much my journey into China I remember as my journey out. I had around ten to twelve cases of equipment with me, so arriving at Beijing airport I tried to find a trolley to load it all onto. There wasn't one to be found in departures, so I asked the driver to look after everything while I ambled down to arrivals to grab one. Just as I grabbed a trolley, two police officers stopped me and said I wasn't to take one. OK, fair enough. I walked around a little bit until they disappeared, grabbed one and dashed back to departures to load it when a woman came running towards me shouting, accompanied by two policemen. I tried to explain I had all these cases, but they were adamant I should only have one bag – that was the rule apparently. In my best Mandarin (which is actually English spoken slowly) I explained I had been working on a movie, and once they realised I wasn't carrying suitcases full of contraband they became very helpful and directed me to the British Airways check-in desk. I then realised it was an honours system whereby they trusted you to place your bag onto the X-ray machine, which presumably someone in an office somewhere was monitoring. But I had fifty rolls of film stock in my baggage that I really didn't want subjected to X-rays. One by one the other passengers slipped on their single bags as I stood scratching my head wondering how I could find someone to speak to. Just then I saw a door with a camera above it, so knocked thinking it must house some official or other, and there through a haze of tobacco smoke this man appeared and said, 'What do you want?'

I started explaining I didn't want X-rays possibly damaging the film stock.

'Well don't put it through the X-ray machine then,' he shrugged and went back to his ashtray. So, I didn't – I circumvented security completely.

A Chorus of Disapproval was an Alan Ayckbourn play adapted into a film by Michael Winner, and only really memorable for the great cast – Anthony Hopkins, Jeremy Irons, Prunella Scales, Richard Briers, Sylvia Syms, Patsy Kensit and so on. He'd persuaded Jeremy Irons to take on the part of a lonely widower who moves to Scarborough and joins the local amateur dramatic society, soon rising through their ranks and seducing all the ladies of the group on the way, by declaring, 'If you do this film, I'll make you the biggest comedy star in Britain!'

I think Jeremy is still waiting ...

Crimes of the Heart unit still – my first US feature film.

Of course, I'd worked with Anthony Hopkins several times before, and we usually had breakfast together at the hotel, chatting about everything and anything; Tony really loved kippers and boy did this place do good kippers. Tony was a very accomplished pianist and on one location in a church hall the unit broke for lunch. I returned early to set up some of my equipment when he walked in alone, spotted a piano and started to play. I sat quietly on my camera case and listened for what must have been a good ten minutes.

At the end Tony put the lid down, turned and saw me. 'Oh, hi Keith. Did you enjoy that?

'I loved it,' I replied.

A couple of days later Tony handed me a cassette tape and said it was some music he'd composed and hoped I enjoyed listening to it. Moments like that are quite magical, I think.

We started shooting in Scarborough and the cantankerous Michael Winner was becoming more difficult to work with, and even refused to allow me to see my own stills when they were returned to the location from our lab at EMI Elstree. One day I spotted some contact sheets tucked into the pouch on the side of his director's chair, so pulled them out to take a peek.

A unit still from *A Chorus of Disapproval*.

'What are you doing there?' Winner shouted from across the set.

'I'm just checking my photos,' I responded reasonably.

'Well, I'll be the best judge of those!' he snapped as he came dashing over to snap them out of my hand.

By this point I'd examined them and felt there was something wrong with the bleed-through.

'Good luck if you want to use those …'

'Wait! What's wrong? What's wrong with them?'

I showed him the problem and, of course, rather than admitting he ought to have let me check them and have another set produced, he dashed off to get the laboratory on the phone and created merry hell, in a way only Winner could. I really wish I hadn't said anything as the poor girl on the other end of the phone would have been so very upset at the way he spoke to her, but it could have been so easily sorted had I been allowed to check my work – but oh no, Winner was becoming a total control freak and enjoyed showing it.

Of course, Winner was extremely pleasant to Tony and Jeremy but considered the rest of the cast fair game to pick on. He once berated dear Prunella Scales in front of the entire unit when

NOT EVERYONE'S A WINNER **191**

The tyrannical Michael Winner.

Michael Caine and Roger Moore played dual roles as nuclear scientists and small-time con men in *Bullseye!* It was initially pitched as being an action comedy set on the Orient Express as it travelled through Europe, but budget cuts meant we ended up on a little train in Scotland, so not quite the European train holiday we'd all anticipated. Winner's (then) girlfriend Jenny Seagrove was with us on a wet location somewhere north of the border, filming Highland Games-type sequences for which we needed hundreds of extras. 'Put an advert in the paper,' Winner instructed his PA, 'asking if you want to be in movies to call this number.' The production office back in London were probably cursing him as they fielded hundreds of phone calls from people all wanting to be film stars. He didn't pay them, of course, though expected all his extras to report on set at 5 a.m. for costume, hair and make-up. When it came to mid-afternoon and they were all understandably a bit fed up and started drifting off home, Winner picked up his megaphone and called out, 'Now lucky people, you've all got a raffle ticket with a number on it and I have £500 in my pocket to give away ...'

He'd call out a number and tell them they'd won £20. Being canny Scots, of course, meant they all wanted to stay a bit longer in the hope they might win £20, or even more, and that's how he kept the crowd on side. When the light started to fade and all these big burly Scotsmen were hanging around, having tossed their cabers and with not much else to do, I sidled over to Jenny and asked her if she thought it a clever idea if they picked Michael up, put him on their shoulders and paraded him around a bit. She smiled and said, 'Yes, that'd be fun.'

So I suggested it to a few of the guys.

'No, no! Put me down, put me down my dears,' Winner cried out as they lifted him into the air. 'I'll give you £20 if you put me down. Put me down! Arrgghhh!'

Well, we were in hysterics, though Michael didn't seem best pleased.

she'd returned a few minutes late from lunch, screaming and shouting at her to the point she was visibly shaking while he then turned, smiled glibly, and said, 'Right let's get on' as though nothing had happened. His behaviour became quite wearing but fortunately the shoot was relatively short. It marked my penultimate film with Winner, as it was on the next that I handed him my resignation.

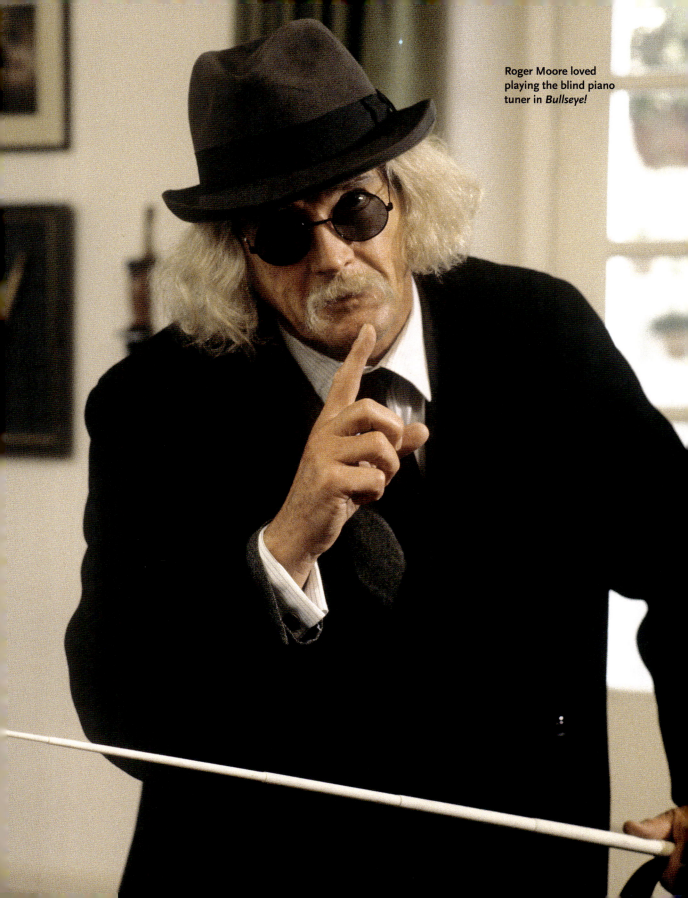

Roger Moore loved playing the blind piano tuner in *Bullseye!*

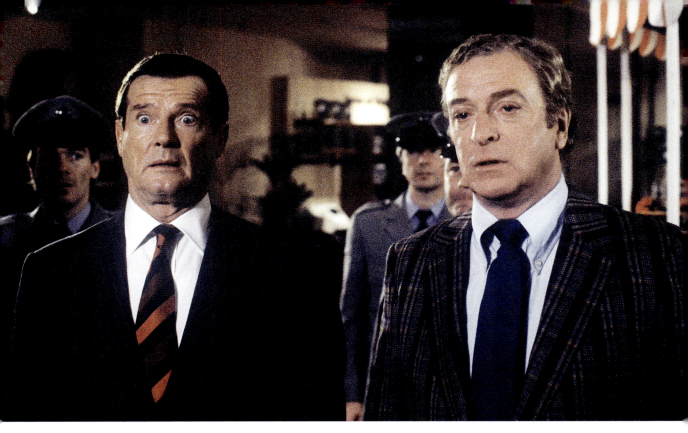

Roger Moore and Michael Caine in *Bullseye!*

A few days later Winner found out I was behind this little prank and decided from that moment on to make my life a total misery, picking on me at every opportunity. He was usually quite good at taking a joke, but his constant sniping and nastiness thereafter wore me down to the point I asked Sally Jones, our script supervisor, if she had a spare piece of paper on which she could type up my resignation. I then served it to Winner, like a writ.

'What's this Hamshere?' he snapped.

'Michael if you're the sort of person I have to work with to remain in this industry, then I'd rather not work any more,' I replied, and walked off feeling very relieved. I've faced up to bullies before, and certainly wasn't going to let Winner treat me the way he thought he could.

I never heard from him again, though I can't say my career was any poorer for it.

After a happy sojourn working for director Carl Reiner on *Bert Rigby You're a Fool*, which reunited me with Robbie Coltrane, I next encountered *Great Balls of Fire* for around three weeks during its UK location shoot. The life story of Jerry Lee Lewis starred Dennis Quaid as the rock and roll star, though Lewis himself said he hated the book it was based on and hated the film but rather liked Quaid's portrayal of him!

There wasn't much film work around in the late 1980s actually, so I moved over to TV for children's series *Press Gang* and a revamp of *The Saint*, starring Simon Dutton in six two-hour episodes, which I remember as being quite poorly received at the time and ITV even pulled the series from prime time after only a couple of episodes had been broadcast. I guess I was scratching around a bit and that's probably why I accepted *Frankenstein Unbound* from director Roger Corman, which I believe was the last film he directed. It was nice to work in Milan with Raul Julia, Bridget Fonda, Michael Hutchence

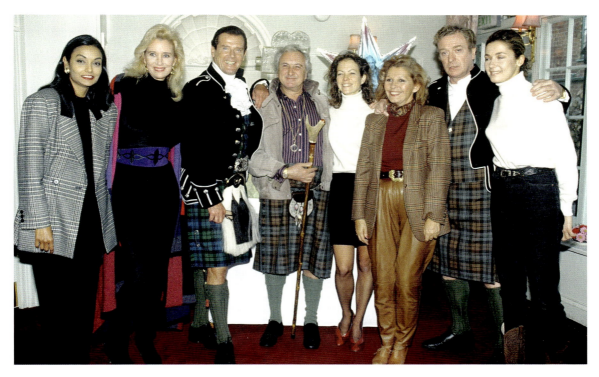

Shakira Caine, Sally Kirkland, Roger Moore, Michael Winner, Jenny Seagrove, Luisa Moore, Michael Caine and Deborah Moore on the set of *Bullseye!* in Scotland.

and John Hurt but I found Corman very, very mechanical in his approach, just wanting to get the job done; I got on with him, but then again learned to keep out of his way.

Hamlet was quite a departure for star Mel Gibson and marked the first production for his Icon company. Famed director Franco Zeffirelli announced production in April 1989 at a press conference, saying he wanted to make an appealing and accessible version of the Shakespeare play and in particular to bring youngsters into the cinema – hence his casting Gibson, fresh from the *Lethal Weapon* films. Gibson also served as one of the producers through his Icon company. We were based out of Shepperton Studios, and had locations in Scotland, England and Italy. Of course, it was big news when Mel Gibson came to town, particularly early on in the shoot at the Dover Castle location in Kent where he was pretty much hounded by the press. They all wanted to get the first shot of him as Hamlet – and no doubt question whether this action star had what it takes. It reached the point where Mel was getting quite upset and harassed by their continual chasing him around, and so I stepped in and suggested if he was to give them what they wanted – a photograph – then they'd likely then leave him alone, so why didn't we set it up?

'Jump on your horse, go outside the castle with your sword and give them their picture,' I said.

The photographers snapped away and ran back to Fleet Street, never to be seen again.

Afterwards Mel smiled at me and simply said, 'Thanks Keith.'

We became good friends actually and he invited Hilary and I out to dinner one evening

Dennis Quaid on the streets of London taking a break from filming *Great Balls of Fire*.

Frankenstein Unbound star Michael Hutchence.

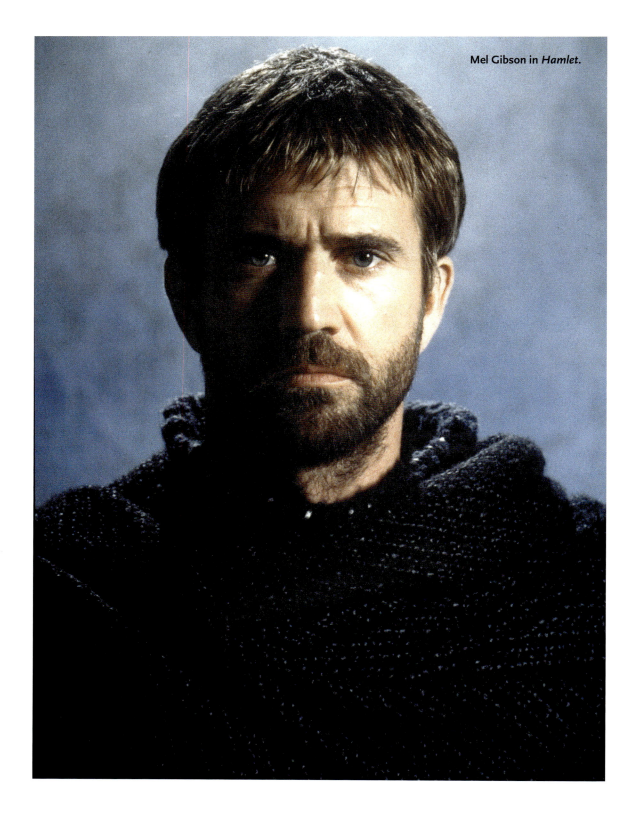

Mel Gibson in *Hamlet*.

Life magazine advert promoting *Hamlet*.

in London, where we had a really terrific time as 'mates', rather than Hollywood star and crew member. I think he enjoyed just being normal in an ordinary Chinese restaurant where diners did a double take but probably decided he was a lookalike and carried on eating.

Shining Through saw cinematographer Jan de Bont give us a bit of a runaround, being a big fan of handheld camera work, which allowed him to move across a set at whim. That was fine but sometimes proved a little problematic for the crew – and especially me – to get out of his way in time! Michael Douglas, Melanie Griffith, Liam Neeson and Joely Richardson starred in the Second World War thriller. It was adapted from an acclaimed book of the same name and we shot in Berlin just after the Wall had fallen, which was interesting, seeing East and West reunite. It was nominated for, and won, several Razzie Awards for worst film, worst director, worst screenplay and worst actors for Michael and Melanie. Happily for me, it led to my next film with Neeson, *Under Suspicion*. Writer Simon Moore got his break as director after Rank Film Distributors backed his script as one of their rare forays into film production. He delivered an interesting script set in 1950s Brighton where Liam played a private detective who – with his wife – happily set up, witnessed and used as evidence adulterous liaisons (often just a photograph in a compromising position) for people who needed to circumvent the strict divorce laws of the era. In real life my friend Roger Moore arranged such a liaison in order

Shining Through stars Michael Douglas and Melanie Griffith on the day the Wall came down in Berlin.

Liam Neeson, Ken Cranham and Simon Moore on the set of *Under Suspicion*.

to gain a divorce from his first wife on reasons of adultery.

But in this thriller, when Liam's wife and a client are murdered, he is placed in the frame for it.

Typically, UK powerhouse Rank financed and distributed the film, yet its own cinema company, Odeon, refused to take the movie widely across its chain despite it being a great little British film, made for the right price with a terrific cast. It was indicative of what was wrong in the British film industry at the time and by the end of the decade the company all but abandoned its film interests.

Harrison Ford remained in my life while I was on still on occasional assignment to *Young Indy* as back in the UK I was invited to work on the London shoot of *Patriot Games*. He starred as Jack Ryan and location work took in various areas around London, including Aldwych Underground station, the Royal Naval College in Greenwich, and, of course, Pinewood. The story centred around Ryan being on holiday with his family in London where he witnesses some Irish terrorists trying to abduct a member of the royal family and steps in, killing one and capturing the other. But the surviving terrorist escapes and vows revenge for his brother. It was a relatively short three-week shoot, but quite exciting and I'm pleased my photo of Harrison in full Jack Ryan mode became the film's poster. It was then back to Michael Caine for *Blue Ice*, which was a perfectly functional spy thriller even if it didn't exactly set the box office on fire, which can probably also be said of my next movie ...

Harrison Ford shooting on location in Greenwich for *Patriot Games*.

Carry On Columbus marked the one-off resurrection of the British comedy series, and the thirty-first entry, tying in with the 500th anniversary of Christopher Columbus discovering America. There were two other big-budget Columbus films in production at the time: one directed by Ridley Scott; the other by John Glen. That's when producer John Goldstone (of Monty Python fame) decided the subject was ripe for a comedy swipe. He persuaded original producer Peter Rogers, and director Gerald Thomas, to join him, and commissioned veteran *Carry On* screenwriter Dave Freeman to pen a script in a matter of a few weeks. The tight deadline was so they could get into production, and more importantly into cinemas, in the anniversary year, with shooting wrapping at the end of May 1992 at Pinewood and on location at Frensham Common.

Many series regulars were offered guest roles but turned them down, including Bernard Bresslaw, Joan Sims and Barbara Windsor. Kenneth Connor was a bit more vocal, saying, 'I want to be remembered as a Carry On star, not a Carry On bit player.' However, Jim Dale, Peter Gilmore, Bernard Cribbins, Leslie Phillips, Jon Pertwee, Jack Douglas and June Whitfield did all return – mainly as a favour to Gerald Thomas, whom they all adored.

Carry On Columbus.

The rest of the cast consisted of 'alternative comedians' – such as Julian Clary, Rik Mayall, Peter Richardson, Alexei Sayle, Tony Slattery and Nigel Planer – who just didn't seem to click with the classic *Carry On* stars in the way that was hoped. Oh, and I had a little role, too! I played a sailor, smoking a clay pipe, on the quayside waving goodbye as Columbus sailed off into the sunset. I'm photographed over my shoulder so, unless you know my shoulder particularly well, I'd challenge anyone to spot me – not that I would want you to!

But I'm afraid the whole thing was one big turkey.

OK the film had some mildly amusing moments, and some terrific stills(!), but the classic fun and comedy simply wasn't there – maybe times had just moved on too much?

One of the memorable days was when we had a set visit from the England football team with manager Graham Taylor, who all happily assembled with cast members for a large group shot.

Sadly, it was the last film Gerald Thomas directed as he died the following year.

Scene 16

UK BOOM

Shadowlands is a film directed by Richard Attenborough and starring Anthony Hopkins and Debra Winger as C.S. Lewis and Jewish American poet Joy Davidman, respectively.

Dickie Attenborough, being an actor himself, always insisted there was plenty of rehearsal time built into schedules as he liked to spend time working with his cast on immersing them into the characters they were playing – in this instance Tony Hopkins was playing the author of the 'Chronicles of Narnia' books who also taught at Oxford University during the 1950s. His passionless life was suddenly turned upside down with the arrival of an American fan, which marked the beginning of an affair of convenience that transformed him, though it was tragically cut short when Joy became terminally ill.

In the film adaptation, the couple spent their honeymoon looking for the 'Golden Valley' in Herefordshire, as depicted in a painting hanging in Lewis's study. The valley is in a picturesque area of gently rolling countryside in the lee of the Black Mountains, Wales.

Gordon Arnell was publicist on the picture and felt the valley would make the perfect backdrop for the poster artwork, and spoke to Dickie, Tony and Debra about his thoughts; it would mean heading to the location a day early in order for me to photograph them, which also meant the trailers, unit vehicles, make-up and hair department, etc. would have to be there too, so it was no small undertaking, though everything was swiftly and enthusiastically agreed.

Meanwhile, the American studio got wind of our plan and decided to fly in a 'Mr Fixit' despite experienced publicist Gordon having everything under total control. Well, Mr Fixit arrived on location and spoke to Debra about how he was going to save the day. Then he went to see Anthony in his trailer and showed him some sketches of how he felt Anthony should place his arm around Debra's shoulder, as though they were in a soppy American love story, whilst staring at her adoringly, and I would then supposedly photograph them looking madly in love. Anthony questioned him about the fact this had been a civil marriage and one initially to purely give Joy the right to stay in the UK without any feelings of love between C.S. Lewis and her. It was anything but a traditional love story where they swept one another off their feet, he explained. The guy thought for a moment and replied, 'Trust me, it's gonna be great!'

Anthony Hopkins and Debra Winger in *Shadowlands*.

A *Shadowlands* unit still, which even I am in – back row 5th from left.

'The one thing I have learned, Keith,' Tony said to me, realising I was slightly deflated by things, 'is that when someone says, "trust me" you know you're in trouble.'

The shoot was called off.

I had already photographed the valley actually before the unit arrived, and it was very picturesque just as Gordon had described. Ironically, the American poster made full use of it, albeit with a shot of Tony and Debra superimposed. The British poster campaign focused on a silhouette of Oxford University with a shot of the couple superimposed above.

Gordon was not at all happy with the American intervention and I often wonder if Mr Fixit, having thrown his spanner in the works, reported back to his superiors to say it was 'gonna be great'.

The next few films I was employed on I approached with the same enthusiasm and excitement as always, though I feel it fair to say that audiences didn't.

There are at least twelve films titled *Black Beauty*, plus a TV series or two, but the version that came into my life was written and directed by Caroline Thompson in 1993. We had a real old-time horse rustler, complete with bow legs and his own spittoon, who brought the 'hero' horse over from America, while Vic Armstrong was the horse master in the UK. The old adage of 'never work with children and animals' proved somewhat incorrect here as the main horse in particular was terrific, and very photogenic. They asked me to take some photos of Beauty rearing for the poster image and I suggested it'd work best on a stage at Shepperton, as obviously such an important photo needed to be lit very carefully, which would have proven tricky out on location with varying weather conditions. The resulting poster image is probably more memorable than the film.

The cast of *Radioland Murders*.

Meanwhile, George Lucas continued to branch out into genres away from sci-fi and action adventure with *Radioland Murders*. Having languished in development hell for twenty years, primarily due to high budget estimates, George persuaded Universal that with advancing CGI technology he could bring the picture in for a relatively low budget of $10 million (which eventually rose to $15 million) and recruited British actor-director Mel Smith to helm. I suppose you could best describe it as a comedy thriller set in 1939 at a radio station against a backdrop of its latest play. It all paid homage to the whodunit murder mystery genre with which George was enamoured.

It was a great gig for me, working in America with a house and car provided in Wilmington and with such a lovely cast, including many comic cameo appearances from the likes of Christopher Lloyd, Rosemary Clooney and George Burns. I remember several people getting quite excited about Burns coming on set, who was then very nearly 100 years old, and to stop him being unnecessarily bothered the production kept saying, 'No, no, it's a George Burns lookalike actually.' Maybe there was just a little too much slapstick and too many cameos though, because as a whole the film just didn't work and was criticised for trying too hard to be funny. It lost most of its budget on release.

Black Beauty poster, the image for which was shot at Shepperton.

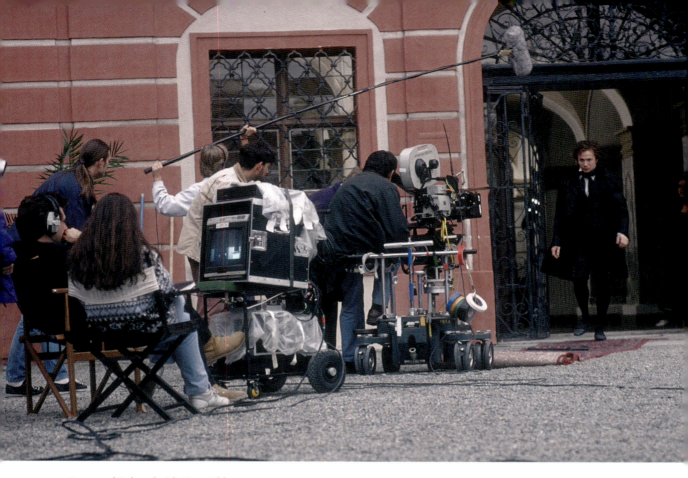

Immortal Beloved with Gary Oldman.

Then came *Immortal Beloved*, which was all filmed in the wonderful Czech Republic for Mel Gibson's Icon Productions and centred on the mystery following Beethoven's death in 1827 when his last will and testament bequeathed his estate, music and affairs to his 'immortal beloved'. But who was that exactly? Writer and director Bernard Rose claimed that he had successfully identified the lady in question – and so came the film. Gary Oldman was a delight, and we had some terrific locations that really evoked the period, though ultimately I guess it's not a subject matter that appealed to cinemagoers en masse. I might have said that would be the case too with my next film, which was originally titled *The Madness of George III* and was based on the hugely successful Alan Bennett play.

The true story of George III's deteriorating mental health and his equally declining relationship with his eldest son, the Prince of Wales, all based around the Regency Crisis of 1788–89, isn't what you'd instantly call blockbuster material, but the play had a long run in the West End and as such there was a bit of 'awareness' of the storyline. Playwright Alan Bennett had a fair amount of sway by insisting both stage director Nicholas Hytner and star Nigel Hawthorne be signed, against some wishes to bring in bigger names, and thank goodness he did. Hytner made his film debut and was very clever in surrounding himself with the best technicians: he turned to Ken Adam to design the movie (Ken won his second Oscar as a result), and recruited Andrew Dunn

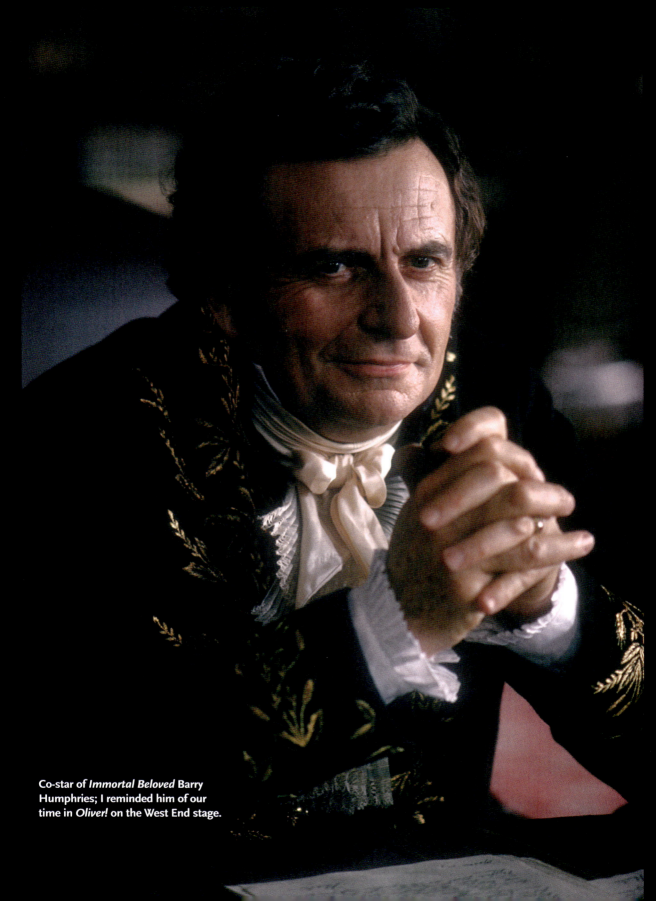

Co-star of *Immortal Beloved* Barry Humphries; I reminded him of our time in *Oliver!* on the West End stage.

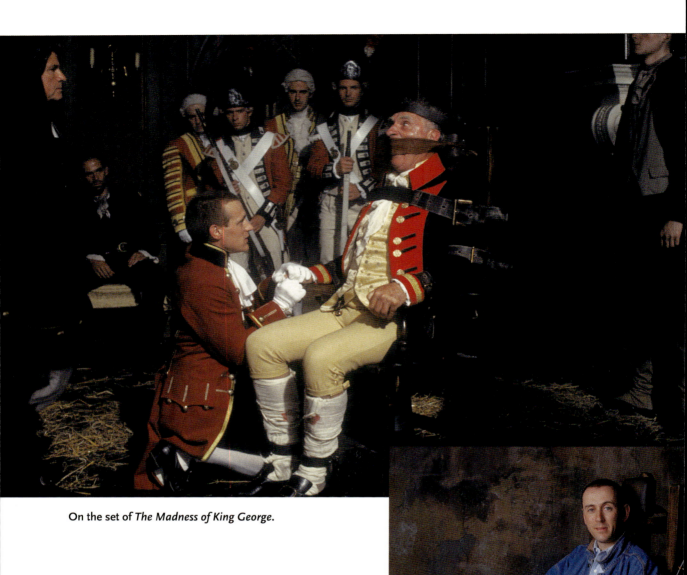

On the set of *The Madness of King George*.

The Madness of King George director, Nick Hytner.

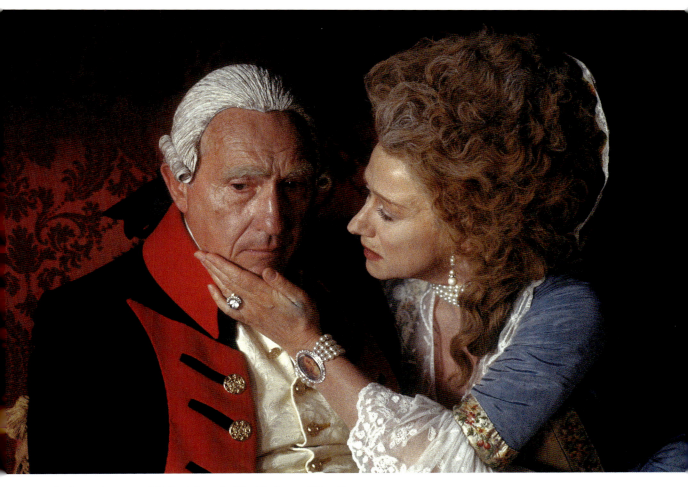

Nigel Hawthorne and Helen Mirren in *The Madness of King George*.

as his director of photography and David Parfitt as his producer – and, of course, a terrific cast.

Although King George was thought to be insane, I think a fair few of the doctors who attended him were actually the mad ones with their bizarre treatments focusing on the state of his urine and bowel movements, along with offering painful 'cupping' (blistering his skin) and administering various laxatives, whilst also restraining him in a straitjacket. I took close-ups of the actors playing the doctors with wide-angle lenses to accentuate their eccentricities, thinking it might make an interesting collage for publicity purposes.

The film's title was later changed to *The Madness of King George*, partly because the publicity department felt including 'King' in the title would bring out all the royalists to see it, and partly because there was a fear American audiences might think they'd missed parts I and II of the story and wouldn't bother to go see this 'sequel'. Plus, American audiences might not completely understand the intricacies of our traditional monarchy system.

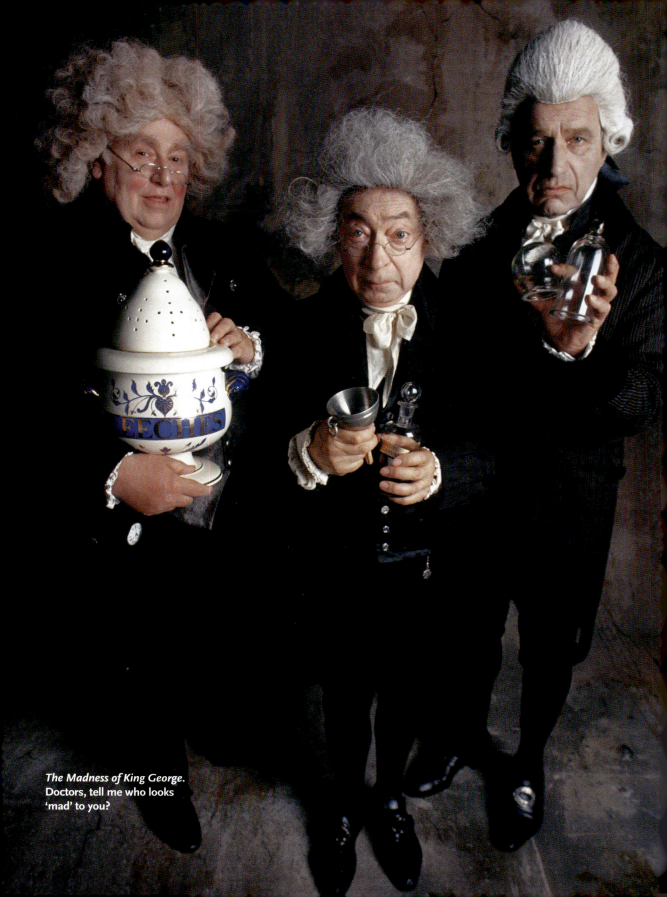

The Madness of King George. Doctors, tell me who looks 'mad' to you?

Terry Jones and *The Wind in the Willows* crew.

Wind in the Willows was a live action film from the creative mind of Terry Jones and followed just one year on from a TV animated film version of the story, which I don't think helped. Terry brought his Monty Python collaborators along for the ride, with John Cleese, Eric Idle and Michael Palin all playing roles, plus Steve Coogan, Victoria Wood, Stephen Fry and Antony Sher. It was a laugh a minute to be honest and huge fun working with all the talented performers. But Pathé, the UK distributor, positioned it as a children's film and concentrated on afternoon screenings in cinemas, which very much limited its box office returns. Consequently, a major New York publication wondered why such a wonderful children's film had been 'dumped by distributors'.

Disney took US rights but given poor UK returns they didn't really put their heart into publicising it much, and after a small theatrical run released it pretty much straight to video. At the time of the US release Terry Jones was working on a documentary in New York and was told that the film was being shown at a cinema in Times Square. He rushed down only to discover that it was actually in 'one of those seedy little porno theatres'. Terry didn't direct another film for fifteen years after this, feeling very disillusioned with the industry. In 2004, Disney changed the title to *Mr Toad's Wild Ride*, to tie into their theme park ride at Disneyland, and re-released it on DVD.

Meanwhile, in 1997 there was a change of UK government when the Labour Party came to power under Tony Blair. Although the previous administration had introduced the National Lottery and channelled a small percentage of proceeds into UK arts, including film, it wasn't until Labour came to power that a tax break was

Eric Idle and Terry Jones in *The Wind in the Willows*.

introduced for films shooting in the UK, much like it had been in Ireland several years earlier, which had proved hugely influential in attracting big-budget blockbusters.

In the three years following its introduction nearly 200 certificates of 'British film' nationality were issued compared with under twenty in 1996. It was a huge game changer, and expenditure in UK production ballooned as more American productions were based here. The knock-on benefits to the economy as a whole were significant, too.

Firelight, which came from Disney and Miramax, was one of the first films to benefit from the new tax laws. Sophie Marceau starred and many of the creative forces behind *Shadowlands* were involved, whom, of course, I knew including writer William Nicholson, who was making his directorial debut having been inspired by 1940s movie love stories. It was the first of two films I made with Sophie in succession, the second being *Anna Karenina* for director Bernard Rose (of *Immortal Beloved* fame). We filmed that in St Petersburg and I vividly remember arriving at my hotel, the Marco Polo, for the first time and seeing walk-through metal detectors being installed at the entrance, similar to those at airports. I then heard that the night before a tourist had been shot dead in the bar by the Russian mafia who had, sadly, mistaken him for someone else. Yikes.

Another American film lured to Pinewood was a wannabe romantic thriller about master art forger Harry Donovan (Jason Patric), who accepts a commission to paint a fake Rembrandt. *Incognito* co-starred Irene Jacob and was a film on which I felt in the way a lot of the time.

That was probably due to them losing their director two weeks into the shoot, which never results in a happy atmosphere. It was to have marked the directorial debut of actor Peter Weller, but he was replaced by John Badham after criticising producer James G. Robinson and the budget. He allegedly said, 'Their idea of a budget is going to a hot dog stand.' Ouch! Never bite the hand that feeds you!

Stephen Dillane and Sophie Marceau in *Firelight*.

I don't think it was a particularly happy time for replacement director John Badham either as it was the last feature film he directed. He preferred instead to move into television where he's remained very active ever since.

My dear friend, publicist Geoff Freeman, was again working with me on *Incognito* and I sadly remember it was on a lunch break one day that he received the news that his wife's cancer, which she had been battling bravely, had now been diagnosed as terminal and there was nothing more the doctors could do. Geoff was absolutely shattered. Obviously, he had to leave, and the

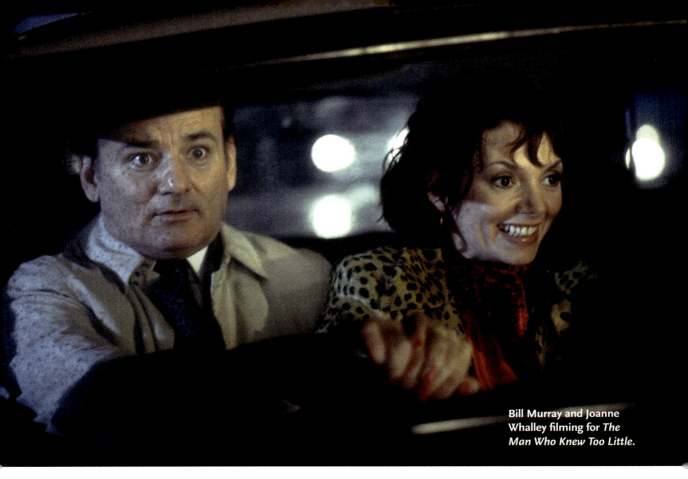

Bill Murray and Joanne Whalley filming for *The Man Who Knew Too Little*.

news spread around the production fairly quickly. Rod Steiger (who was playing Jason Patric's father in the movie) called the hospice to which Geoff's wife had been taken and asked they 'fill the room with flowers' at his expense. What a gent he was.

Over at Elstree, American comedy *Watch That Man* started production, though it was soon retitled as *The Man Who Knew Too Little*. Writer Robert Farrar developed the idea from a chance remark at a dinner party where someone told him about murder mystery weekends that were popular in England where participants would telephone someone for instructions. He thought, 'Wouldn't it be fabulous if somebody got the wrong number, and it all went hopelessly wrong?'

That, too, was another movie that started off with a firing – this time it was the cameraman, who had a falling out with both director Jon Amiel and star Bill Murray over the way they felt the set should be lit. The atmosphere on set felt tense. The largely British supporting cast included Joanne Whalley who was, very sadly, in the process of divorcing Val Kilmer and was not a happy bunny. If you remember I was there when they met and when they married, so I felt particularly sad for the couple and their children.

Val was over at Pinewood simultaneously filming *The Saint* and called me suggesting he and I should meet for dinner. When we got together he asked how everything was and how Joanne was getting on, and how Joanne was feeling and behaving. It quickly became clear he wanted me to be his spy in the camp, so I changed the subject very quickly each time he mentioned her – I think he eventually realised I wasn't going to get involved and in fact I never heard from him again. I didn't mention my meeting to Joanne, and she never spoke to me about Val either.

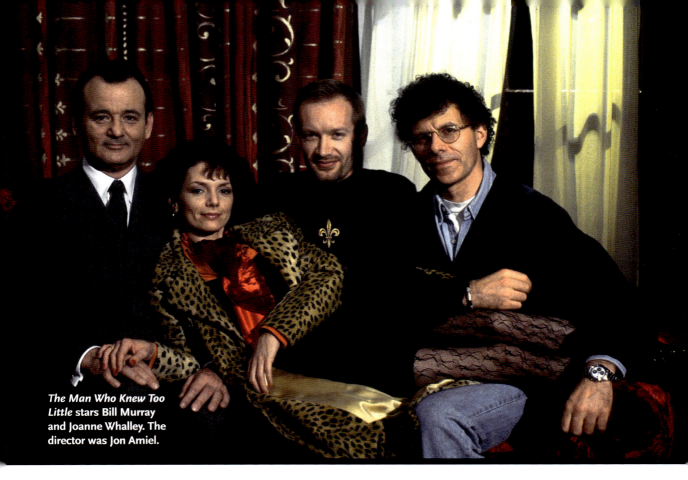

The Man Who Knew Too Little stars Bill Murray and Joanne Whalley. The director was Jon Amiel.

Joanne Whalley with her daughter Mercedes on the set of *The Man Who Knew Too Little*.

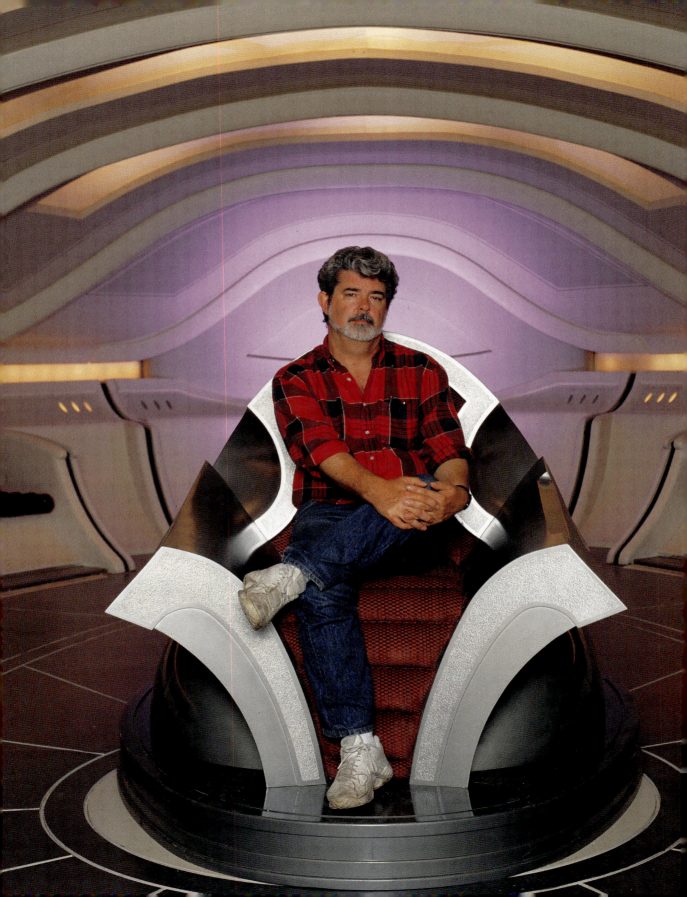

Scene 17

STAR WARS – THE PREQUELS

George Lucas had created an elaborate backstory to aid his writing of the original *Star Wars* trilogy and though he said he was not going to continue with the saga beyond 1983's *Return of the Jedi*, he nonetheless remained fascinated with the idea of prequels.

Given the original three films' continuing success along with merchandising and spin-off publications, George knew all too well that there was still a large audience out there and that, coupled with the advancements of CGI, led him to announce in 1993 that he would be making three prequels.

He initially approached a few directors, including Stephen Spielberg and Ron Howard, to take the helm, but they all said that, as this was very clearly George's baby, he ought to direct.

George envisioned a much grander, more epic scale to these new films built around the central idea of focusing on Anakin Skywalker as the main protagonist and going on to explore Darth Vader's origins. The film's working title was *The Beginning*, which later changed to *The Phantom Menace*.

The earlier three films were all shot in the UK, mainly at Elstree Studios, and George was keen to return; also, the recent introduction of the tax credit proved an additional lure. We were based at Leavesden Studios. Eon were planning to take *Tomorrow Never Dies* to Leavesden after the success of *GoldenEye*, but Lucasfilm producer Rick McCallum nipped in quickly and signed a cheque for a two-and-a-half-year lease period. The length of the lease was primarily to allow the sets to remain intact for them to return for any pick-up shots needed after principal photography had wrapped at the end of September, after four months of shooting.

There was a lot of CGI and green-screen work, though also a lot of work was done in-camera with puppeteers and really rich and lavish sets. With the story taking place on three planets, there were many varied environments, too. Terryl Whitlatch, with her background in zoology and anatomy, was in charge of creature design, resulting in many of the aliens combining features of real animals, though I'm not sure I'll forgive her for helping create Jar Jar Binks!

The film made extensive use of 'digital pre-visualisation', a new technique using computers to create 3D animated storyboards that proved helpful and marked the way of the future.

George Lucas.

Lucasfilm gave me pretty much carte blanche to get on with my work, photographing the main actors in studio sessions and, of course, on set, and I knew George pretty well from earlier films and TV series on which he might have been calling 'turn over and action' but was ever present. George tended to sit in what they called the 'video village' on set, as there was so much green screen he was able to watch on monitors and see the CGI blended in with live action.

After shooting wrapped, I spent a lot of time inserting some of the CGI work into my stills such as the light sabres, as during shooting the actors used wood-like swords painted green. Plus, I removed actors and puppeteers who were dressed in white or green suits operating some of the creatures and technology. It was quite detailed, painstaking work but very fulfilling and great fun.

I'd obviously seen the original trilogy and knew where the prequel-trilogy storylines had to get from and to, and it was fascinating to see actors grow into the roles over the films, such as Ewan McGregor morphing towards Alec Guinness.

There were several units shooting simultaneously across locations from Tunisia to Italy and the UK, all under George's overall supervision. He more than anyone realised there was a lot riding on this film, as if it didn't perform well it would surely bring into question when parts II and III would go into production. George was very conscious of the fans too and didn't want to disappoint or short-change them.

With the number of visual effects – and bear in mind this episode employed lots of miniature models, matte paintings and on-set visual effects ahead of the CGI work – editing took two years. Then came the publicity campaign, for which, of course, I'd been banking on a lot of photography work.

Lucasfilm spent $20 million on the advertising campaign and struck promotional deals with Lego, Hasbro and PepsiCo, among other leading brands. The company also helped the *Star Wars* fan club to organise an event called 'Star Wars Celebration' in Denver, perhaps not quite realising how big it would be and how much of a calendar fixture it has been with fans, stars and leading crew ever since.

The first teaser trailer was released on 13 November 1998 and became a cinema event in itself, with many people paying to see a movie purely to watch the trailer. To keep them from leaving before the film was over (or even started in some instances), cinemas promised repeat screenings of the trailer after the movie ended. As the release date approached, one New York newspaper reported that so many workers had announced plans to take a day off and head to cinemas, lots of companies had decided to close! Cinemas limited ticket sales to twelve per person to avoid people reselling them, but when reports filtered back to Lucasfilm that ticket touts were charging up to $100 per ticket outside theatres, they said this was exactly what they wanted to avoid. I think it's fair to say the demand was unprecedented.

The film received its UK premiere at the annual Royal Film Performance event, held in aid of the Film & TV Charity, on 14 July 1999 at the Odeon Leicester Square and was attended by the (then) Prince of Wales. Film reviewers largely praised the film, and though some offered up mixed feelings, the most important critics – the film-goers – gave it the big thumbs up and the film smashed all sorts of box office records around the world. If there were any doubts about *Episodes II* and *III* going into production, they were now long forgotten!

Writing on *Episode II* (which became *Attack of the Clones*) got under way immediately after *The Phantom Menace*'s release and set the story ten years later. Shooting was slated to commence in June 2000 – but where, was the question. The series distributor 20th Century Fox (then owned by Rupert Murdoch) had recently completed the construction of Fox Studios in Australia and was keen to fill it with productions they were

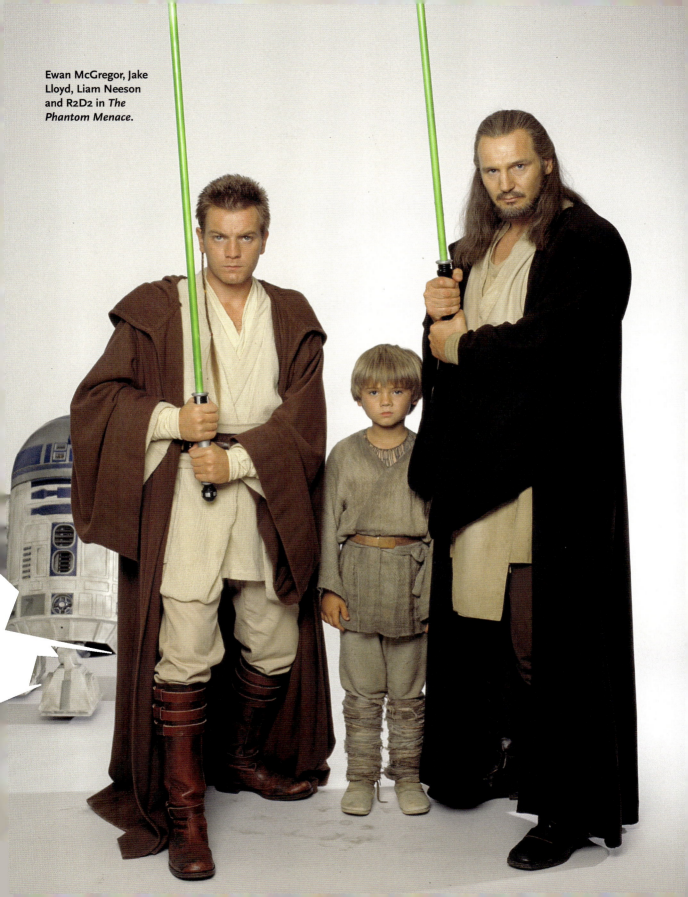

Ewan McGregor, Jake Lloyd, Liam Neeson and R2D2 in *The Phantom Menace*.

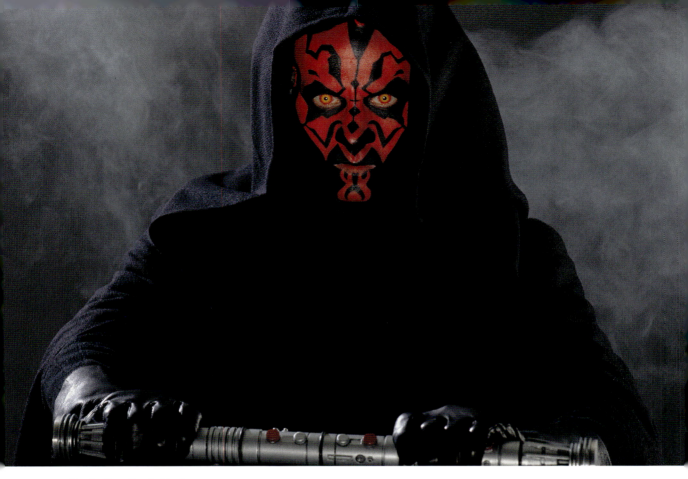

Ray Park as Darth Maul.

involved with. That, with a favourable exchange rate, tax incentive, cost efficiencies and producer Rick McCallum's familiarity with the country, having shot some of the *Young Indy* shows there, sealed the deal.

I believe part of the Australian government's tax incentive necessitated a certain number of 'local crew' to be employed, and to be honest Australia has some pretty good photographers, so Lucasfilm suggesting I was indispensable didn't really cut the mustard. I was obviously sad about the situation, but that unfortunately is how it goes sometimes.

All the stars – Ewan McGregor, Natalie Portman, Hayden Christensen, Ian McDiarmid, Samuel L. Jackson, Christopher Lee, Anthony Daniels, Kenny Baker and Frank Oz – decamped to Australia with additional locations in Tunisia, Spain and Italy. The production then pulled back to the UK for pick-up shots at Ealing and Elstree Studios, which is where I came in!

The head of Lucasfilm's publicity department, Lynn Hale, required more material to complete the Australian photography and asked that I come in to set up some extra sessions with the cast members for publicity and memorabilia purposes, which I happily spent many weeks doing.

The film was released in the United States on 16 May 2002, and despite receiving mixed reviews some critics suggested it was an improvement over its predecessor. It performed well at the box office, making over $645 million worldwide and paving the way for *Episode III*, which George had already started writing.

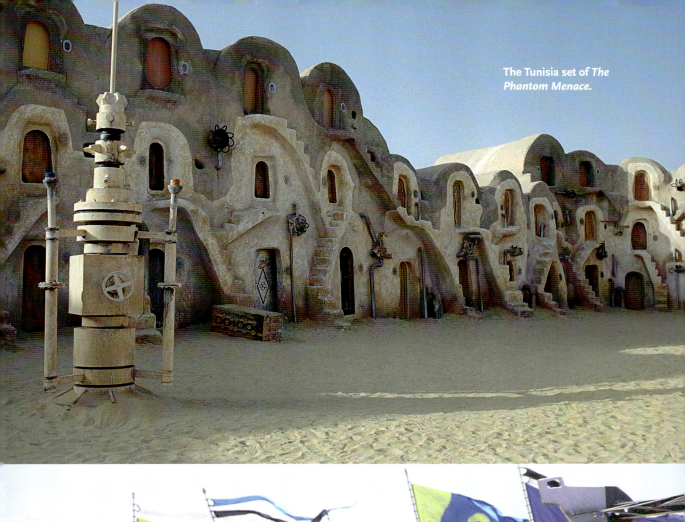

The Tunisia set of *The Phantom Menace*.

A scene during filming in Tunisia.

Ewan McGregor.

Thankfully, Lucasfilm did make the case for me on *Revenge of the Sith* and asked me to decamp to Australia with them for the duration of the production starting in June 2003 – George always liked to start his films in June and if not on the 21st then as close to it as possible as the summer equinox was his 'lucky date', he said.

There was certainly much more green-screen work this time around – more than I'd ever encountered before – and to be honest taking photos of actors standing against huge blank backdrops isn't terribly exciting for anyone, so I suggested my time would be better employed if I set up a photography studio and brought in the artists and props. Then when there was a 'real' set I would obviously take photos with the artists on those and deliver a complete and very comprehensive portfolio of photography. I was extremely happy doing all the fun stuff on the movie and was granted pretty much a free rein across the production – on which there was a really good atmosphere and excitement that we were now completing the final instalment in the *Star Wars* prequel trilogy, and the third chronological chapter of the 'Skywalker Saga'. The culmination, of course, was actors Hayden Christensen and Ewan McGregor fighting a dramatic lightsaber duel, which they rehearsed for many weeks training with stunt co-ordinators.

Just as with the previous film, after production wrapped in Australia some pick-up shots were later filmed at Shepperton and Elstree Studios in the UK.

The Phantom Menace unit still.

John Knoll and Christopher Lee, who played Count Dooku in *Attack of the Clones* and *Revenge of the Sith*.

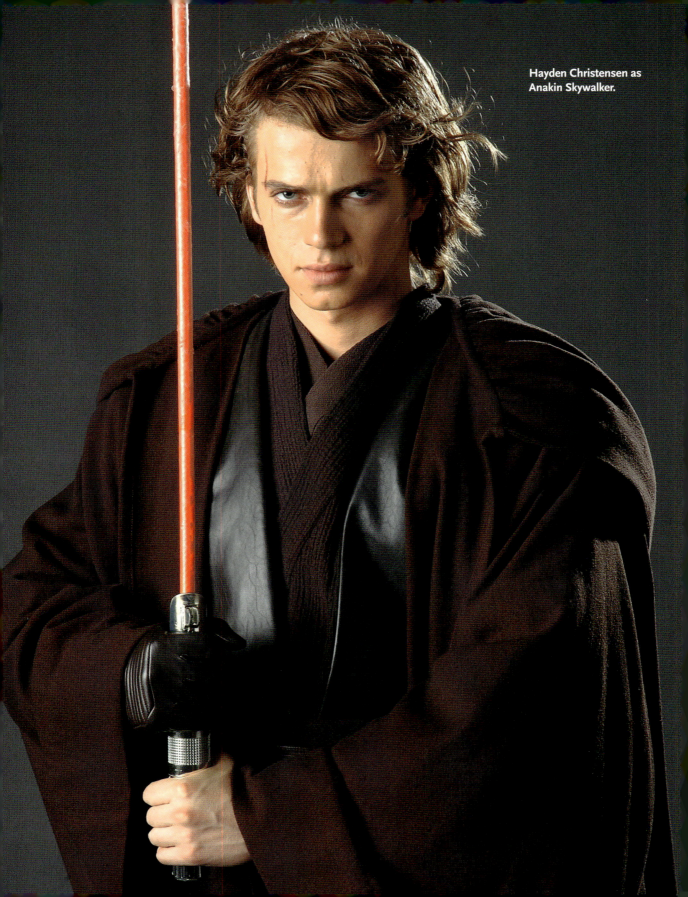

Hayden Christensen as Anakin Skywalker.

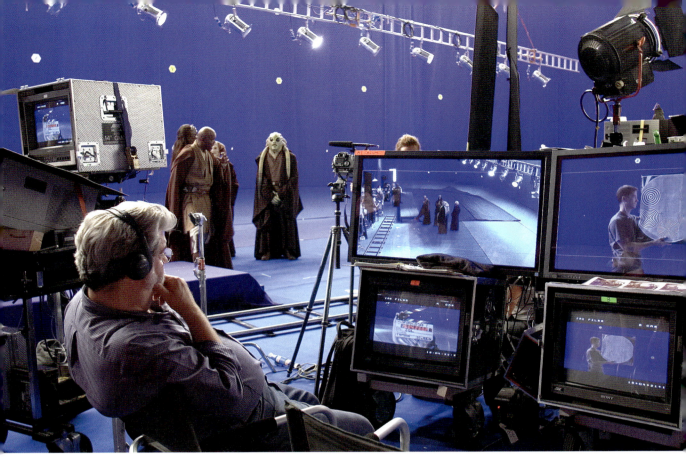

George Lucas in the video village on the set of *Revenge of the Sith*.

Revenge of the Sith premiered on 15 May 2005 at the Cannes Film Festival. It was then released worldwide on 19 May to positive reviews and was widely considered to be the best instalment of the prequel trilogy.

It also marked George Lucas's swansong with the saga as, on 30 October 2012, Disney acquired Lucasfilm for $4.05 billion after George let it be known he was considering retirement a year earlier. It led to a whole new series of films and TV series in the *Star Wars* world, along with another *Indiana Jones*. I've been happy to sit back in the cinema watching them go from strength to strength, whilst forever seeing my photos in hundreds of books and magazines as well as publicity material, smiling at my little tiny bit of involvement over many years.

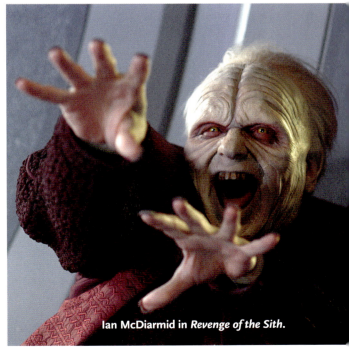

Ian McDiarmid in *Revenge of the Sith*.

Scene 18

MUMMY, MUMMY

The Mummy was Universal's remake of its 1932 Boris Karloff movie, albeit with a more adventurous and romantic take.

I think the idea of a remake had been in development for many years, if not decades, until director Stephen Sommers arrived on the scene in 1997 having heard the new management at Universal was desperate for a hit after various box office failures and had 'revisited' the studio's properties, which included nearly 5,000 old scripts and films. His eighteen-page pitch suggested the hero Rick O'Connell should be an Errol Flynn-type of swashbuckling character, 'a kind of Indiana Jones or Jason and the Argonauts type with the mummy as the creature giving him a hard time'.

Keen to avoid the bandaged mummy of the old film, Stephen envisioned a faster, meaner and scarier monster, and set it all in the 1920s, rather than the modern day, around the time of the discovery of the tomb of Tutankhamun. Universal liked it and gave him the green light.

Curiously, the part was offered to Tom Cruise, who turned it down only then to star in the 2017 reboot, but Stephen was impressed with *George of the Jungle*'s Brendan Fraser and cast him.

Filming began in May 1998, in Marrakech – which actually looked much less modern than Cairo, thus making it easier to dress like the 1920s. Then we moved to the Sahara Desert outside the small town of Erfoud, and having worked in the Sahara before I was all too aware of dehydration issues, sandstorms and the wildlife offering up the odd problem or two. Several crew members reported bites and stings, though we were all having so much fun that it was more a minor inconvenience than anything else.

Back in the UK, Chatham dockyards doubled for Giza Port on the River Nile, even including a full-size steam train, and over at Shepperton Studios scale models of the columns and statues were built replicating those of Hamunaptra, the City of the Dead. I did some of my 'virtual tours' for the studio executives in LA and Brendan was really helpful to me in those. In fact, we had a terrific cast in Brendan, Rachel Weisz, John Hannah, and Arnold Vosloo as Imhotep (aka the Mummy), and although we thought it was a great movie, there were stirrings in the marketing department that the title *The Mummy* might conjure up comparisons with the creaky old 1932 black and white B-movie and maybe turn some cinemagoers off.

Ready for the family portrait.

The cast and director of *The Mummy*.

However, rather than change the title, the studio really got behind the movie and pushed the trailer's fun-like adventure hard with a great publicity campaign. It paid off spectacularly well, with one influential critic declaring it 'Indiana Jones for a new generation ... setting a new mould for action heroes that more films would follow in the years after'.

It was little wonder that Universal asked Stephen to deliver a sequel.

Keen to replicate the luck he felt we'd enjoyed on the first film, Stephen set principal photography to start exactly two years later on the same day, in the same locations. He even ensured everyone had the exact same offices at Shepperton – he was leaving nothing to chance.

The Mummy Returns saw the same lead cast return too, though perhaps the CGI effects played more of a part than in the first film as several critics picked up on the characters seeming to be secondary to the visuals. Nevertheless, it was a box office hit, leading to questions about a third film. Stephen felt that while there was a demand for it, most of the gang would only be up for it again if we could find a way to make it bigger and better. Several years later, a third film was made, without Stephen directing and without Rachel Weisz, centring on a Chinese mummy. I wasn't involved on that one, but although it performed well, the general consensus seemed to be that it lacked the fun of the first film and was a 'series past its prime'.

I am incredibly fond of Brendan and was so very delighted to see him win the Best Actor Oscar in 2023.

Brendan Fraser hanging about on the set of *The Mummy*.

Stephen Sommers, director of *The Mummy*.

Arnold Vosloo as Imhotep in *The Mummy*.

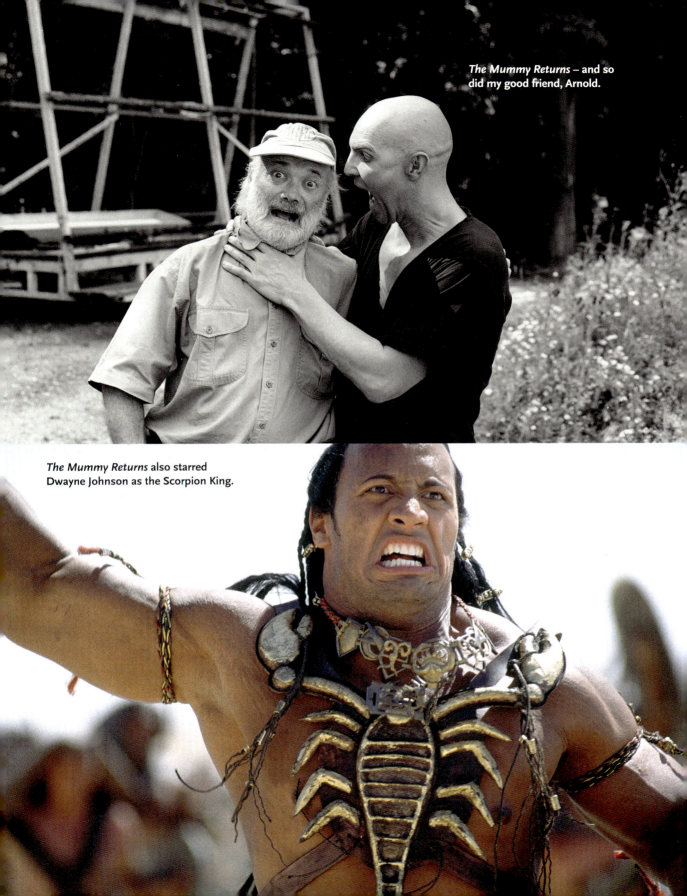

The Mummy Returns – and so did my good friend, Arnold.

The Mummy Returns also starred Dwayne Johnson as the Scorpion King.

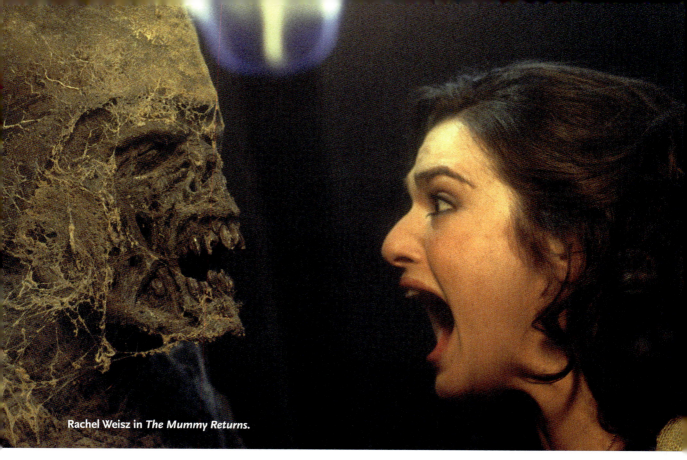

Rachel Weisz in *The Mummy Returns*.

Rachel Weisz and Brendan Fraser in the Sahara.

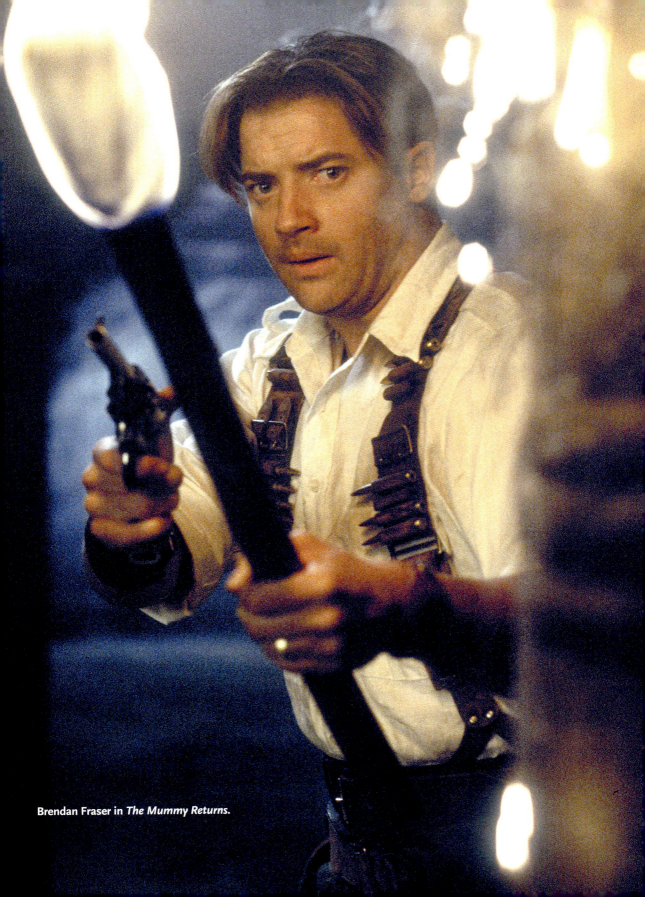
Brendan Fraser in *The Mummy Returns*.

Band of Brothers with Damian Lewis, a show I dropped in and out of throughout its production.

In between the two *Mummy* films I enjoyed a little sojourn on *Band of Brothers*, which was created by Steven Spielberg and Tom Hanks. A bit like the *Young Indy* series, I dropped in and out a little over a few of the episodes. But then came *Spy Game*.

Robert Redford and Brad Pitt headed the cast on Tony Scott's action thriller. Redford plays a retiring CIA agent who recalls his training of a fellow agent Tom Bishop (Brad Pitt) while working against agency politics to free Bishop from his Chinese captors after his CIA employers leave him for dead.

We mainly filmed in Morocco, Hungary, London and then back at Shepperton and its environs, which also doubled for everything from Hong Kong and Berlin to Washington DC.

Tony Scott was my favourite sort of director in that the buck stopped with him – he was very much in charge. He had an incredible energy and although we'd work from dawn until dusk he was always reluctant to stop for a break, and consequently we usually had lunch on the run in order not to slow his momentum. Even on our rest day Tony would go running. He was a veritable dynamo. I remember one afternoon on location in Morocco, Tony was into what we all thought would be the last scene of the day, and I started packing up my equipment and walked over to my car when I saw the crew all following Tony like the Pied Piper up a hill and Tony puffing his cigar at the helm. He'd seemingly suggested they should do 'just one more shot' to wrap the day (as he never really wanted the shooting days to end) and told the crew to follow him. Whether he was looking for inspiration I can't be sure, but they disappeared over this hill only to reappear moments later walking back in my direction. In fact, Tony ended up

Robert Redford and Brad Pitt in *Spy Game*.

I enjoyed my talks with Brad Pitt about photography during the filming of *Spy Game*.

Robert Redford in *Spy Game*.

doing a 360-degree walk, right back to where he started, saying, 'OK we'll just do a shot here, then!'

Robert and Brad were undoubtedly two of the biggest stars in Hollywood, at the very top of their game, and were an absolute and utter delight to work with. Brad's character was a photographer, and he was very keen on everything I did and often asked me questions to help with his characterisation, often playing up to me snapping photos. Robert liked nothing better than serving the crew tea and coffee from the refreshment stall – two more humble people you'd be hard pressed to meet.

Tony Scott was a taskmaster in that he'd dream up complex and challenging shots and would expect the crew to be able to set them up quickly. Invariably they would, all the time feeding off his enthusiasm. Tony always wore a red Malboro baseball cap, which he said was his 'lucky hat' – I also think he'd made a few commercials with Marlboro so I'm sure they appreciated the publicity. It became a bit of a trademark with him, and most of his publicity photos were with him in the cap.

Speaking of publicity, Robert and Brad didn't actually film together until later on in the schedule and the studio was very keen to get some

Spy Game: Tony Scott in his lucky cap.

shots of them together. It wasn't anything too exciting, just them both walking down a street, but that seemed enough to start the marketing campaign off.

I worked again with Tony Scott a couple of years later on *Man on Fire*. It was a film he had tried to make twenty years earlier, but as his only feature at that point was *The Hunger*, it was felt he lacked the experience to follow on with this bestselling novel adaptation of an entrepreneur's 9-year-old daughter kidnapped right under the nose of her bodyguard, ex-CIA officer John Creasy. I think it was made as a TV film a few years later but then came back into Tony's life when 20th Century Fox wanted to give it the big-screen treatment in 2003.

I received a call from the production office in Mexico asking if I was free as Tony wanted me.

I was committed to a little film called *Star Wars* at a point a bit later in the year, but they said that was fine by them and I'd be finished in plenty of time. So I packed my bags, flew over to Mexico City and landed, only to realise I was taking over from someone who had been fired because they didn't get on with Christopher Walken, who was starring opposite Denzel Washington. It's never a very nice situation to be dropped into, but as I'd worked with Christopher on a Bond film Tony obviously thought I'd be the right man for the job.

Everyone seemed pleased to see me, that is until we were filming in the city on one of my first days with Christopher. I was photographing the action from a tracking vehicle, with Christopher in the cab of a truck, and ensured I was definitely out of his line of sight.

Tony Scott looks over Casablanca

Nevertheless, he stopped the shoot, demanding I be removed from the set after claiming I was getting in his eyeline and distracting him. Thinking on my feet, and not wanting to be the second photographer fired, I thought I'd try to defuse the situation by first apologising and then following through swiftly with, 'Oh by the way, Barbara Broccoli asked I pass on her love ...' figuring if I took his mind back to the Bond film, he might remember our happy experience working together. Sorry Barbara! But it started a conversation and, although he still seemed slightly resentful of me being around, he graciously accepted me as being a necessary part of his job.

Roll on to a hospital set, where Denzel was lying in bed having been shot. It was quite a small set with lots of lights and equipment and Christopher was to come in and talk to Denzel. I suddenly became very conscious I might get in the way, so I asked Christopher if it would be OK for me to be in a corner and cover the first take, before then diplomatically withdrawing. The only trouble was I couldn't get out as I'd thought, and Christopher spotted I was hemmed in. 'Ssh. Just stay there, it's OK,' he kindly suggested.

From there I flew back to London, and on to Australia to begin work on *Revenge of the Sith*, which was every bit the big-budget epic where money was no object.

Scene 19

MISSION: RETIREMENT

After completing the final *Star Wars* prequel I found myself at the other end of the budget spectrum in the UK with *I Capture the Castle*, a modest film backed by the BBC and Isle of Man Film Fund. It was an adaptation of Dodie Smith's 1948 novel, she being more famous for writing *The Hundred and One Dalmatians*, of course.

Unit photographers are usually an offset cost of the marketing budget and when an independent film comes together via a jigsaw of financing sources, such as *I Capture the Castle*, invariably distribution (and marketing) budgets are sealed a little later in the deal and there's suddenly a panic when the production realises they need someone like me on board – a bit of an afterthought, you might say. Of course, independent features have modest marketing budgets anyway and my salary is even more modest as a result, so it becomes a bit of a balancing act of delivering all they ask for within the shrinking budgets available. I've always seemed to find a way, though I must admit it was becoming more tiresome.

Sky Captain and the World of Tomorrow was larger in scale and ambition, and all came about when writer-director Kerry Conran, who had grown up reading old comic books of the 1930s and '40s, began a career working with 2D computer animation at Disney. He realised it was possible to apply some of the techniques associated with animation to live action, but being a young, inexperienced director he knew that studios in Hollywood wouldn't be willing to take a risk with him and what they viewed as untested technology. So, Conran created a black and white teaser trailer in the style of an old-fashioned movie serial trailer with a very retrospective look, with a vague story idea of a guy who flew a plane. He managed to get it to producer John Avnet, who was so bowled over that he wanted to make the movie. Avnet spent the next two years with Conran developing the script and sketching it out via hand-drawn storyboards and then recreating it with computer-generated 3D animatics, with all of the 2D background photographs digitally painted to resemble a 1939 setting. It was like taking Wally Veevers's sausage factory to a whole new level.

Avnet then brought on board actors Jude Law, Sadie Frost, Angelina Jolie and Gwyneth Paltrow for the sci-fi, action-adventure story about a pilot and a reporter teaming up to try to discover the origin of flying robots that have attacked New York, and the reason for the disappearance of famous scientists around the world, before convincing Aurelio De Laurentiis (nephew of Dino) to finance the film. When asked who he would like to play the role of Dr Totenkopf, the mysterious mad scientist and supervillain, Avnet replied

Romola Garai, who starred in *I Capture the Castle*.

Sky Captain and the World of Tomorrow, which starred Gwyneth Paltrow and Jude Law.

Angelina Jolie, who starred in *Sky Captain and the World of Tomorrow*.

'Laurence Olivier'. The fact that Olivier had been dead for nearly thirteen years was a minor point as via computer manipulation of video and audio from when he was a young actor they were able to 'computer generate' the great man. I think it was one of the first uses of AI to bring an actor back to life and, although he only appeared in the closing minutes of the film, there are few people who possess the fearsome authority he delivered. Primarily shot on blue screen at Elstree Studios, the live action was all filmed in twenty-six days and was one of the first major Hollywood films to be made almost completely digitally. While largely forgotten today, I think the style and technology paved the way for the Marvel films that have since followed.

Back in the 2D world, Dirk Pitt is a fictional character created by American novelist Clive Cussler and first featured on film in *Raise the Titanic*, which admittedly wasn't a huge success. A couple of decades later producer Mace Neufield (with whom I'd worked on *Patriot Games*) decided to adapt Cussler's novel *Sahara* as a hopeful launchpad to a series of Dirk Pitt action-adventure movies. Matthew McConaughey was cast as the treasure hunter and teamed up with Steve Zahn and Penélope Cruz to find a lost American Civil War Ironclad warship in the Sahara Desert, which we shot in Morocco.

Initially budgeted at $80 million, costs ballooned to $160 million by the time we wrapped, due to numerous rewrites and having some twenty producers and executives on the payroll. It grossed much less on release and all plans for a sequel were abandoned. Clive Cussler sued the production company for $100 million for 'failing to consult him on the script' and for the fact they didn't then option a second book. The case went back and forth through the courts for almost a decade afterwards but ultimately everyone lost out.

Incidentally, Tom Cruise used to fly in every weekend as he was in a relationship with Penélope but wanted to try to keep it under the radar, as it were.

This ever-increasing number of producers on films seemed to be the norm in Hollywood now, and I often heard from friends and colleagues in the business who said the main problem they found was that the buck didn't stop with one person any more: it went to committees of producers and getting a decision was never easy nor straightforward. It was another way the industry was changing and becoming ever more tiresome.

With the massive boom in gaming, it wasn't long before one of the best-selling games transformed into a film. *Doom* was that film and was

A shot from *Sahara*.

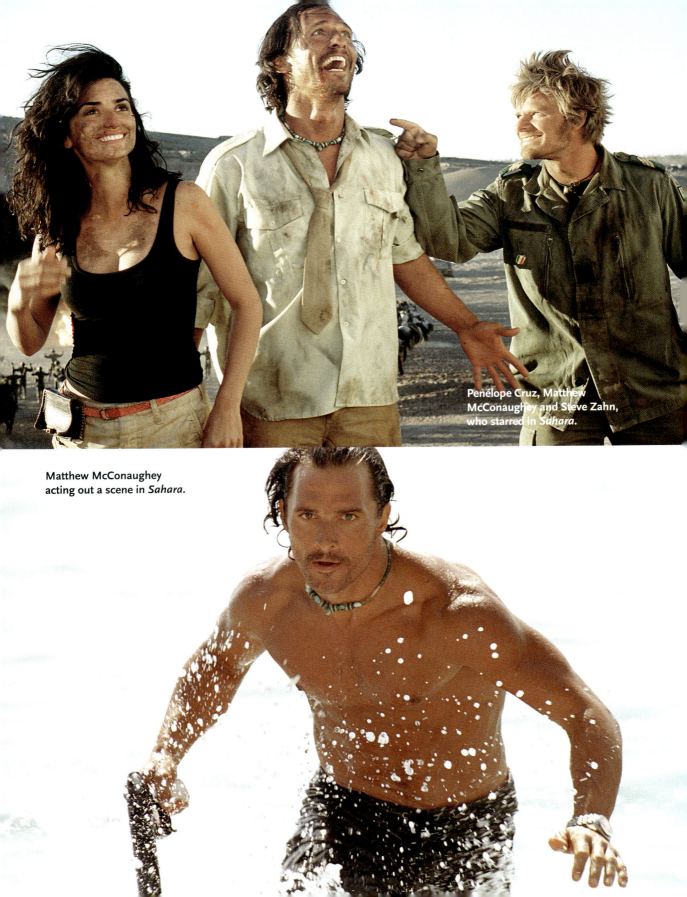

Penélope Cruz, Matthew McConaughey and Steve Zahn, who starred in *Sahara*.

Matthew McConaughey acting out a scene in *Sahara*.

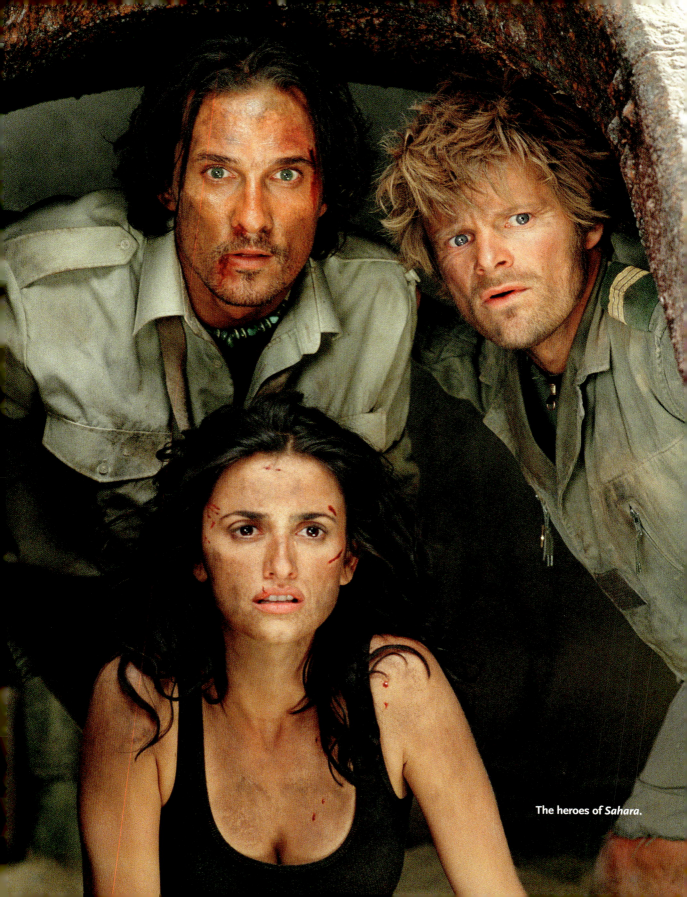

The heroes of *Sahara*.

Doom, which starred Dwayne Johnson.

the first movie on which I went fully digital with my photography.

I had, up until the early 2000s, shot stills on conventional film stock, which was then processed in a laboratory. I was actually well into digital technology on a personal level but hadn't really felt Nikon had produced cameras with a resolution I felt comfortable with using full-time on a professional level. My main apprehension with this on *Doom*, having spoken with the director and director of photography, was how it would work in the low-light look they envisioned for the whole picture recreating the planet Mars.

I was also mindful you couldn't really shoot a sequence of photos quickly as the camera had to record the images to its memory. After taking, say, five images you needed to wait for the card to be written up until Nikon produced the D2H model, which I went on to favour. Digital wasn't that much quieter, as some people think, because you still had the mirror going up and down as it was a reflex camera after all, but as digital technology advanced, the upsides certainly outweighed any earlier downsides. In more recent years they have started manufacturing mirrorless digital SLRs.

Karl Urban gives chase during a scene for *Doom*.

The *Doom* production office was quite insistent they wanted me to shoot digitally, for cost reasons primarily, but also because images could be emailed across to pretty much anywhere instantly, and especially to executives in LA.

Arnold Schwarzenegger was considered for the lead of John Grimm before it was offered to Vin Diesel – but he turned it down. Then Dwayne Johnson was offered the role but turned it down in favour of playing Sarge, having been drawn more to that character, he said. Karl Urban and Rosamund Pike were eventually cast as John and Samantha Grimm and, of course,

I knew Rosamund from *Die Another Day* and made a point of congratulating her on her American accent, which I thought one of the best I'd heard from a British actor. Dexter Fletcher played a supporting role and every time he saw me he'd say, 'Keith, can you get me on a Bond film please? Go on, get me on a Bond …'

Who knows if he might get to direct a Bond in the future given his success on the other side of the camera nowadays?

A lot of the sequences were dark in look and texture, but that was the style and feel of the film, and I think I came up with some

English actor Rosamund Pike had the best US accent I've heard.

interesting material, adding a bit of contrast to some of the actors' faces at times. However, marketing didn't ask for the usual studio portrait images, favouring set-based photography, which sort of leads you to think the actors were secondary to the game. Executive producer John Wells stated in press interviews that a second feature film would be put straight into production if the first was a box office success. That didn't happen.

Someone who did produce his fair share of sequels, however, was Dino De Laurentiis. He had more than 500 films to his credit, and he must have 'discovered' me at least three times over my career!

The Decameron: Angels and Virgins (later shortened to *Virgin Territory*) was one of his UK–Italian–French co-productions and was set at the time of the Black Death, with the young people of Florence all engaging in bawdy adventures. It starred, fresh from *Star Wars*, Hayden Christensen in very much a 'Tom Jones'-type role, and also featured a young David Walliams in an early film appearance. It was great fun and the first of a three-in-a-row I worked on for Dino and his wife Martha, who I liked

Virgin Territory: **Hayden Christensen takes a bath.**

enormously because the buck stopped with them; they were in control and not a committee of twenty producers.

The Last Legion was the second Euro-pudding from Dino, which was very much based in the swords and sandals genre with Colin Firth, Aishwarya Rai and Ben Kingsley … sorry, Sir Ben Kingsley, as we were often reminded. However, I don't think either of these two movies bothered cinemagoers very much, which obviously made Dino a little more mindful of his earlier box office successes and particularly with Hannibal Lecter. *Manhunter* in 1986 was the first film adaptation to feature the character, though curiously Dino passed on making the more successful *The Silence of the Lambs*. Perhaps he then realised his mistake and produced the two follow-ups, *Hannibal* (2001) and *Red Dragon* (2002), the latter being a re-adaptation of *Manhunter*. Dino next turned his attention to a prequel, *Hannibal Rising*, which told the story of how Dr Lecter became a serial killer.

The film was directed by Peter Webber from a screenplay by novelist Thomas Harris, and Dino chose French-born Gaspard Ulliel as the young title character. It was a very bloody film and quite distasteful at times – but then again cannibalism is hardly comedic.

Sadly, Dino didn't replicate his earlier successes with the character, with this film going on to receive two 'Razzie' nominations as Worst Prequel and Worst Horror film. Nevertheless, Dino said to me, 'Keith I want you on ALL my films!' as he took us all out for a celebratory meal on New Year's Eve, having spent Christmas in Prague where we were shooting, and for which Hilary joined me.

Virgin Territory: Dino De Laurentiis looks on.

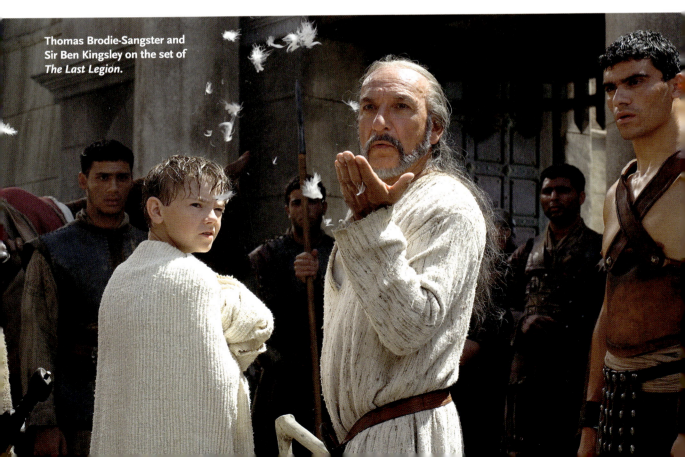
Thomas Brodie-Sangster and Sir Ben Kingsley on the set of *The Last Legion*.

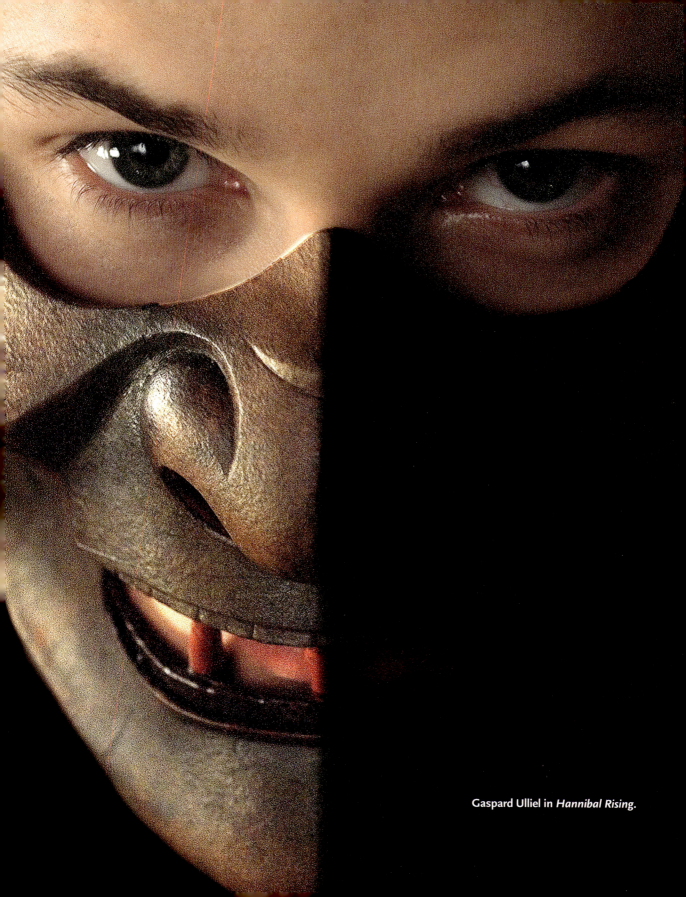
Gaspard Ulliel in *Hannibal Rising*.

Death at a Funeral: Frank Oz told me, 'Don't take pictures of me pointing'.

Sadly, soon afterwards, Dino passed away at the grand age of 91 and we never did get that chance to work on another picture together.

I had worked with Frank Oz on the *Star Wars* films, of course, in his role as Jedi Master Yoda, but I next had the opportunity of working with him as director on a smashing little British comedy called *Death at a Funeral*. Frank had made some terrific comedies such as *Dirty Rotten Scoundrels* and *Bowfinger*, and now came this delicious black comedy containing everything from hypochondriacs to sour old men, a homosexual blackmailer, accidental drug taking and much more, set around a dysfunctional family gathering for a funeral.

Filmed on location in rural Oxfordshire and at Ealing Studios, it was one of those movies where I used to look forward to getting up in the morning as I knew it would be fun and laughter all day long. Frank had a great sense of humour but in an earnest moment told me that he thought all the recent photos of him on film sets were of him standing next to a camera pointing, 'So whatever you do, don't photograph me pointing,' he cautioned.

Well, of course, the first set of images I took for him to see were all of him pointing.

'I told you not to take photos of me like that!' he screamed with a broad grin.

The next morning he presented me with a gift box. I opened it to discover he'd enclosed all those same photos cut up into tiny pieces. This exchange of photos and gifts continued throughout the shoot!

Frank was a director you really found yourself wanting to be with. He had complete control of the set, knew what he was doing and did it with

Peter Dinklage and Matthew Macfadyen on the set of *Death at a Funeral*.

Death at a Funeral: Frank's birthday cake made by Jane Asher.

Death at a Funeral actors Matthew Macfadyen, Jane Asher and Rupert Graves.

a smile and a chuckle. He celebrated a birthday while we were shooting and Jane Asher, who played Sandra in the movie, came to the set with the most gorgeous birthday cake for us all, which she'd baked. I only wish a few more cast and crew had celebrated birthdays whilst we were together.

This amusing and perfectly nice little British comedy somewhat surprisingly spawned two Indian remakes plus a Hollywood version starring Chris Rock, which also saw Peter Dinklage reprise his role as the blackmailer. I'm not sure they were as successful, dollar for dollar, as the original but it just goes to show that death is a subject that actually creates perhaps more laughs than tears.

Speaking of comedy, a master of the genre next came back to London for his thirty-seventh film as director, *Cassandra's Dream*.

Woody Allen had made the majority of his most successful films in New York but had probably been celebrated more as a filmmaker in Europe, so when financing for a couple of films came via London, the natural step seemed to be for him to decamp to the UK. This film actually became his third in the capital and starred Ewan McGregor and Colin Farrell among many

Cassandra's Dream actors Ewan McGregor and Colin Farrell.

Woody Allen directing *Cassandra's Dream*.

Anthony Hopkins and Woody Allen on the set of *You Will Meet a Tall Dark Stranger*.

other first-time collaborators who were all keen to work with Woody, often before a completed script was in place. Woody was very much an introvert and a quiet character, but with a lovely sense of humour and again a man in total charge of the set. He made a film every year and each for a fairly modest budget to ensure a decent return and a continuation of backers' support.

I often saw him sitting in his director's chair between takes, making little notes on slips of paper, which he'd then pop into a little bag. I later discovered these were ideas, plot points or just observations that he'd later take back to his office and from there form ideas and characters for his next story.

I hugely enjoyed working with Woody and after he spent a little time in Spain and the US on his next projects, he returned to London with *You Will Meet a Tall Dark Stranger* in 2009 and asked for me. Happily, the film also reunited me with Anthony Hopkins, who on his first day on set came over and gave me a big hug. Talk about friends reunited.

When my grandson Callum visited the set one day, aged around about 9 I guess, he sat on my camera case and watched filming while also helping me out with carrying my equipment. I took a few photos of Callum and Woody obviously saw, because he quietly photo-bombed us, which was really sweet. Woody also made a point of calling for a unit still at the end of shooting, as he said he wanted a memory of all the cast and crew together. He really did care about the cast and crew and quite clearly loved making movies, and in the

David Frost walks by the set of *You Will Meet a Tall Dark Stranger* and says hello. Tony Hopkins is in the background.

My grandson Callum looking through the movie camera.

Michelle Williams in *Incendiary*.

old-fashioned way – he started at 8.30 a.m., broke for lunch and then by 5.30 p.m. he liked to wrap and go home. It was a very decent way of working.

Finance next took Woody to France and Italy, and eventually back to the US, where sadly stories from his private life really overshadowed his professional life. This led to a lucrative deal with Amazon Studios falling through and several actors saying they'd never work with him again. It was a great shame and I have nothing but fond memories of Woody. Had every film I was employed on afterwards been as much fun and civilised, I may still be at it today.

I did, however, stay with Ewan McGregor to make a film called *Incendiary*, which co-starred Michelle Williams. In fact, when I was offered the job I was told it was because 'Ewan had agreed', and I'm only pleased he felt so kindly towards me. The story was set during the aftermath of a terrorist attack at a football match and marked writer-director Sharon Maguire's first film since the hugely successful *Bridget Jones's Diary*. It was filmed in and around London, which is never easy logistically, and despite me explaining I needed a parking space next to the set, I'd invariably have the production office quiz me as to why I couldn't get on the bus with everyone else from the location base. I just pointed to my ten or twelve cases of equipment and said, 'that's why,' yet it always became a bit of a battle with the thirteen producers, who were all trying to save a pound or two on the budget.

Ewan McGregor and Michelle Williams in a photo shoot for *Incendiary*.

Ewan McGregor in *Incendiary*.

From London I moved to Belfast and its new film studio The Paint Factory (which is now Titanic Studios) for *City of Ember*, which turned out to be one of the lowest-lit sets I'd ever worked on and extremely challenging as a result. In fact, the growing trend seemed to be dark-looking films, and in this instance it was illuminated via a net of suspended lights, the Lighting Grid, which made Ember an intriguing setting that defies time and place. It was based on a 2003 novel for which Tom Hanks and Gary Goetzman had purchased the film rights, with an option on the sequel novel, about how the main generator in the post-apocalyptic underground city is failing and how two teenagers must unlock an ancient mystery before the lights go out for good.

I very fortunately recruited a young assistant named Helen Sloan, who later went on to really make her name with *Game of Thrones*. I remember her asking me for any words of advice I might offer, so I told her to always believe whatever film she was working on was going to be a huge, enormous success, and as such she'd need to have stills of *everything*. On *Ember* there were lots of interesting costumes and sets, so I shot front, back and sides of all the actors and sets because if it had taken off in a big way and become a series then I knew merchandising was to be big business (as it was with the first *Star Wars* film) and then it's those stills the producers will look for.

Sometime later, Helen wrote to me and told me that's exactly what she did when she went

City of Ember stars Martin Landau and Harry Treadaway.

Bill Murray in *City of Ember*.

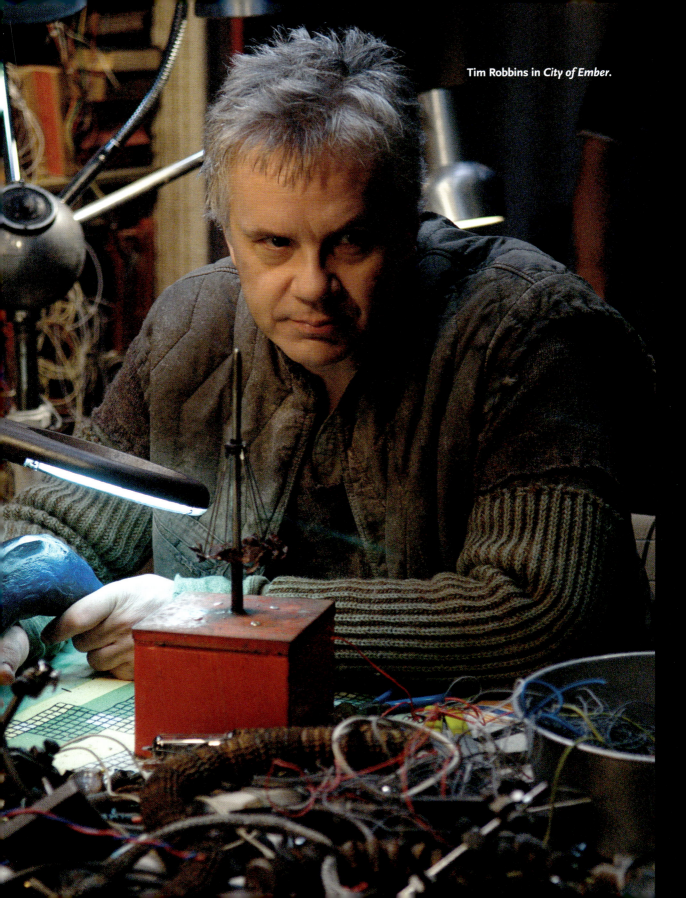
Tim Robbins in *City of Ember*.

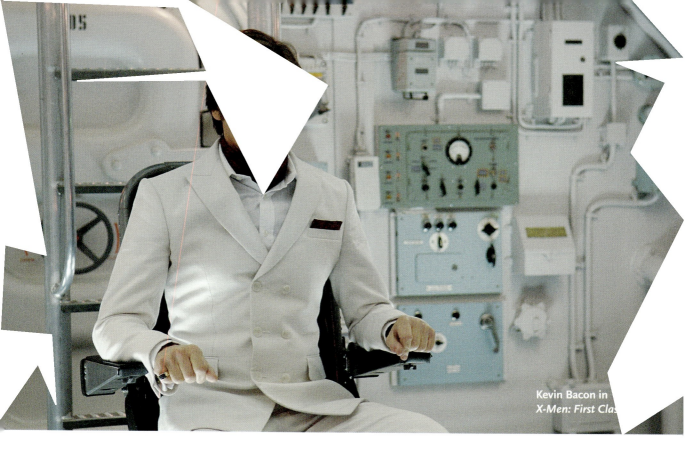

Kevin Bacon in *X-Men: First Class.*

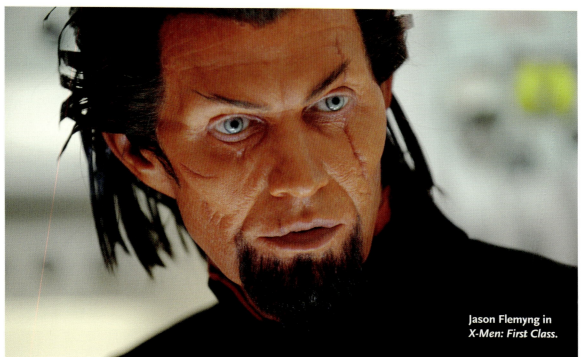

Jason Flemyng in *X-Men: First Class.*

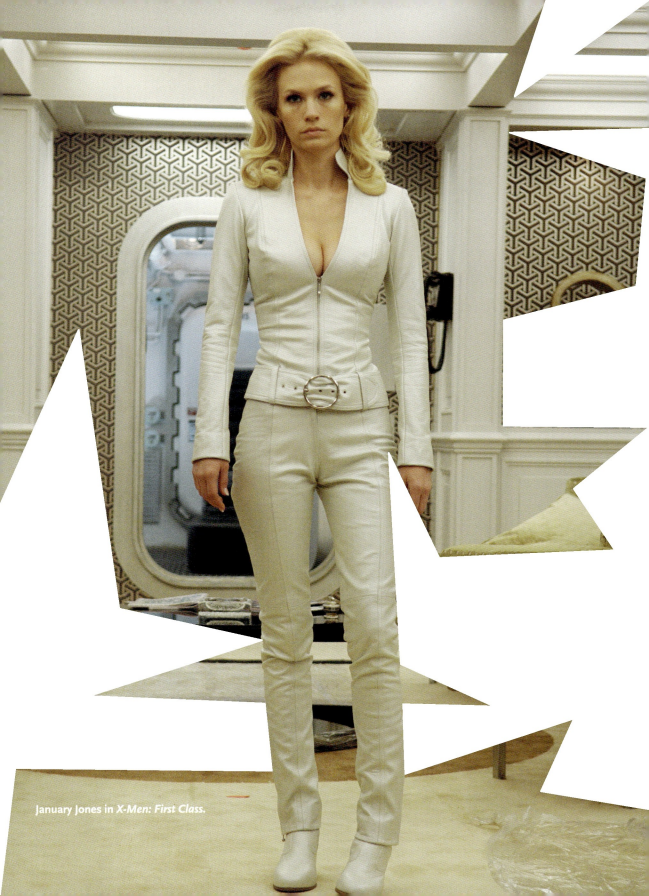

January Jones in *X-Men: First Class*.

onto a little production called *Game of Thrones* in Belfast. Nobody knew how it would go but Helen had everything banked and was ready for them when it became a major hit.

Oh, on our first day of shooting *Ember* Bill Murray arrived on set and looked at me for a moment, obviously thinking he knew me, before proclaiming, 'This is going to be much better than the last bloody film we worked on together [*The Man Who Knew Too Little*] isn't it?' Sadly, no, it wasn't!

As I've said before, no one ever sets out to make a bad film, though I felt I was working on more turkeys than hits in recent times, and coupled with ever-longer shoot days, the impatience of companies in the digital age who wanted to 'see everything NOW' before I had even had a chance to edit them, plus growing a bit older and feeling less agile, made me re-evaluate things a bit. Living out of a suitcase for months on end was never fun, but it seemed to be appealing less and less, as did air travel and passing through airports.

My mother sadly passed away in 2006 too, and all of this combined left me feeling I needed to spend more time at home, not least to deal with her affairs and clear my parents' house (my father had pre-deceased her) but also to enjoy being with my family.

Losing a parent really does shake you. I therefore let it be known I was 'semi-retiring'.

Of course, everyone took that to mean I was retiring, full stop. Maybe I shouldn't have said anything and just been a bit choosier about what work I accepted. The phone stopped ringing and I probably had more time on my hands than I ever anticipated, so I did put myself around a little and let it be known I was still available.

Thankfully I was invited to do some second unit work on *X-Men: First Class*, which was great fun over at Pinewood, and then came the Woody Allen film *You Will Meet a Tall Dark Stranger*, which I've already mentioned, plus a stint on *Maleficent* for Disney, which was essentially the tale of 'Sleeping Beauty' though told from the perspective of the evil witch, who was played by the lovely Angelina Jolie.

But then came *Mission Impossible: Rogue Nation*. David James – who started out just ahead of me at MGM Borehamwood – photographed a lot of Tom Cruise's films but wasn't available for the duration of this one as I think he was working on one of the new *Star Wars* sequels, so they asked if I'd handle some location work in Morocco and London, plus bits and pieces here and there.

I found myself working sixteen-hour days as the norm, after which the emails and phone calls from LA started in the late evening, all wanting to see the day's material just as I was setting my alarm for the next morning – though that is typical of any Hollywood movie nowadays, not just this one.

As the nature of the *Mission: Impossible* films is action, action, action, there were a lot of cameras on set at any one time – steady cams, floating cameras, handheld cameras – and so I found myself ducking and diving a lot making sure I wasn't ever in shot. Maybe my knees were getting a bit too old, as I found myself thinking, 'This is a job for a younger person.'

I'd turned 65 and didn't feel I was enjoying my work so much, and so with the conclusion of *Rogue Nation* I hung up my cameras for the last time.

Angelina Jolie as Maleficent in the film of the same name.

Scene 20

REFLECTIONS

There is no question that I have been extraordinarily lucky and privileged to have worked on so many movies with so very many wonderful cast and crew over the decades, though I was asked recently, 'Is there anyone you would have liked to have worked with, but never had the opportunity?'

Yes – John Huston.

I came close once, towards the end of his career, on a movie he was directing at Twickenham Studios. I did try to get on it, but it just wasn't to be.

I'd also have loved the opportunity to have been on set with Martin Scorsese. Not only are he and Huston hugely talented and visionary filmmakers, but they are also directors who are in total charge and with whom the buck truly stopped.

So if I did have any regrets, not working with those two gentlemen would be top.

Looking back, though, I don't think I've done too bad for a ukelele-playing boy from Essex. I hope you've enjoyed sharing some of my memories and photographs, and fingers crossed, as Sir Roger Moore always cautioned me, they're in focus!

With my cameras (on *Cassandra's Dream*), which are now hung up as I enjoy my retirement. It's all been great fun!

CREDITS

On Stage

As an actor	Year
Swinging Down the Lane, London Palladium	(for nine months, 1959)
Clown Jewels, at the Victoria Palace	(for three weeks, 1959)
Oliver!, at the New Theatre	(for fourteen months, 1960–61)

Filmography

As an actor	Year of release
In Search of the Castaways	(1962)
Play it Cool	(1962)

As photographer	Year of release
2001: A Space Odyssey	(1968)
Battle of Britain	(1969)
Tam-Lin	(1970)
Freelance	(1970)
The Walking Stick	(1970)
The Magnificent Seven Deadly Sins	(1971)
Under Milk Wood	(1971)
The Tales of Beatrix Potter	(1971)
Murphy's War	(1971)
Young Winston	(1972)
The 14	(1973)
11 Harrowhouse	(1974)
Juggernaut	(1974)
Phase IV	(1974)
The Little Prince	(1974)
Rosebud	(1975)
Royal Flash	(1975)
Barry Lyndon	(1975)
Lucky Lady	(1975)
Trial by Combat	(1976)
Joseph Andrews	(1977)
The Spy Who Loved Me	(1977)
The Deep	(1977)
Philadelphia, Here I Come!	(1977)
The Big Sleep	(1978)
Death on the Nile	(1978)
The Corn is Green	(1979)
Lost and Found	(1979)
The Lady Vanishes	(1979)
Saturn 3	(1980)
Green Ice	(1980)
Superman II	(1980)
Heaven's Gate	(1980)

For Your Eyes Only	(1981)	*The Madness of King George*	(1994)
Clash of the Titans	(1981)	*Immortal Beloved*	(1994)
The Hunchback of Notre Dame	(1982)	*Radioland Murders*	(1994)
Superman III	(1983)	*Black Beauty*	(1994)
The Winds of War (TV)	(1983)	*GoldenEye*	(1995)
Krull	(1983)	*Haunted*	(1995)
Master of the Game	(1984)	*The Wind in the Willows*	(1996)
Indiana Jones and the Temple of Doom	(1984)	*Tomorrow Never Dies*	(1997)
Spies Like Us	(1985)	*The Man Who Knew Too Little*	(1997)
A View to a Kill	(1985)	*Incognito*	(1997)
King David	(1985)	*Firelight*	(1997)
Crimes of the Heart	(1986)	*Anna Karenina*	(1997)
Half Moon Street	(1986)	*The World is Not Enough*	(1999)
The Last Emperor	(1987)	*Star Wars: Episode I: The Phantom Menace*	(1999)
The Living Daylights	(1987)	*The Mummy*	(1999)
Ishtar	(1987)	*Spy Game*	(2001)
Willow	(1988)	*Band of Brothers*	(2001)
Jake's Journey (TV)	(1988)	*The Mummy Returns*	(2001)
Great Balls of Fire!	(1989)	*Die Another Day*	(2002)
Licence to Kill	(1989)	*Star Wars: Episode II: Attack of the Clones*	(2002)
A Chorus of Disapproval	(1989)	*I'll Sleep When I'm Dead*	(2003)
Bert Rigby, You're a Fool	(1989)	*I Capture the Castle*	(2003)
Pressgang (TV)	(1989)	*Sky Captain and the World of Tomorrow*	(2004)
The Saint (TV)	(1989)	*Man on Fire*	(2004)
Hamlet	(1990)	*Sahara*	(2005)
Bullseye!	(1990)	*Doom*	(2005)
Frankenstein Unbound	(1990)	*Star Wars: Episode III: Revenge of the Sith*	(2005)
Mister Johnson	(1990)	*Virgin Territory*	(2007)
Under Suspicion	(1991)	*Cassandra's Dream*	(2007)
Chaplin	(1992)	*The Last Legion*	(2007)
Blue Ice	(1992)	*Death at a Funeral*	(2007)
Carry on Columbus	(1992)	*Hannibal Rising*	(2007)
Patriot Games	(1992)	*City of Ember*	(2008)
The Power of One	(1992)	*Incendiary*	(2008)
Shining Through	(1992)	*You Will Meet a Tall Dark Stranger*	(2010)
The Adventures of Young Indiana Jones (TV)	(1992–96)	*X-Men: First Class*	(2011)
Shadowlands	(1993)	*Maleficent*	(2014)
		Mission: Impossible Rogue Nation	(2015)

ACKNOWLEDGEMENTS

There are many people to thank for their encouragement and help in making this book a reality.

First of all, my family.

My wife Hilary, son Scott and daughter Tansey; grandson Sebi and granddaughter Willow, and especially my other grandson Callum, who nagged me until I gave in and got the whole venture going;

My friend Gareth Owen for not falling asleep while we chatted, and also for helping make literary sense of all my stories – and without whom this wouldn't have been possible;

Pierce Brosnan for being a good mate;

Barbara Broccoli and all at Eon Productions and MGM for permission to reproduce stills from the James Bond films I worked on;

My dear friends in the publicity department: Jerry Juroe, Gordon Arnell, Geoff Freeman, Sue Darcy, and in particular Lynn Hale, who were my absolute bricks during the times I worked with them;

Mark Beynon and all at The History Press for being such terrific publishers;

Robin Harbour for casting his good eye over the text;

John Richardson for being a catalyst;

And finally, to all the cast and crew I have worked with throughout my career – thank you. Thank you for allowing me to be part of the amazing movies you made and for allowing me to capture you in my lens.

The James Bond films and images are © Eon Projections and MGM Studios 1962–2024, All Rights Reserved.

The Stars Wars and Indiana Jones Films and images are © Walt Disney Company, Lucasfilm Ltd. LLC, All Rights Reserved.

Samuel L. Jackson in *Revenge of the Sith*.

Brad Pitt being questioned in *Spy Games*.

The Mummy Returns: Dwayne Johnson in action.

The amazing funeral scene in *Immortal Beloved*.

The brilliant ta...
GoldenEye: all filme...
Leavesden back...

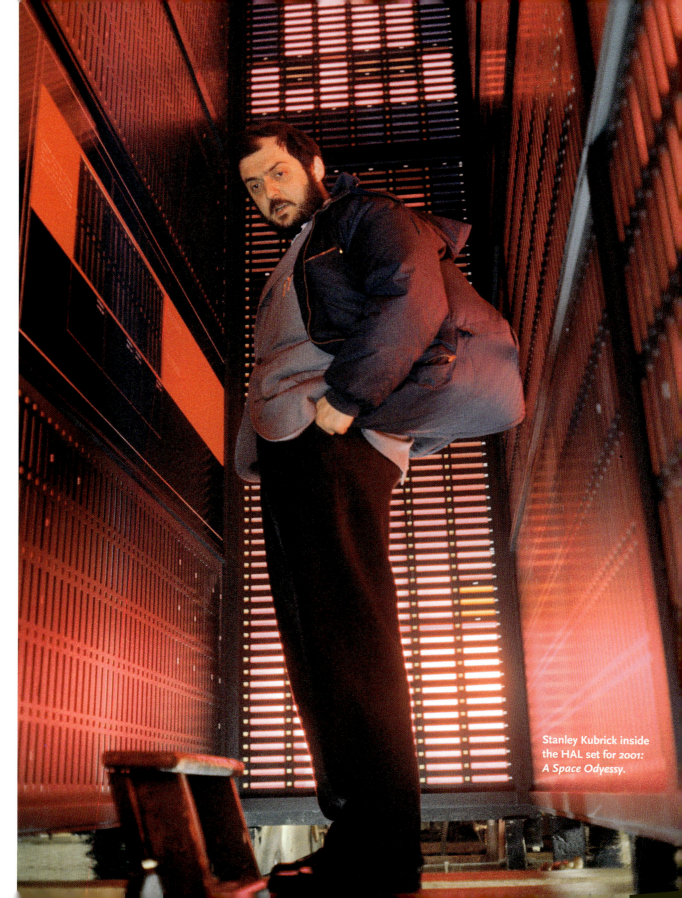

Stanley Kubrick inside the HAL set for *2001: A Space Odyessy*.